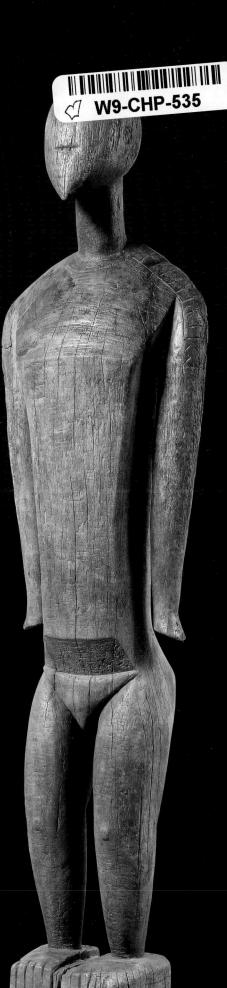

OCEANIC ART
A CELEBRATION OF FORM

by George R. Ellis

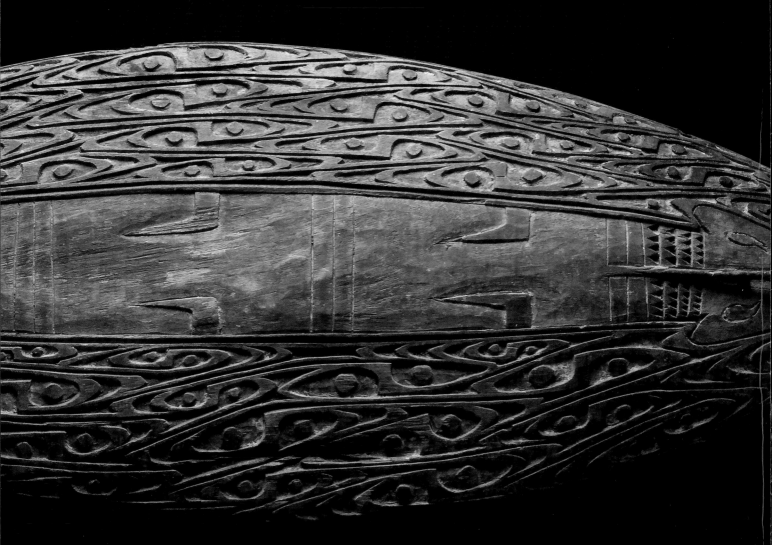

San Diego Museum of Art

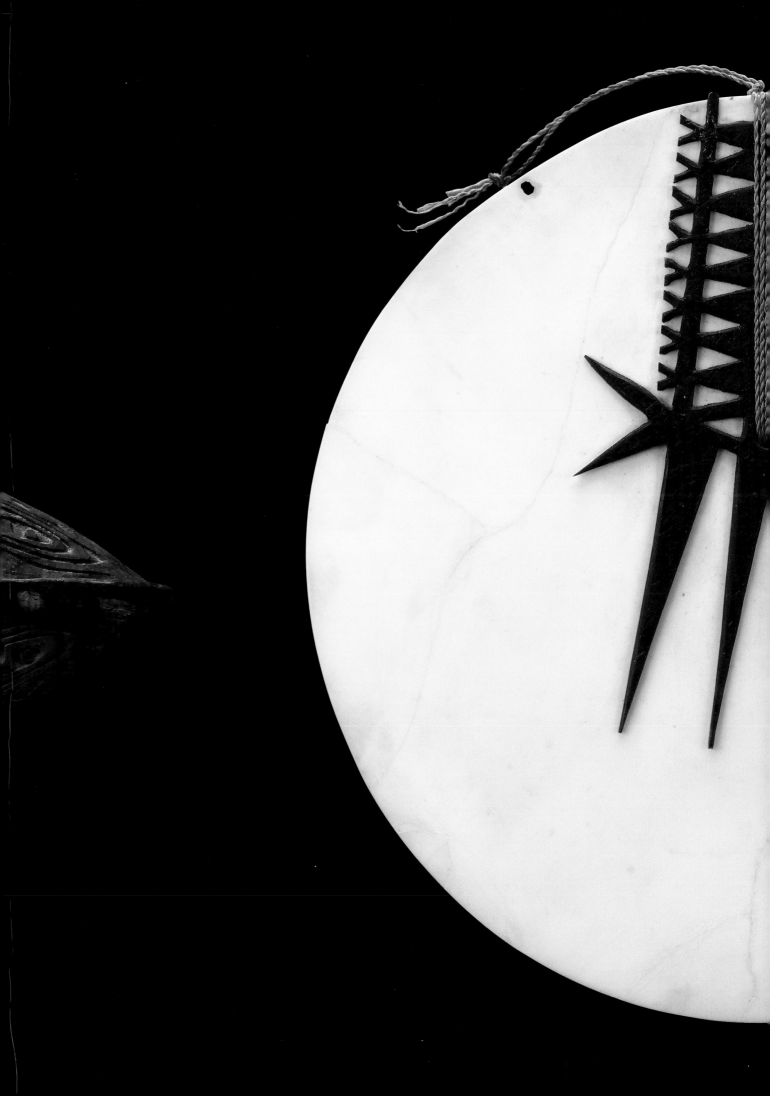

This publication accompanies the exhibition *Oceanic Art: A Celebration of Form*, organized by the San Diego Museum of Art, on view at the San Diego Museum of Art, San Diego, California, from 31 January 2009 to 3 January 2010.

The exhibition and its accompanying publication have been generously supported by Tanya and Charles Brandes, Joan and Frederick Nicholas, and the Ray and Wyn Ritchie Evans Foundation.

Additional funding has been provided by the City of San Diego Commission for Arts and Culture, the County of San Diego Community Enhancement Program, and members of the San Diego Museum of Art.

Library of Congress Cataloging-in-Publication Data
Ellis, George R.
 Oceanic art : a celebration of form / by George R. Ellis.
 p. cm.
 Publication accompanying an exhibition held at the
San Diego Museum of Art, San Diego, Jan. 31, 2009–Jan. 3, 2010.
 Includes bibliographical references.
 ISBN 978-0-937108-46-8 (softcover : alk. paper)
 1. Art, Pacific Island—Exhibitions. I. San Diego Museum of Art. II. Title.
N7410.E45 2009
709.95'074794985—dc22
 2008050748

COVER front left: Fly whisk, detail cat. 30; front right: Roof gable ornament (*teko teko*), cat. 97; front flap: Tapa cloth (*salatasi*), detail cat. 44; back: Mask, cat. 41; back flap: Tapa cloth (*kapa moe*), detail cat. 46

INTERIOR DETAILS page 1: Figure (*tino aitu*), cat. 36; page 2: Platter, cat. 64; page 3: Ornament (*kapkap*), cat. 48; page 10: Panel, cat. 93; page 12: Canoe prow mask, cat. 87; pages 14–15: Tapa cloth (*siapo vala*), cat. 47; pages 16–17: Tapa cloth (*kapa moe*), cat. 46; pages 18–19: Tapa cloth (*kapa moe*), cat. 46; pages 20–21: Tapa cloth (*salatasi*), cat. 44

Exhibition curated by George R. Ellis
Exhibition coordinated by John Digesare, Scot Jaffe, Julia Marciari-Alexander, and Vas Prabhu
Publication coordinated at SDMA by Julia Marciari-Alexander
Designed by John Hubbard
Photography of all objects from the Edward and Mina Smith Collection, the Sana Art Foundation Collection, and SDMA by Gregory Bertolini; photography of all objects from the Valerie Franklin Collection by Alison Duke
Edited by Mariah Keller
Proofread by Sharon Rutberg
Color management by iocolor, Seattle
Produced by Marquand Books, Inc., Seattle
 www.marquand.com
Printed and bound in Singapore by CS Graphics Pte., Ltd.

CONTENTS

DIRECTOR'S FOREWORD

Here, near my hut, in complete silence, I dream
of violent harmonies in the natural scents which
intoxicate me.
> —Paul Gauguin, excerpt from a letter
> written in Tahiti, March 1899

Apart from exotic sentiments, the experiences of South Pacific cultures have scarcely been considered outside Oceania. Paul Gauguin left vivid examples of those experiences through his works and writings. The great French painter generated images that were lush and erotic, but that remain fundamentally cryptic representations of the island life he lived during his final decades away from his family and the bourgeois norms of modern Europe. Today, more than a century later, our own imaginative sense of Oceania depends on a limited variety of sources—Gauguin or Robert Louis Stevenson, perhaps, but also mass market magazines, television, and popular cinema. Even as our own relative proximity to the South Pacific subtly shapes that experience, we would learn much more from direct contact with Oceanic objects. Without them, the unique island myths and cosmologies that were so deliriously intoxicating for the post-Impressionist artist remain foreign to us. How might a twenty-first century museum begin to suggest new perspectives on the Oceanic world?

Several major institutions have recently proposed answers to that question. The opening of the Musée du Quai Branly in Paris in mid-2006 offered a strong response to the lesson of Gauguin's sojourns to the South Pacific. At the inauguration of Jean Nouvel's breathtaking building on the Left Bank, President Jacques Chirac described the motivations behind the museum's dedication to these art forms by asserting, "France [had] wished to pay homage to peoples to whom, throughout the ages, history has all too often done violence." Cultural display as an act of political restitution may be questioned on theoretical grounds, but there can be no doubt that the new French museum has, practically speaking, brought tremendous new international attention to this material. Quai Branly continues to mount authoritative exhibitions rooted in European curiosity about Oceanic cultures, such as *Polynésie: Arts et divinités, 1760–1860* (2008). Similarly, the reinstallation of the Michael C. Rockefeller Wing at New York's Metropolitan Museum of Art in November 2007 refocused U.S. attention on Oceanic art. With approximately 17,000 square feet of exhibition space dedicated to Oceanic and Native American art forms, as well as handsome new publications to document the works shown in those galleries, an undeniable new inquisitiveness about these cultures can be measured.

This year, the San Diego Museum of Art (SDMA) initiates a multi-year project to show the arts of Africa, Oceania, and the Americas as part of its permanent collection galleries. In so doing, we recognize that popular fascination with the Oceanic world takes place on multiple levels. Whether being driven by a voyeuristic interest in castaways competing in tropical locales or as a response to high-end travel programs, increasingly we are embracing the material culture of Oceanic groups as a positive, environmentally conscious decision. *Oceanic Art: A Celebration of Form* participates in the burgeoning curiosity about the works of art that come out of these inherently fragile, insular ecosystems and provides a meaningful context for understanding the sheer breadth and diversity of visual art from this watery part of the globe. As the first exhibition and publication to document the San Diego Museum of Art's exploration of these traditional representations, *Oceanic Art: A Celebration of Form* announces SDMA's commitment to presenting and interpreting art in an encyclopedic context.

This first project capitalizes upon the unique circumstance of having two outstanding Southern California collections whose principal strengths reside in Oceanic objects. Without the support of Edward and Mina Smith and of Valerie Franklin, we would not be able to share such important objects with a worthy public here in San Diego. I wish to thank the collectors, first and foremost, for their great taste and their generosity in lending to this long-term installation at SDMA. Valerie Franklin

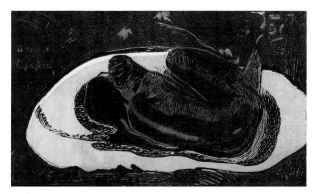

Paul Gauguin (1848–1903), *Manao tupapau (The Specter Watches Over Her)*, 1893–94. Woodcut. 8⅟₁₆ × 14⅟₁₆ in. San Diego Museum of Art, Gift of Mr. and Mrs. Irvin T. Snyder, 1949:17.

has been a personal friend for more than a decade. I first came to admire Valerie during my tenure as the director of the Hood Museum of Art at Dartmouth College, where the Franklin Collection is considered one of the most treasured resources within a stellar and well-researched ethnographic art collection. Edward and Mina Smith are newer friends, but their passion for studying the finest examples of Oceanic art throughout the world, and bringing many works back to their home in San Diego County, has been similarly instructive. By dedicating this publication to these three individuals, I hope to underscore my admiration for what they have accomplished in building their collections. I also celebrate their instinct to share these works generously with a diverse public in San Diego. The promised gift of a large group of African, Oceanic, and Native American objects from the Sana Art Foundation to SDMA in early 2009 and the foundation's commitment to partnering with SDMA on a number of current and future projects have cemented the logic behind *Oceanic Art: A Celebration of Form.*

George Ellis—a scholar of Oceanic art and one of the most beloved museum professionals in the field—curated the exhibition. The chance to collaborate with George has been a privilege. His contribution to the project goes far beyond the essay that follows and the initial selection of works for display in San Diego. For many years, George brought a wide array of projects to Southern California in his capacity as associate director of the Fowler Museum at UCLA. It seems fitting that he return to California in his retirement to work on this important project and that his considerable impact on the field be acknowledged one more time. His commitment to the arts of Africa, Oceania, and the Americas is truly inspiring. George, and his wife,

Nancy, have become great friends of the San Diego Museum of Art, and I hasten to use this opportunity to communicate my gratitude to them both.

In preparing the exhibition and publication, we at SDMA have received invaluable support from Chelsea Dillon-Miller, administrator at the Sana Art Foundation; we are immensely grateful for all her work to ensure the success of this publication and exhibition. Additionally, all of my colleagues at SDMA deserve recognition for the hard work they have put into making this exhibition come to fruition. Vasundhara Prabhu, deputy director for education and interpretation, and Julia Marciari-Alexander, deputy director for curatorial affairs, each played critical roles in bringing the exhibition and publication to a successful conclusion. They have my thanks as well. Julianne Markow, deputy director for operations and finance, and Katy McDonald, deputy director for external affairs, also made key contributions to the project. Scot Jaffe, exhibition designer, and John Digesare, registrar for loans, and their expert teams, along with Vanessa Corbera, curatorial assistant, and Christianne Penunuri, public relations manager, and her team, all helped ensure the best presentation of this museum's work.

Oceanic Art: A Celebration of Form would not have been possible without the contributions of some valued friends of SDMA. In particular, I would like to thank Tanya and Charles Brandes, Joan and Frederick Nicholas, and the Ray and Wyn Ritchie Evans Foundation for their substantial support of the project. Peter Ellsworth, president of the Legler Benbough Foundation, has long been a proponent of broadening this museum's focus, and it is hoped that this project adds measurably to this goal. I also wish to express my gratitude to my colleagues at the Joe and Vi Jacobs Center in San Diego for their sincere interest and advice about this project: Jennifer Vanica, Lisette Islas, and Lefaua Leilua foremost among them.

Finally, I would like to record my appreciation to the board of trustees at the San Diego Museum of Art. Their vision for a more engaged museum, one that offers the fullest spectrum of high-quality experiences for the broadest conceivable public, stands behind this and every effort at the institution. I hope that they, and many others, will find both the subject of the exhibition and this catalogue more than just mildly intoxicating, but worthy of admiration, contemplation, and repeated study.

Derrick R. Cartwright
The Maruja Baldwin Director

LENDERS' STATEMENTS

THE VALERIE FRANKLIN COLLECTION

The Valerie Franklin Collection is a collection of two lifetimes, mine and that of my father, Harry A. Franklin (1903–83). He was a pioneer collector, one of the first on the West Coast to devote himself to what was then called "primitive art." His collection had a special emphasis on the Oceanic world, including a wide selection of art from Melanesia, particularly New Guinea, as well as sculpture from Polynesia. Continuing my curatorial role with his collection, I became solely responsible for it twenty-five years ago following his death.

My father enjoyed teaching others about the merits of this art. He loved the open imagination, endless variation, and radical use of form that it represents. Beginning in the 1930s, he followed the European and American artists who discovered the riveting beauty of traditional tribal art. And, in furtherance of his passion for this art, he sponsored Dutch botanical expeditions to New Guinea; the scientists collected plant specimens and sent my father the art that they acquired.

During the 1950s, other families bought new cars—we acquired new art. My parents also began the tradition of inviting scholars, collectors, and museum curators and directors from Europe and America to participate in an interdisciplinary exchange of ideas, information, and camaraderie. This cross-fertilization led to an ongoing "salon" of sorts that bore fruits of increasing connoisseurship and support for museum and university exhibitions of traditional tribal art. Many of these efforts are now recognized as classic and innovative.

This unusual upbringing led me to a deep understanding of and love for Oceanic art. Being surrounded by my father's great collection made it natural for me to become an art historian, studying first at Scripps College and then receiving my degree from UCLA. I worked with my father for years and then led our gallery, which opened in 1955 in the new La Cienega arts district at La Cienega and Beverly Boulevard. In 1961, it moved to Rodeo Drive in Beverly Hills, where it stayed for seventeen years. It then moved to the seventh floor of the Union Bank Building in Beverly Hills for ten years and next to another bank building on Rexford Drive, where we worked privately until its closing upon my early retirement in 1989.

Ever advocates for traditional tribal art, over the last half-century, we have lent to innumerable museums and exhibitions and have actively donated art to fine museums across the country, among them the Denver Art Museum, the Detroit Institute of Arts, and the Baltimore Museum of Art.

Over the past two decades, I have given, as a legacy to my family, a large and significant collection of Oceanic art to the Hood Museum of Art at Dartmouth College, in Hanover, New Hampshire. In my quest to educate people about traditional tribal art, I have served on the board of directors at the Smithsonian's National Museum of African Art. I strongly believe in the power of art to bring diverse people together, to show the similarity in our humanity, and to bring forth the greatness of the human spirit.

The San Diego Museum of Art (SDMA), led by its director, Derrick Cartwright, is guiding the museum into the twenty-first century in concert with a vision of the global village. Initiating a new program for SDMA to exhibit the arts of Oceania, Africa, and the Americas, Dr. Cartwright has been magnetic in galvanizing enthusiasm for this project of cultural diversity. A new audience will thrill to the artistic magic of these fascinating, but lesser known, cultural traditions. I am delighted to be a part of this initiative from the beginning.

THE EDWARD AND MINA SMITH COLLECTION

We are both passionate art collectors and are drawn especially to the arts of Africa, Oceania, and the Americas, or what is commonly referred to as AOA. Within this historically underrepresented field, we find the objects have great visual impact and powerful imagery, often possessing beautiful and abstract forms. As collectors, it is not only the aesthetic of these arts that intrigues us, but also the fact that each piece represents a set of culturally coded meanings that encourage us to explore further.

Before acquiring a particular work, we determine whether the object displays the characteristics that will retain our interest and whether or not it will strengthen and enhance our collection. These are often difficult choices to make and would not be possible without the guidance and advice we have received from experts and fellow collectors.

Oceanic art represents an important part of our collection. Outstanding objects from that area of the world are scarce and difficult to source. As a result, we travel extensively to secure objects. On occasion, our travels involve the discovery of a great work of art, and those serendipitous moments make this adventure and passion an important part of our lives together.

An essential aspect of enjoying our collection is sharing this art with others. We reach out to individuals, museums, and institutions by providing access to these unique objects, and we have a personal and professional goal of sharing these arts with the public. For this reason, we founded the Sana Art Foundation in 1996.

Recent initiatives by the San Diego Museum of Art (SDMA) to expand collection areas and programming to include the arts of AOA offered us an excellent opportunity to participate in an exciting new development by making our Oceanic collection available for this project. The exhibition presents us a unique opportunity to collaborate with our friend Valerie Franklin and her exceptional collection. Derrick Cartwright's forward vision assembled the following group of outstanding professionals, and we thank them for bringing about new cultural content within the Southern Californian art community: George Ellis, Julia Marciari-Alexander, Vas Prahbu, Katy McDonald, Scot Jaffe, John Digesare, and the rest of the SDMA team.

This exhibition and publication of Oceanic works finally gives the San Diego community a venue for making these arts accessible to the broadest possible audience. This is a celebration of the rightful place that these arts have in the world of great art.

THE SANA ART FOUNDATION COLLECTION

The Sana Art Foundation, located in Escondido, California, is a nonprofit organization whose mission is to increase public appreciation and awareness of the importance of cultural diversity in the world. The foundation provides educational programs that relate to the historical and evolving cultures and arts of Africa, Oceania, and the Americas.

Established in 1996 by Edward and Mina Smith, the foundation has one of the largest public collections of non-Western art in the San Diego region and was formed over a period of the last fifteen years. Works from the Sana Art Foundation have been exhibited at the de Young Museum, San Francisco; the California Center for the Arts, Escondido; the Mingei International Museum, San Diego; the San Diego State University Art Gallery; the William D. Cannon Art Gallery, Carlsbad; the San Diego Mesa College Glass Gallery; and the Sana Gallery, Escondido.

The foundation's notable art collection and in-depth library, along with the support of our members and funds from the endowment, have allowed it to provide much-needed support for the following graduate and undergraduate student-collaborative exhibitions and publications: *Asking for Eyes: The Visual Voice of Southeast Africa* (2004), *The Space Between: Ritual Transformations* (2006), *Rituality* (2007), and *Weaving Connections: Cultural Exchanges during the Southern California Basket Trade 1880s–1940s* (2007). These programs would not be possible without the tutelage of the following professors: Dr. Teri Sowell (UCSD, SDSU), Dr. Barbara Blackmun (UCSD, San Diego Mesa College), and Dr. Elizabeth Newsome (UCSD).

The foundation supports SDMA's plan to expand collections and programming, and we look forward to collaborating with the museum's talented team of professionals over the next several years. This initial show of Oceanic art is an exciting first step in bringing the arts of these various cultures to our community and hopefully establishes a new home for the art of Africa, Oceania, and the Americas in San Diego.

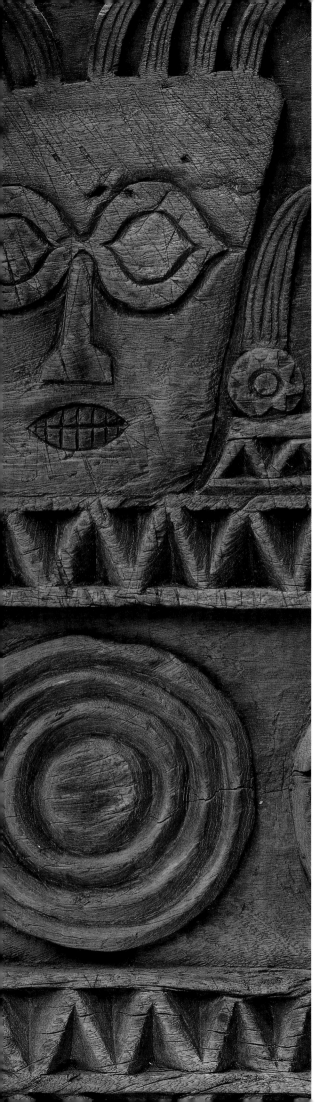

ACKNOWLEDGMENTS

I was flattered to be asked to guest curate this exhibition and write its accompanying catalogue. My return to working directly with collections, after many years in museum administration, has been a very gratifying experience, a transition aided and expedited by everyone I have had the pleasure of working with at the San Diego Museum of Art. This highly professional staff has been helpful, gracious, and supportive. I am especially indebted to the museum's director, Derrick Cartwright, for his unfailing encouragement and his advocacy for the presentation of non-Western arts. Derrick's leadership and vision for the museum is exemplary. A special debt of gratitude is owed Vasundhara Prabhu, deputy director for education and interpretation. Vas has carefully monitored the early progress of the catalogue and exhibition, offered sensitive and constructive suggestions, and developed appropriate educational programs and activities. Newly appointed Deputy Director for Curatorial Affairs Julia Marciari-Alexander enthusiastically assumed responsibility for the project after her arrival and has been instrumental to the success of this endeavor. Exhibition designer Scot Jaffe's excellent work has resulted in a beautiful exhibition, while the expertise of Julianne Markow, deputy director for operations and finance, Christianne Penunuri, marketing and communications, and Golda Akhgarnia, former public relations coordinator, has guaranteed that the show was well supported, publicized, and attended. The editing of the catalogue was in the expert hands of Mariah Keller. For production of the beautifully designed catalogue, I thank Ed Marquand and his staff at Marquand Books, especially designer John Hubbard and editor Marie Weiler. Tye Barber ably and cheerfully handled the logistics of travel and scheduling. Chelsea Dillon-Miller, administrator for the Sana Art Foundation, has been of great assistance in identifying photographs for possible use in the exhibition, assisting with logistical problems, and aiding with certain research issues. The foundation has been most generous in releasing Chelsea to work with me.

The last twenty-five years have seen significant growth in Oceanic arts scholarship and publication. My thanks and respect go to all the scholars whose efforts have made my work far easier; many are cited in the selected bibliography. Building on the work of early pioneers, their dedication and perseverance is responsible for expanding our knowledge, understanding, and appreciation of the people and art of Oceania. Friends and colleagues Barry Craig, Christian Kaufmann, Eric Kjellgren, John Terrell, and Deborah Waite have kindly responded to my queries. Roger Rose read the text, offering appropriate suggestions and noting errors of commission and omission. As is always the case, however, the final essay is totally my responsibility.

I have had the extreme pleasure of working with three important collectors and their excellent collections. I knew Valerie Franklin's parents, Harry and Ruth, when I was a graduate student at UCLA, and I have known Val since she was a young girl. Her parents, legendary among the first dealers and collectors of non-Western art, were known for their knowledge, connoisseurship, and kindness— traits that are clearly in Valerie's genes. She is deeply devoted to the art and basic human dignity of Oceanic people and carries on the Franklin family tradition with great distinction. Ned and Mina Smith are equally devoted to the Pacific world and have immersed themselves in information gained from scholars and literature worldwide. They, too, have a keen eye, and exceptional works grace their collection as well. These collectors are united in their desire to acquire only the finest work available. Regrettably, not all the work from their collections could be included in this publication and exhibition, but after larger display spaces were identified, the initial selection was increased. The additional objects could not be fully discussed in this publication, but each is illustrated. The collectors' desire to share their collections has made possible an extended presentation of their holdings that is extremely generous. These three friends have also donated many works to museums and universities and have underwritten a variety of

educational initiatives, clear indications of their commitment to preserving the legacy of Oceanic peoples and their art.

Finally, I want to especially thank my wife, Nancy, who has been essential and vital in the production of the catalogue text. I continue to work with a felt-tip pen and yellow pad, but Nancy entered today's high-tech world some time ago and is fully able to communicate in cyberspace. Aside from my longtime executive secretary at the Honolulu Academy of Arts, Litheia Hall, Nancy is the only person who can decipher my handwriting and sometimes intuit my meaning as well. I truly could not have done this without her unwavering assistance and good-natured encouragement.

My most profound thanks go to the people of the Pacific, both past and present. Oceanic cultures and art may superficially seem quite different from those in the Western world, but, in reality, they are simply and fundamentally another reflection of all people's desire to create order, understanding, meaning, dignity, and beauty in their lives.

George R. Ellis

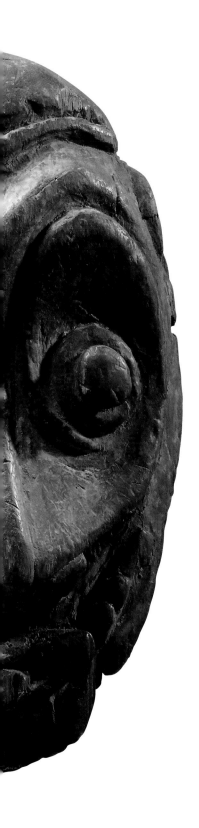

OCEANIC ART

This essay is dedicated to the memory of Philip Dark and to his widow Mavis—dear friends and champions of Pacific people and their art.

The vast Pacific Ocean covers one-third of the earth's surface and encompasses thousands of islands. This region, known as Oceania, is divided into three distinct geographic components: Micronesia, Melanesia, and Polynesia (see map, p. 19).[1] These divisions generally comprise distinct ethnic, linguistic, and cultural traits, but these are not absolute.

Scattered across this shimmering expanse of water, the islands are extremely diverse in size and topography. The sometimes snow-covered high mountains of Papua New Guinea, New Zealand, and Hawai'i rise thousands of feet above sea level, while the tiny atolls of Micronesia may only protrude a few feet above the ocean's surface. New Guinea is the second-largest island in the world, but the majority of the Pacific islands are considerably smaller, some only constituting a few square miles. As one might suspect, climate and vegetation are extremely diverse; temperate and tropical climates accommodate a wide range of flora and fauna, including many unique endemic species that are now endangered.[2]

The larger Oceanic islands are found in Melanesia, with Polynesia's New Zealand being one notable exception. Melanesia includes New Guinea, the Admiralties, New Britain, New Ireland, the Solomons, and the islands of Vanuatu, Fiji, and New Caledonia.[3] Polynesia encompasses the triangular area delineated by and including the islands of Hawai'i, Easter Island (Rapa Nui), and New Zealand. The island groupings located there are Tonga, Samoa, the Cooks, the Australs, the Societies, the Marquesas, and Mangareva. Micronesia, which lies to the east of the Philippines, includes several thousand tiny islands that support a small population. Its four main archipelagos are the Marshalls, the Carolines, the Marianas, and the Gilberts. Today, the geopolitical status of the islands of Oceania is varied. Some islands are independent countries; some are a part of other countries; and some are areas of special sovereignty.[4]

Today, few Westerners are familiar with this remote region of the earth. The American educational system makes infrequent voyages and forays into Oceanic history, and an American's impressions frequently stem from popular culture as well as tourist brochures and promotions. It is "paradise on earth," not unlike the reports of early Western explorers who visited Polynesia. Hawai'i, Tahiti, Fiji, and select islands in Micronesia are now marketed in this way and receive the greatest number of visitors. Not fitting this image, however, is all of Melanesia, a vast area of beauty and exceptional cultural diversity that does not yet possess the infrastructure to handle tourism on a large scale. But this seems to be changing. Tourist boats once plied the Sepik River, and visitors can also enjoy the comfort of luxurious small ships that travel between the Trobriand Islands, the Solomons, and New Britain.[5] The cruises tout authentic cultural encounters with "primitive society," and descriptive information serves to sensationalize the journey, referring to "cannibals" and "the uninhibited sexual mores" of the people. Our knowledge has also been severely tainted by Hollywood, with Elvis Presley and a sarong-clad Dorothy Lamour swaying in the breeze, or images of dark jungles inhabited by horrific masked and painted "savages" terrorizing hapless Westerners. Our impressions are further influenced by television shows such as *Survivor* and *Lost.* For other Americans, the islands of Melanesia and Micronesia are only reminders of their wartime experiences in the Pacific, and Micronesia seems best known as the location for atomic testing by the United States.

The ancestors of today's Pacific people faced formidable challenges. Adapting to existing physical and climatic circumstances as necessary, they developed the rich cultural mosaic that the first Western explorers encountered.[6] In contrast to most popular treatments and depictions of the Pacific islands as leisurely, luxurious, and romantic, life was often challenging. Earthquakes, volcanic eruptions, cyclones, floods, tidal waves, droughts,

warfare, malarial and other disease-carrying insects, and wild animals made life far from idyllic. Traditional agriculture and fishing were conducted, and taro, sweet potatoes, yams, cassava, breadfruit, coconuts, and bananas were grown as the particular climate allowed. Fish was the primary source of food in many areas.

THE SETTLEMENT OF OCEANIA

Perhaps as early as 50,000 years ago, man first arrived in Australia and western Oceania from Southeast and East Asia. Although archaeological work in these areas is still in its nascent stage, sites in New Guinea, New Ireland, New Britain, and the Solomons have been dated to around 40,000 years ago. Sea levels were much lower at the time; Australia and New Guinea were physically attached, and only narrow waterways separated that landmass from an uninterrupted land bridge that extended through today's Indonesia to the Asian mainland. Water separated New Guinea, the Bismarck Archipelago, and the Solomon Islands, but the distances between them were not great. Initially, humankind's journeys from the Asian mainland were therefore largely by foot, with limited watercraft use. The sophisticated oceangoing vessels that would later be used to sail to the outer reaches of Polynesia were as yet undeveloped and unnecessary. Warmer temperatures later brought about higher water levels and travel between all islands was thereafter by boat.

This early occupation did not take place in one single movement, and it is assumed that successive migrations and groups of people first entered New Guinea and then fanned out onto other islands in western Melanesia. Evidence suggests that humans did not reach beyond the middle Solomons until much later.

Around 3000 BCE, an archaeological and cultural complex, which Western archaeologists have named Lapita, developed in the Bismarck Archipelago and rapidly spread through the remaining

islands of Melanesia. It slowly reached western Polynesia, Fiji, Tonga, and Samoa, arriving in those places in 1000 BCE. Their original homeland was most likely China. These later arrivals either mingled with or displaced existing populations who had earlier settled in Melanesia. They spoke an Austronesian language that would spread as far west as Madagascar and throughout the Pacific. It is believed that the canoes of the Lapita people were extremely seaworthy and that their sailors were skilled navigators.

From their base in western Polynesia, those intrepid seaman embarked on epic voyages into the farthest reaches of the Pacific, the last area of the world to be settled by man, eventually reaching all the inhabitable islands of Polynesia. It was an extraordinary feat, accomplished without the aid of modern navigational equipment. The Cooks and Societies were settled by 500 CE, and Hawai'i, the Marquesas, Mangareva, Pitcairn, Henderson Island, and Easter Island somewhere between 700 and 1000 CE. New Zealand is thought to have been reached sometime after 1200 CE. After a period of considerable activity, during which all of Polynesia was populated, long-range voyaging seems to have gradually ceased.[7]

It is assumed that man first reached western Micronesia, probably from the Philippines, some time between 2000 and 1500 BCE. Later arrivals in the eastern islands may have come from western Polynesia around zero CE, after settlement there had occurred. One further migration, not readily explained, was the movement of some people from western Polynesia, at least five hundred years ago, back into select Melanesian and Micronesian locations. These resettled islands are called "Polynesian Outliers," one being the Micronesian island of Nuku'oro. The small number of sculptures collected from Nuku'oro are considered among the most extraordinary works of art ever produced.

When Westerners first arrived in the sixteenth century, Polynesians, Melanesians, and Micronesians had long before "discovered" all the islands of Oceania and made them their home, developing rich and complex societies and creating an exciting array of arts equal to any in the world. Intense scientific debate and research continues regarding the exact origins of Pacific people and the specific dates of Pacific settlement; however, it is clear that these knowledgeable, daring, and courageous people possessed the skills to traverse vast areas of the Pacific Ocean long before Europeans developed the suitable ships, scientific knowledge, and navigational skills necessary for successful blue-water sailing.

Ferdinand Magellan (1480–1521) was the first Westerner to sail across the Pacific Ocean, and he did so under the Spanish flag (1519–22; the voyage was completed after Magellan's death). This "first" for the West seems to have been accomplished without sighting a single inhabited island until Magellan reached the Marianas in Micronesia. Following his voyage, sixteenth-century exploration was left to other Spanish and Portuguese discoverers, who sought new lands and souls for the benefit of the king and the church. Mercantile interests drove Dutch explorers in the seventeenth century; however, European activity was sporadic until the British dispatched Captain James Cook (1728–1779) on his three epic voyages, beginning in 1768. Cook's journeys and the subsequent publication of books and prints as well as the display of artifacts fired the interest, imagination, fantasies, and greed of European people and served as the catalyst for 150 years of active, consistent, and persistent European exploration and exploitation. As a result, the Oceanic peoples' way of life, which had been forged in response to the ecology of their island world, was altered, modified, or completely destroyed, resulting in the demise of many traditional arts. Missionaries brought the Christian faith; planters seized land for large-scale farming and cattle operations; and sailors, adventurers, and others introduced Western diseases. Labor was sometimes acquired through force, and when native labor was insufficient, workers from Asia (China, Japan, the Philippines, and India) were imported by the thousands. A fragile, respectful partnership between

man and his environment was irreparably damaged or destroyed after Westerners arrived.

OCEANIC ART

Unaware of each other's existence, the artists of Ming Dynasty China, Renaissance Europe, and Aztec Mexico independently created great works of art. During the same time period, in one of the most remote regions of the world, Oceanic artists were producing extraordinary sculpture, masks, decorative and utilitarian arts, and body art that have only been recognized as their equal in the last fifty years.

Little of the Oceanic art produced prior to the sixteenth century survives, but small and tantalizing glimpses of precontact work make it clear that the arts have been a vital part of Pacific secular and religious life for thousands of years. Insufficient material precludes a comprehensive picture of these arts, but it is likely that the works included in this publication and exhibition echo their antecedents to a greater or lesser extent. Archaeological work in Oceania remains sparse, and a tropical climate does not lend itself to the preservation of perishable materials. A few existing examples offer some clues to what might have been.

A great deal of scholarly research and speculation centers around the chance finds of intriguing and beautiful stone mortars, pestles, and discs in New Guinea, some in animal and human form. None have been unearthed in scientific contexts, and they are therefore not dated. They are, however, unlike any pieces created by other historic cultures, and it is likely that they are of considerable age.

Evidence of the presence of the Austronesian-speaking Lapita people (ca. 3000 BCE) in various parts of Melanesia and western Polynesia has been documented by materials found at numerous archaeological sites. The Lapita people created beautiful pottery that was widely dispersed throughout their cultural sphere. Most finds are fragmentary, and worse, some are merely shards. But reconstructed examples and a handful of largely intact pieces offer still another window to the past.

In New Zealand, greenstone ornaments exist that have been passed from generation to generation for hundreds of years.[8] Many have genealogies that substantiate very early dates, and a great deal of work in stone or other nonperishable material from other Polynesian locations may be quite early as well. Many pieces from the historic period could have had considerable age at the time of Western collection. Until recently, it had been assumed that works in wood that appeared to be old were likely no more than several hundred years old. These assumptions have recently been proven wrong. In preparation for the installation of the Jolika Collection in 2006 at the de Young Museum in San Francisco, carbon testing was conducted on select pieces in order to determine their age. The results are accurate within a range of plus or minus forty years before 1450 CE and plus or minus two hundred years after 1500 CE. They are therefore not particularly useful for the dating of works created in the last two hundred years. Tests, however, determined that many examples are hundreds of years old, with some perhaps dating back as much as one thousand years.[9] The Museum der Kulturen, Basel, has obtained similar results for its New Guinea Korewori River collection.[10]

But, as previously stated, the early record remains extremely thin, and the distant past remains clouded in obscurity. Most surviving Oceanic art is no more than 250 years old, and the majority of material is considerably younger. There is little documented historic material from any source prior to the acquisition of pieces made during the three voyages of Captain Cook in 1768, 1772, and 1776. Over the next two hundred years, explorers, scientists, missionaries, tourists, traders, whalers, and colonial officials collected pieces that entered both public and private European and American collections. Traditional Polynesian art and Micronesian art largely disappeared during the nineteenth century, but Melanesian arts survived well into the twentieth century.

Traditional Oceanic art is firmly rooted in religion and cultural values. Figures, masks, costumes,

15

music, dance, and other art forms were created in order to engage, honor, and propitiate supernatural forces that were completely unpredictable. Actual control over these forces was not possible, but the appropriate behavior and actions of individuals and communities could result in positive benefits for all. Failure to follow the basic tenets of the pre-scribed social and religious order could seriously undermine the well-being of the entire community. Balance and order were achieved through mutually agreed-upon community and individual social and religious conduct that demanded the timely staging of rituals and ceremonies associated with, among others, important rites of passage, the fertility of both humankind and crops, and warfare. The arts played a pivotal role in all these activities, serving as important tools and vehicles for the communi-cation of commonly held beliefs that served to support, illustrate, and teach values. Today, these beliefs are more commonly transmitted through the written word.

According to the Oceanic scholar Dirk Smidt, artists in New Guinea must have had special knowl-edge related to magic and abstained from sex and certain foods while working on specific commis-sions.[11] The artist was not just an artist, but served as a priest or shaman in his role as an intermediary between the living and the spirit world. Smidt fur-ther states that the artist's hand was thought to have been literally guided by supernatural forces. Similar characteristics and qualifications can be found in other Melanesian cultures; for example, in Polynesia, artists were also priests.

In Polynesia, art was strongly tied to a social structure that featured clearly defined societal stratification controlled by nobility and priests. The most highly prized Polynesian art forms were, in fact, oral, including speech-making, music, and poetry. Visual art was often seen and utilized in contexts that served to validate the inherent power of an object as well as the social rank of its owner. Objects also served as symbols of status and power, especially in Polynesia, where members of royalty traced their genealogical descent back to the gods.

OCEANIC ART IN CONTEXT

Since the late eighteenth century, when Westerners first began collecting Oceanic art, the reaction to it has undergone a complete metamorphosis. First viewed as "curiosities" and the work of primitive people in accordance with the Eurocentric views of the time, the worth and status of Oceanic objects gradually evolved and changed in accordance with prevailing Western societal values. By the late nine-teenth century, the new discipline of anthropology referred to these objects as ethnographic specimens. Some cultural anthropologists began to look seri-ously at the art in the artifact, but with an emphasis primarily on technology and process rather than artist and art. Western art historians continued to view Oceanic art through a lens that focused on Greek and Roman ideals.

During the late nineteenth and early twentieth centuries, anthropologists and archaeologists con-ducted research that enhanced Western knowledge of non-Western people, cultures, and art. This new data was used in part to support installations at emerging natural history museums that showcased non-Western cultures for a Western audience. Inter-est in exotic people was further amplified when world expositions in both Europe and the United States included non-Western pavilions that dis-played not only objects, but also their makers. At the 1904 World's Fair in St. Louis, for example, a forty-seven-acre "Philippine Village" housed indige-nous people from various islands who were on "display" for seven months.

But it was modern Western artists who first expressed admiration and respect for Oceanic art as "art." Artists like Paul Gauguin, Pablo Picasso, Henri Matisse, André Derain, and Maurice de Vlaminck proclaimed "primitive" works to be not only art, but also art of the highest quality. They were impressed by the expressive power and beauty of African and Oceanic art—qualities that they believed the official art of the French Academy no longer represented through works that they deemed lifeless and de-clared dead. A cross section of the intelligentsia, including writers, poets, and philosophers, shared

16

these beliefs, but there was no widespread public acceptance of their views.

From the end of World War I to the end of World War II, there was only limited public interest in and support for declaring the cultural legacy of non-Western people "art." Art museums did not include "primitive" art in their collections, art history texts gave the genre short shrift, and art historians remained atop their Eurocentric pedestals, while making exceptions for Asian and pre-Columbian art.

This was to change in a very dramatic way when the Museum of Modern Art (MOMA) in New York presented groundbreaking exhibitions of African and Oceanic art in 1935 as well as *The Arts of Oceania* in 1946. Only works deemed to be of excellent quality were included, echoing a practice also used in selections for exhibitions of Western art. In Paris, African and Oceanic art of mixed quality had been shown in commercial galleries for many years, although art museums remained largely uncommitted. The initiatives of MOMA, with the strong support of its director, Rene d'Harnoncourt, and the enthusiastic endorsement of Nelson A. Rockefeller, played a pivotal role in the general public's appreciation for, and acceptance of, non-Western art. The opening of the Museum of Primitive Art in New York in 1957 generated even greater recognition. There followed an impressive program of temporary exhibitions, three or four annually for eighteen years, covering diverse cultures and people. Included were groundbreaking exhibitions and publications dealing with Oceanic art, most featuring the work of New Guinea artists.[12] In 1962, the general exhibition, *Art of the South Seas,* was presented, and more than seventy publications would be produced during the museum's existence. Private collections as well as work drawn from the museum's own collections were often shown for the first time. A beacon of light and a champion for the recognition of non-Western arts had appeared in America.

Despite this positive development, in the 1960s "primitive" art remained largely the domain of natural history museums, anthropologists, and archaeologists. The field was still in flux, and schol-

arly debate continued to rage over such basic issues as what to call this new "art." The term "primitive art" continued to hold sway, and "tribal," "traditional," "ethnic," "indigenous," "non-Western," and others were also used. Nothing proved completely satisfactory, and today all these terms are used, sometimes interchangeably. Today, the preference is to identify works by region, country, specific location, cultural unit, and in extremely rare instances, because makers are often "anonymous," by artist.

By 1966, the art history department at UCLA had instituted a new Ph.D. program in "primitive art." One of the first universities in the nation to do so, UCLA also established a new museum (the Museum and Laboratories of Ethnic Arts and Technology, which later became the Fowler Museum of Cultural History and is now known as the Fowler Museum at UCLA) that was also a first among university-based art museums. In 1969, the Metropolitan Museum of Art in New York mounted an exhibition of work drawn from the collections of the Museum of Primitive Art, which was followed by the announcement that the collections of the Museum of Primitive Art were to be permanently housed at the Metropolitan in a new wing built especially for the collections. With this commitment, one of the world's elite general art museums had officially validated and endorsed "primitive art." The ice was broken and art museums throughout the country began to collect and display the work of non-Western artists. In 1979, the National Gallery of Art in Washington, D.C., presented a massive exhibition and groundbreaking publication of Pacific Island art. The Metropolitan Museum of Art followed in 1984 with an extraordinary and internationally acclaimed exhibition and publication of Māori art titled *Te Maori: Maori Art from New Zealand Collections.*

Interestingly, Europe has not been so quick to incorporate "primitive art" into the collections of its general art museums, but that is changing. Notably, there is now a dedicated display at the Louvre, and in 2006 the spectacular Musée du Quai Branly in Paris opened, devoted solely to the display of non-Western arts.

Today the field is at a crossroads for the study and presentation of Oceanic art in the Western world. In 2002, Oceanic scholar Robert Welsch stated:

> No longer do art historians and anthropologists debate whether Pacific Island art is really art. Silent is the debate over whether art means the same things to Pacific Islanders as it does to Western people or whether art serves the same functions in Western and Oceanic societies. No longer do scholars debate whether anthropologists and art historians should even bother studying ethnic art, tourist art, and contemporary Pacific Island art. Nearly everyone interested in art has moved beyond these issues.[13]

New directions and methodologies in academia and museology seek to determine how Oceanic art is viewed, analyzed, interpreted, and understood.

Although many critical issues have been laid to rest, some still confront art museums. Of key importance is the manner in which Oceanic art is presented. Should a cultural context for the art be provided—usually through the use of field photographs, film, or the re-creation of an object's original context—or should the object be presented on a white wall and speak for itself? Natural history and anthropology museums generally choose the first option, while art museums most often follow the second course of action. Interestingly, some art museums are beginning to show some Western art in context, especially decorative art. Art museums have for decades displayed certain collections in historic and culturally accurate "period rooms," but the current effort does not seek to replicate absolutely their original context. Through careful placement and associations, these arrangements of collections provide visual information that allows the viewer to have a more complete and intensified experience and understanding. Today's museum visitor may have no greater knowledge of art from eighteenth-century colonial America than that of Papua New Guinea. An object might be familiar, but often its context and use are not.

Some have argued that presenting "primitive art" in context could be seen as diminishing its status and recognition as art, symbolically returning the "object" to a natural history museum display. It is also argued that this form of presentation detracts from the work of art and the viewer's ability to enjoy a direct relationship with it. The primacy of the object, free from any distracting information, has been the mantra of most art museums since their inception. An approach that provides sufficient information for a meaningful experience without detracting from the object seems most prudent, and some art museums are adopting exhibition installation and interpretation strategies in keeping with this philosophy. These and other issues will continue to be debated in the years ahead, but it is certain that the intrinsic power and beauty of Oceanic art is now accepted.[14]

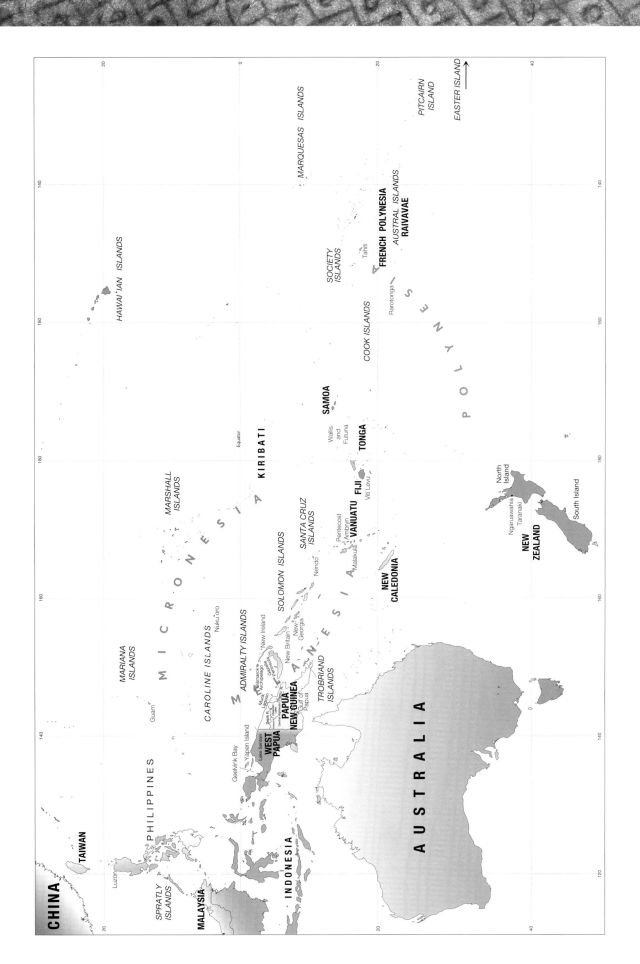

MAP

19

CATALOGUE
OF THE EXHIBITION

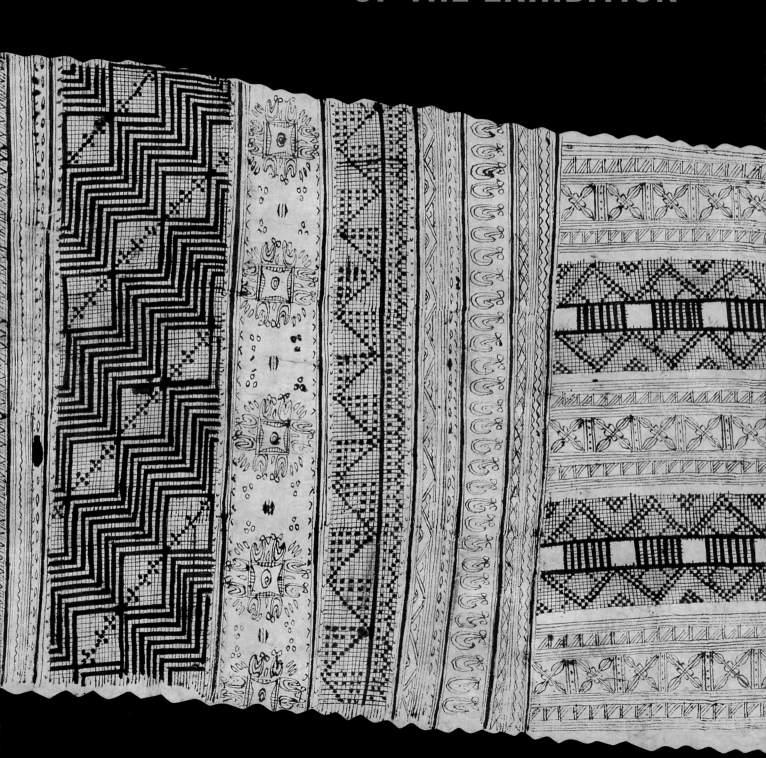

The larger island groups on the western edge of the Pacific (Japan, the Philippines, Taiwan, and Indonesia) are not generally represented in any presentation of Oceanic art. Their history and culture is largely distinct from their Oceanic neighbors, but the indigenous people of Taiwan, the Philippines, and Indonesia lay claim to historic and cultural links with their distant relatives in the Pacific. For this reason, curatorial license has been exercised to include two pieces from Taiwan and another from the Philippines in the exhibition. The arts of Australia have always received separate treatment. The arts of Melanesia and Polynesia are the primary focus of the exhibition and catalogue, and one object from Micronesia has been included.

No one presentation can offer a truly comprehensive view of Oceanic art, and this small publication and exhibition are no exception. Many surviving works are ephemeral, and the size of others precludes easy acquisition by collectors. Still other works are constructed of highly fragile materials that are difficult to transport. Nevertheless, the works in public and private collections that have survived the vagaries and ravages of time offer compelling evidence of the power and beauty of Pacific art and a tantalizing glimpse of a lost world.

Rather than divide the exhibition strictly by geography and cultures, we have organized the art in this publication into functional and descriptive divisions more suited for this particular group of objects and a visitor's introduction to Oceanic art. Selections were made in part to demonstrate that Oceanic art objects frequently serve more than one function and are stylistically varied. From a visual standpoint this often results in a more provocative and exciting display, and a primary goal of this catalogue and exhibition is to enhance the general viewer's experience and appreciation of Oceanic art.

Drawn from two nationally recognized private collections of Oceanic art—those of Valerie Franklin and of Edward and Mina Smith—the exhibition also includes work from the Sana Art Foundation. Included are exceptional and rare pieces that have had limited public exposure. Most are being seen for the first time in San Diego. All are of uniformly high quality, representing the extraordinary creativity and skill of Oceanic traditional artists and reflecting the discriminating eye of their collectors.

FIGURES

Most Oceanic sculpture depicts the human form portrayed in greater or lesser degrees of abstraction. Animals, fish, insects, and birds are also represented, as are combinations of all configurations. This generalization is especially true of works from Melanesia; however, Polynesian sculpture is often characterized as being more realistic. Most sculptures depict standing males, but female figures are also much in evidence. Certain masks appear in pairs, male and female, as do carved flute stoppers from the Sepik River in Papua New Guinea. Figures can be two dimensional, but most are carved in the round.

Wood is the most common medium, but figures are also created from ivory, sennit (twisted or braided coconut husk fiber), tapa, feathers, mud, bamboo, tree fern, fungus, and other organic materials. Even spiderwebs find their way into an artist's repertoire. Stone is utilized in Hawai'i, Easter Island, the Marquesas, Tahiti, the Australs, New Zealand, and some limited locations in Melanesia. In Polynesia, art is often created in more permanent materials and is passed down from generation to generation, with the works becoming increasingly revered and powerful with the passage of time. In contrast to Polynesia, art in Melanesia is often ephemeral.

Many sculptures depict spirits, deities, or ancestors, each specific to a given culture or region, and an exceptional variety of unique styles is represented. In size, the works range from miniature Tongan ivory figures no more than four inches in size to Melanesian and Polynesian works that are larger than life. In fact, the only Micronesian work in the exhibition is a life-size sculpture from Nuku'oro (cat. 36).

Artists from the Sepik River region of New Guinea were especially prolific, and their works grace and enhance public and private collections worldwide. This great river flows from west to east for approximately seven hundred miles, before emptying into the ocean along the north coast. Upper, middle, and lower sections of the waterway are home to diverse cultural groups whose artists produced works with distinctive stylistic characteristics. Along the upper reaches of the river, the Kwoma, Nukuma, Yasyin, and Warasei people carved striking images. Resembling masks, these spirit figures were used during the *Yina-ma* ceremonies conducted in the Ambunti Mountain region in celebration of the yam harvest. Placed with newly harvested yams on this occasion, *Yina* figures are both male and female, were named, and were the property of a particular clan.[15] The figure from the Smith collection (cat. 1) was carved by the Kwoma.

Undecorated hooks were hung from house rafters along the entire river. Perishable, important, and valuable goods were suspended from the hooks in order to safeguard them from the degradations of rats or other vermin. As such, the hooks were purely utilitarian in nature. But those that incorporate the human form were imbued with supernatural power, representing individual or clan ancestors or mythological figures that protected both the owner and the owner's property. The hook figure from the Franklin collection (cat. 2) is unusual in that the figure is female. A second hook

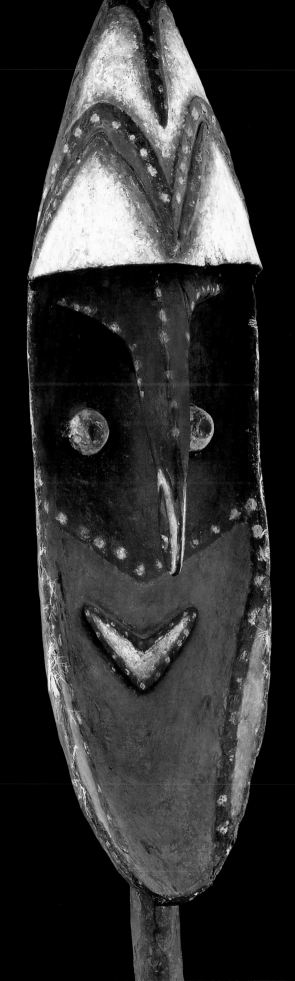

1
Spirit figure (yina)
Melanesia; Papua New Guinea;
Upper Sepik River; Ambunti
Mountains
Kwoma people
Early 20th century
Wood and feathers; red, white,
yellow, and black pigments
Height $49\frac{1}{2}$ inches
Edward and Mina Smith Collection

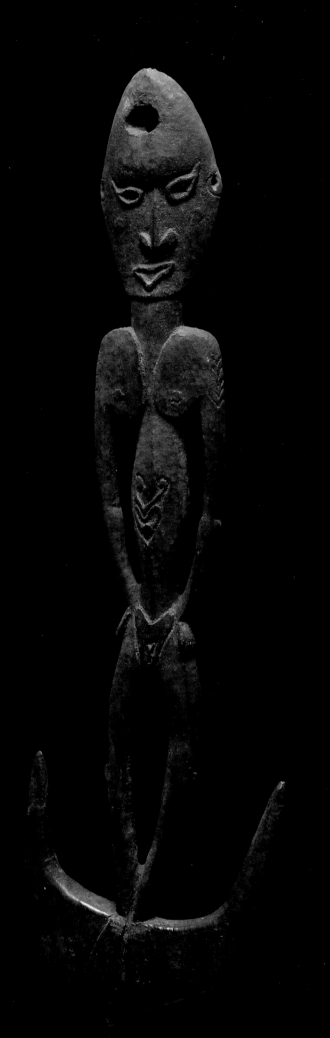

2
Female hook figure
Melanesia; Papua New Guinea;
East Sepik Province; Middle Sepik River
19th century
Wood
34 × 10 × 2 inches
Valerie Franklin Collection

(cat. 3) is surmounted by a flat plank carved with elegant, low-relief designs on the front and back, terminating in a head. Particular designs were often the property of specific clans. Three other hooks, two from the middle section of the river (cats. 4 and 5) and the other (cat. 6) from its lower reaches, may have been the property of a clan. The diversity and sculptural power of these hooks are readily apparent.

A large male figure from the middle Sepik region (cat. 7) is unusually elongated. What appears to be female genitalia between the feet is combined with depictions of flying foxes on the shoulders, a protruding tongue, and yet another face at the back of the head. These intriguing iconographic features likely refer to a clan ancestor, but no specific information is available. The figure was probably placed in a men's house, the center of men's activities throughout much of Melanesia.

The two small standing male figures from the lower Sepik and Ramu River Delta area (cats. 8 and 9) are stylistically typical of this area, especially their long beaklike noses. The smaller piece is probably an amulet that men would have carried in a bag to ensure successful hunting, fishing, and sexual ventures.[16] The larger size of the second figure most likely indicates that it represents a clan ancestor or spirit.

The Abelam, who live north of the Sepik River in the Prince Alexander Mountains, erected impressive structures with elaborately painted façades that housed a wide array of figurative sculpture. The figures vary in size and are decorated with vividly painted ochre, yellow, black, and white geometric designs of great complexity and variety.

Unlike the men's houses of the Sepik River people, Abelam men's houses, or *korumbo*, were not occupied by the living. In fact, the korumbo was primarily used during male initiation rites and was also a home for the spirits necessary for the successful fertility of crops and people. Sculptures found in the korumbo are both male and female. The male figures are said to represent ancestor spirits called Nggwal, and the female figures depict a sinister creature called Kutagwa. Paintings and sculptures were jointly produced by men acting under the supervision of a master artist, and comments and criticism from bystanders were welcome. After the work was completed and the appropriate ceremonies were conducted, men from neighboring villages were also invited to comment on the quality of the piece.[17]

The Abelam bust from the Franklin collection (cat. 10) is a good example of the overall quality of Abelam carving as well as the skill of its artist. By comparison, another Abelam figure from the exhibition (cat. 11) is an unusually complex sculpture that has lost its surface paint. This striking stone-carved piece depicts a female figure at the base, a male figure above, and representations of hornbills (a bird with a very large beak). It is an exceptional tour de force of openwork carving.[18]

Beautiful and unique works of art from the upper Korewori River, a tributary of the Sepik, first came to the attention of outsiders in the mid-1960s.[19] Both male and female figures, referred to as *aripa*, have been found.

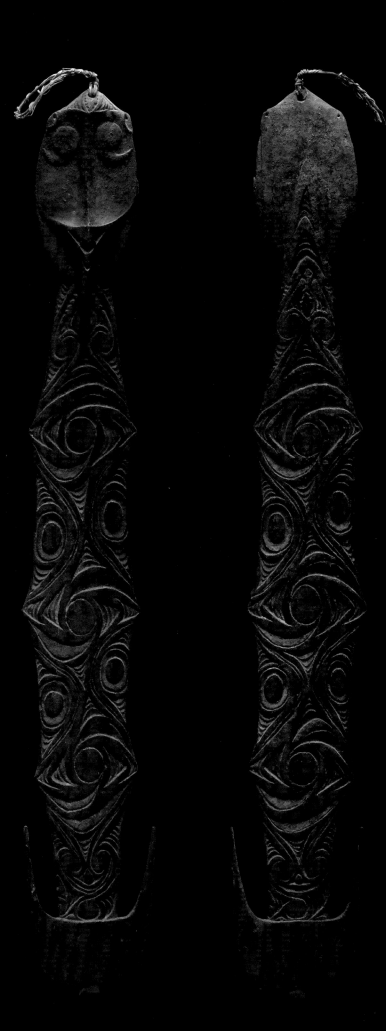

3
Janus hook figure
Melanesia; Papua New Guinea;
East Sepik Province;
Middle Sepik River
Western Iatmul people
19th century
Wood
$66 \times 10\frac{1}{8} \times 3$ inches
Valerie Franklin Collection

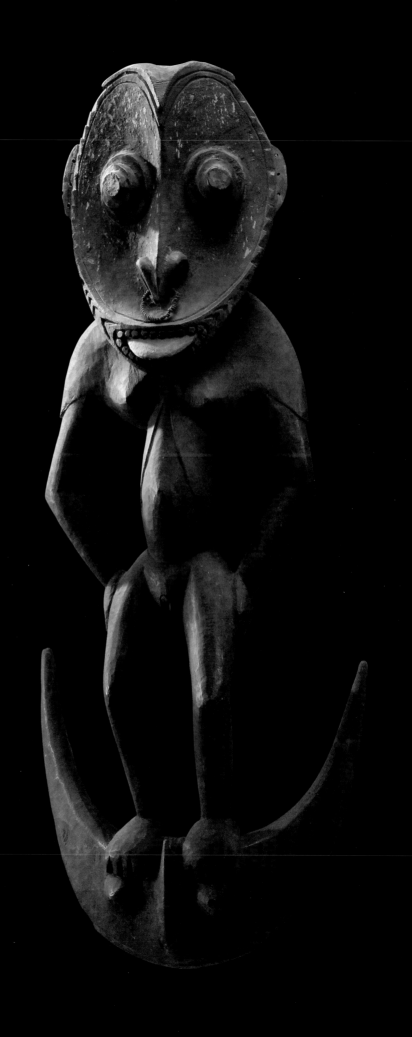

5
Female hook figure
Melanesia; Papua New Guinea;
East Sepik Province; Middle
Sepik River; Chambri Lake
19th–early 20th century
Wood
$30\frac{3}{4} \times 12\frac{3}{4} \times 5\frac{1}{4}$ inches
Valerie Franklin Collection

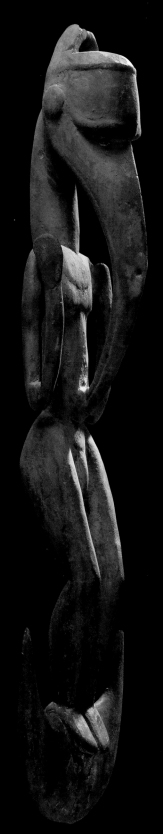
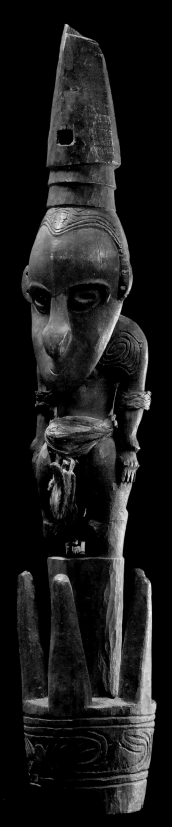

4
Male hook figure
Melanesia; Papua New Guinea;
East Sepik Province;
Middle Sepik River
Late 19th century
Wood; traces of red ochre
Height 32 inches
Valerie Franklin Collection

6
Five-pronged hook figure
Melanesia; Papua New Guinea;
East Sepik Province; Coastal Lower
Sepik River; Murik Lagoon
Murik people
19th–early 20th century
Wood; bark cloth; plaited fiber
Height 24½ inches
Valerie Franklin Collection

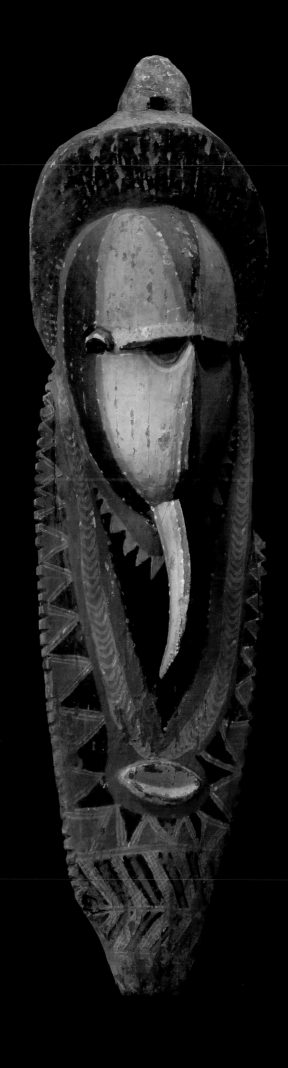

10
Bust
Melanesia; Papua New Guinea;
East Sepik Province; Prince
Alexander Mountains
Northern Abelam people
Late 19th–early 20th century
Wood; red, yellow, black,
and white pigments
Height 52 inches
Valerie Franklin Collection

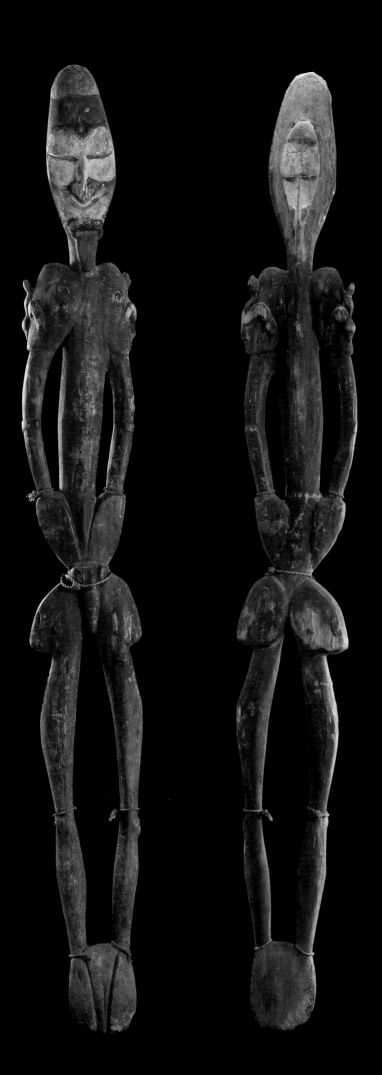

7
Male figure
Melanesia; Papua New Guinea;
East Sepik Province;
Middle Sepik River
Iatmul people
Late 19th–early 20th century
Wood; fiber; black, red,
and white pigments
$77 \times 9\frac{1}{2} \times 3\frac{1}{2}$ inches
Valerie Franklin Collection

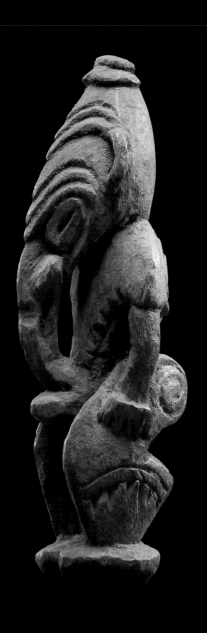

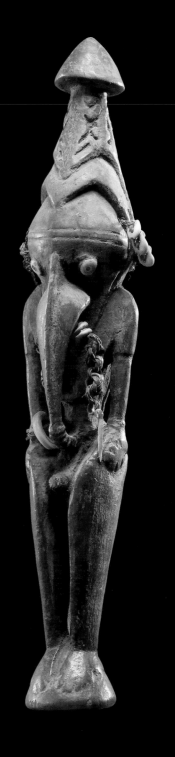

8
Male figure
Melanesia; Papua New Guinea;
East Sepik Province; Coastal
Sepik River; Murik Lagoon
Murik people
19th century
Wood; red ochre pigment
$5\frac{1}{2} \times 2 \times 2$ inches
Valerie Franklin Collection

9
Male figure
Melanesia; Papua New Guinea;
Madang Province; Ramu River
Delta
Bosman people
19th century
Wood; fiber; shell; red ochre
pigment
$9\frac{3}{4} \times 2\frac{1}{8} \times 1\frac{1}{2}$ inches
Valerie Franklin Collection

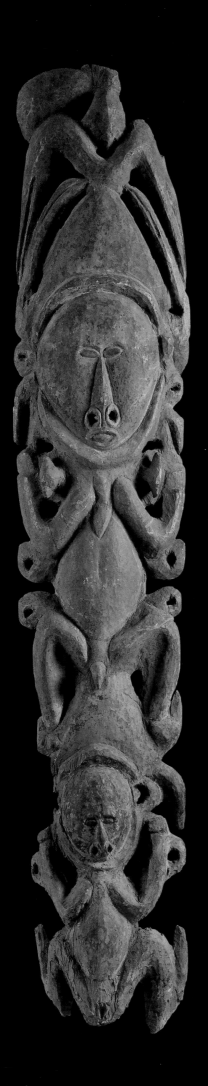

11
Figure
Melanesia; Papua New Guinea;
East Sepik Province;
Prince Alexander Mountains
Northern Abelam people
Late 19th century
Wood
Height 84 inches
Valerie Franklin Collection

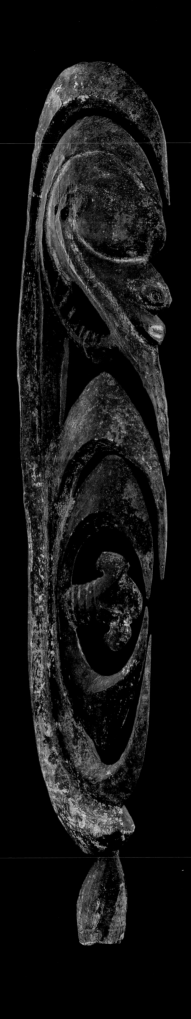

14
Figure (yipwon)
Melanesia; Papua New Guinea;
Korewori River
Yimar people
Late 19th–early 20th century
Wood; black and red pigments
Height 41 inches
Edward and Mina Smith Collection

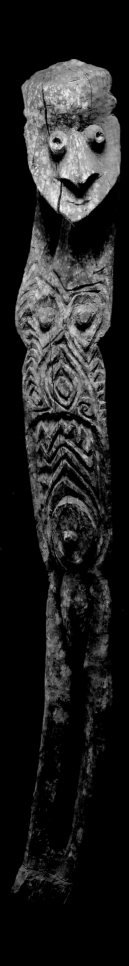

12
Female figure (aripa)
Melanesia; Papua New Guinea;
East Sepik Province; Middle
Sepik / Upper Korewori River;
probably Ewa Village
Inyai-Ewa people
19th century or earlier
Wood
$45 \times 6\frac{1}{4} \times 4$ inches
Valerie Franklin Collection

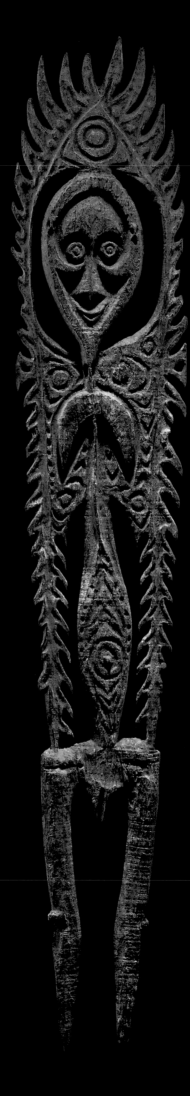

13
Female figure (aripa)
Melanesia; Papua New Guinea;
East Sepik Province; Middle Sepik /
Upper Korewori River
Inyai-Ewa people
19th century or earlier
Wood
62½ × 11 × 2 inches
Edward and Mina Smith Collection

Discovered near the Ewa Village of Inyai and restricted to a small area, they had somehow escaped the attention of ethnographers, government officials, collectors, missionaries, and others for decades. All together they form one of the most distinct and exciting groups of sculptures in Oceania. The largest single collection of these sculptures is housed in the Museum der Kulturen in Basel, but a limited number of others have found their way into museums and private collections worldwide. Two of the finest are in this exhibition.

The dynamic aripa from the Franklin collection (cat. 12) has a three-dimensional head, legs, arms, and torso, in contrast to other similar female figures that are conceived frontally and two-dimensionally. Like the aripa from the Smith collection (cat. 13), all motifs are abstractions of the skeleton or organs of the human body. The small round breasts indicate that the figure is a young woman, and the central area of the chest refers to the heart/lung, with circling lines representing intestines. The breastbone is visible between the breasts. Chevrons likely signify bones, and the navel appears above the prominent vulva. The quality of the incising is excellent, and the S-shaped twist of the body contributes to a sense of movement that is a hallmark of many Korewori pieces.

Flat, boardlike female figures represent two sisters who were regarded as ancestors of the hornbill clan. The sisters were thought to have carved out the valleys of the Korewori region and revealed the utility of the sago palm from which flour is made. Their brother was the mythical primal ancestor Toutou'imbangge, who dwelled in the earth. The Smith aripa likely represents one of those two sisters and is arguably the finest example of its kind in the world. In contrast to the majority of figures representing young females, this sculpture depicts an older woman, recognized by her pendulous breasts.[20] The treatment of the chest area is a variant of what Oceanic scholar Christian Kaufmann refers to as the opened-out "wings" (or ribs) of the female figure. The circles above and below the breasts may refer to internal organs and the vertical outside uprights the vertebrae. A navel appears in the center of the torso and a vulva in the pelvic area. The flamelike "halo" possibly represents ribs or vertebrae.[21]

Generally, aripa figures were spirits evoked in order to ensure a successful hunt, and they were also intermediaries between man and his environment. Kaufmann calls aripa figures "hunting helpers." Each had a soul (*tite*), and offerings were made to them prior to setting out on a hunt. Aripas were also asked to seek out the souls of game and convince them to place their hosts in harm's way in order to ensure the hunter's success. Korewori sculptures in the Jolika Collection at the de Young Museum in San Francisco may date to as early as the fifteenth century, and Kaufmann, on the basis of carbon-14 testing of sculpture from the collection at Basel, states that the majority of Korewori figures were carved between the sixteenth and nineteenth centuries.[22] While neither the Franklin nor the Smith piece have been tested, they clearly are also of great age.

The Yimar (human being) people carved *yipwon* (see cat. 14) that represented mythical ancestors who aided in the hunting of game, warfare, and headhunting. Each was named, and larger examples were the property of clans. Each yipwon has one leg and is considered male, regardless of the presence or absence of a phallus. The hooklike extensions between the head and leg refer to the ribcage, and the knob at the center represents the heart.

Papuan Gulf communities built large structures that were the focal point for men's activities. In these houses were stored hundreds of ritual objects that were the physical manifestations of powerful spirits and ancestors responsible for the well-being of the living. Individual spirits were identified with distinct local topographic sites and were the protectors of specific clans. These painted flat boards carved in low relief were placed in close proximity to the skulls of ancestors and slain enemies, as well as those of pigs and crocodiles. Together they were the receptacles for omnipotent spiritual forces whose goodwill could not under any circumstance be compromised. Boards are known by different names according to culture and geographic region, but all of them served essentially the same function: to assure the overall welfare of the clan and to achieve success in hunting and warfare.[23]

Four pieces in the exhibition (cats. 15, 16, 18, and 19) are from the Era River area, and a fifth (cat. 17) is thought to be from the western gulf. Boards generally depict stylized heads and full figures in an exceptional variety of designs that refer directly to a specific clan. *Agiba* (skull racks) were also found in men's houses. A Kerewa artist working in the western gulf carved the example from the Franklin collection (cat. 20). The skulls of slain enemies and ancestors would have been suspended from the prongs on each side of the figure's torso.[24] The exceptional ability of Papuan Gulf artists to fully exploit this genre of low-relief carving is readily apparent in these few examples.[25]

Carvers from the Admiralty Islands produced impressive large- and small-scale ceremonial food bowls, figurated war charms, weapons decorated with human figures, and large slit gongs. Certain islands created different objects, and Rambutyo and Mantankol people carved sculpture in human form. The Pak made Western-style "beds," the only ones used in Melanesia. The relatively short legs of those beds were often carved and painted in human form, and were then inserted into the bed frame at its four corners. Although not a bed leg, the standing male figure from the Franklin collection (cat. 21) is stylistically similar to one. All Admiralty figures incorporate geometric low-relief motifs painted in black, red, and white, and this one is no exception. The figure's topknot represents a male hairstyle. This piece likely depicts an ancestor and would have been placed in men's houses or dwellings.[26]

Twentieth-century artists, especially the surrealists, greatly admired the extraordinarily rich and varied art of northern New Ireland. For its admirers, it represents the most complex and exciting combination of openwork carving and painting produced anywhere in the world. In short, it is spectacular. Most of this art was created for memorial ceremonies held in honor of

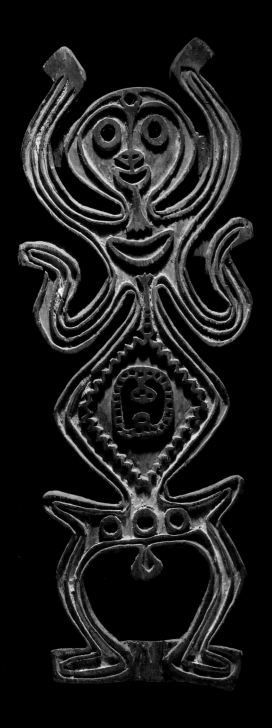

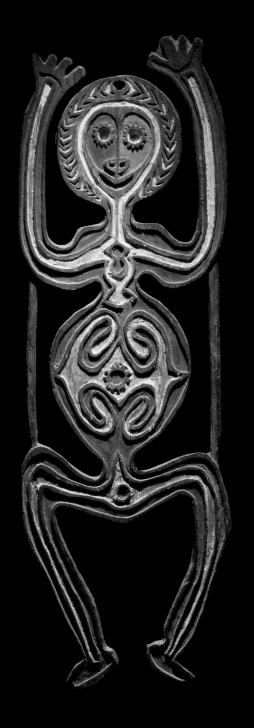

15
Figure
Melanesia; Papua New Guinea;
Gulf Province; Papuan Gulf;
Era River District
19th century
Wood; red ochre and
white pigments
$28\frac{1}{2} \times 11 \times 1\frac{1}{2}$ inches
Valerie Franklin Collection

16
Figure
Melanesia; Papua New Guinea;
Gulf Province; Papuan Gulf;
Era River District
19th century
Wood; red ochre and white
pigments
$29 \times 10 \times 1$ inches
Valerie Franklin Collection

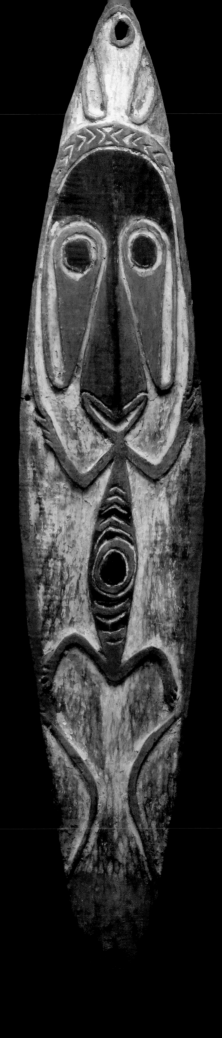

17
Carved board
Melanesia; Papua New Guinea;
Papuan Gulf; Kikori River Delta
Kerewa people
19th–early 20th century
Wood; black and white pigments
$48 \times 9\frac{1}{2} \times 1\frac{1}{8}$ inches
Valerie Franklin Collection

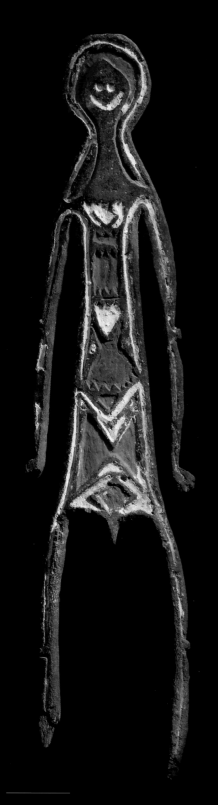

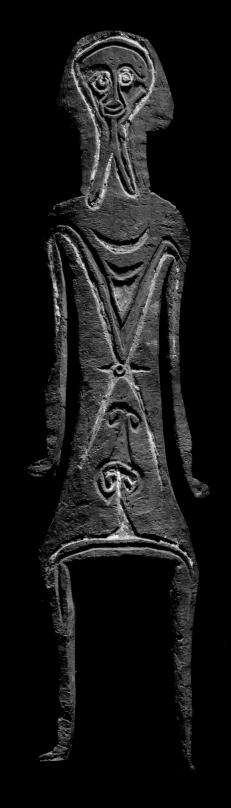

18
Figure
Melanesia; Papua New Guinea;
Papuan Gulf; Era River District
19th–early 20th century
Wood; red ochre, black,
and white pigments
$22 \times 5\frac{1}{2} \times 1$ inches
Valerie Franklin Collection

19
Figure
Melanesia; Papua New Guinea;
Papuan Gulf; Era River District
19th–early 20th century
Wood; red ochre, black,
and white pigments
$21\frac{1}{4} \times 5\frac{1}{2} \times 1\frac{1}{4}$ inches
Valerie Franklin Collection

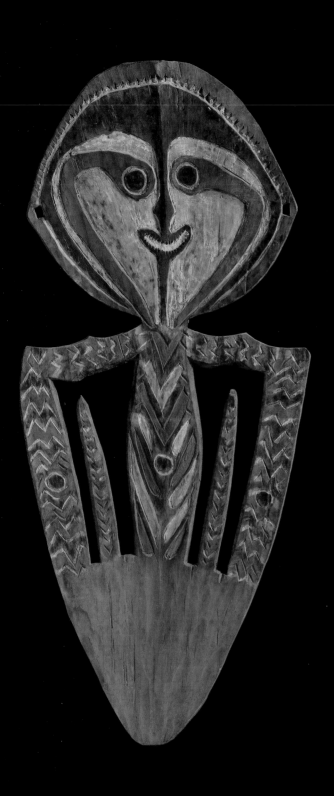

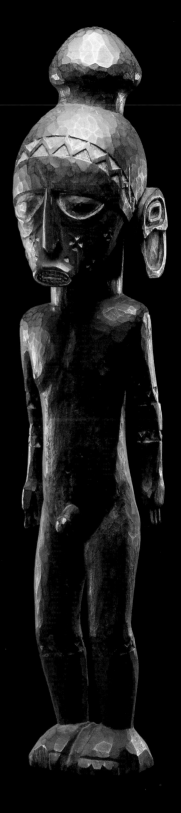

20
Skull rack (agiba)
Melanesia; Papua New Guinea;
Papuan Gulf; Kikori River Delta
Kerewa people
First third of the 20th century
Wood; red, white, and black
pigments
$35^3/_8 \times 15^3/_8 \times 1^1/_4$ inches
Valerie Franklin Collection

21
Male figure
Melanesia; Papua New Guinea;
Admiralty Islands
19th century
Wood; black and white pigments
$28 \times 6^1/_4 \times 5$ inches
Valerie Franklin Collection

recently deceased "prominent" members of the community, usually males. A number of ceremonies were held over an extended period of time, a complete cycle sometimes lasting several years. These ceremonies, called *malagan,* culminated in a large event that included feasts, gift exchanges, music, dance, and the unveiling of an impressive display of sculpture (also known as *malagan*) carved especially for the event. While malagan ceremonies acted directly as a vehicle for sending the dead into the world of spirits, they also served other purposes related to the social, economic, religious, and political well-being of the community.

Artists were specifically commissioned to create malagan sculptures, and depending on the importance of the deceased, traveled considerable distances to carry out their work. Working in isolation, this "artist in residence" had his work revealed to the assembled audience at a "grand opening" that occurred at the end of a malagan cycle. Both masks and figures were carved. Masks could be reused, but all sculpture, which included freestanding figures, plaques, panels, and other configurations, were ephemeral and were left to decay outdoors afterward. The sculptures incorporate humans, birds, fish, snakes, and pigs in a masterful interplay of carving and painted patterning, and particular configurations may refer to specific clans and ancestors. Four malagan sculptures from northern New Ireland are included here (cats. 22–25).

Central New Ireland is best known for freestanding figures that range in size from two to five feet. These imposing figures (see cat. 26) exhibit both female breasts and male genitalia, leading to their general designation as hermaphrodites, but they actually represent male chiefs. It is said that the breasts are a reference to fertility and a man's responsibility for the welfare of women. The figures were displayed at ceremonies honoring an important deceased male who was a community leader. Called *uli,* they were carved for a specific person and displayed at a ceremony that was the culmination of a series of events that might extend over years. Activities included general feasting, dance, and music. Those invited from neighboring communities transported their ulis to the ceremony, creating an assembly of departed ancestors that was displayed in structures made for the occasion. The spirit of the deceased entered the newly carved uli after appropriate rituals were conducted and continued to serve the community. The sculptures were stored in the men's house.[27]

A small number of unusual pieces from the Solomon Islands are stylistically more closely related to Western naturalism than to the more abstract main corpus of Solomon Island art. Some figures are shown in movement and are depicted engaging in everyday activities.[28] The creator of the female figure from the Smith collection (cat. 27) caught her in mid-stride in what appears to be a dance posture. Her now-empty right hand may have once held a dance implement or perhaps a spear. She wears a belt, armlets, and bracelets, but the inlaid shell facial decorations found on other Solomon Island figures and overmodeled skulls are only indicated by raised lines. It

is possible that this discrete body of unique work within the Solomon Islands repertoire represents early examples of objects produced solely for a Western audience, possibly by a single artist or one workshop.[29] Together, they are wonderful examples of sculpture created in response to new Western patrons. This particular example dates to the last quarter of the nineteenth century. The monumental feeling of the New Caledonia figure from the Smith collection (cat. 28) belies its small size. A limited number of other examples that are similar in form and scale are known. They were all said to aid in bringing about rain, but information is sketchy at best. Few examples of freestanding sculpture from New Caledonia exist, and the majority of wood sculptures now in Western collections are architectural elements.

Figures from Fiji are extremely rare, and it is possible that even those collected from the island were not carved there (or were not carved by Fijian artists). The Fijian figure from the Smith collection (cat. 29) has been attributed to Fiji on the basis of a stylistic comparison with a sculpture in the collections of the Cambridge University Museum of Archaeology and Ethnology.[30] Thus, although this enigmatic female figure is of great historical importance, because of its extreme rarity, its exact origin remains problematic, as generally, Fiji and Samoa did not produce sculpture.

Janiform (faced front and back) fly whisks have always been greatly admired by Western collectors. Most were originally attributed to artists working on Tahiti and the Society Islands, but subsequent research has determined that they were carved in the Austral Islands and traded to other locations.[31] Approximately fifty of the whisks are known. The whisk from the Smith collection (cat. 30) is missing the whisk itself, as is the case with many examples, but the elegant and beautiful handle clearly reveals the artistry that went into the creation of these objects. The property of high-ranking members of society, such as chiefs and rulers, whisks were held on all-important ceremonial occasions as symbols of their owners' rank, power, and prestige.[32]

The first Westerner to see Cook Island staff gods was Reverend John Williams (1796–1839), who was presented with fourteen pieces by new Christian converts in 1827. One of these is now in the British Museum, but the fate of the others is not as well documented. Some may have been destroyed, along with scores of others, and some may be among the twenty-six examples now known, which range in size from several feet to more than twelve feet in length. The figures consist of three sections: a "head," an uncarved central portion that was originally wrapped in bark cloth, and a carved end segment that terminates in a penis. Early Western collectors usually cut off the heads and discarded the middle section and penis before transporting the figures back to the West. Of the larger works, only the figure in the British Museum's collection is complete.[33] The sculpture in this catalogue (cat. 31) is an extremely rare and beautiful example of the complete head section of a "god staff" and includes many subsidiary figures below the large head. There is no definitive information regarding which deity is represented, although it has been suggested that it could be

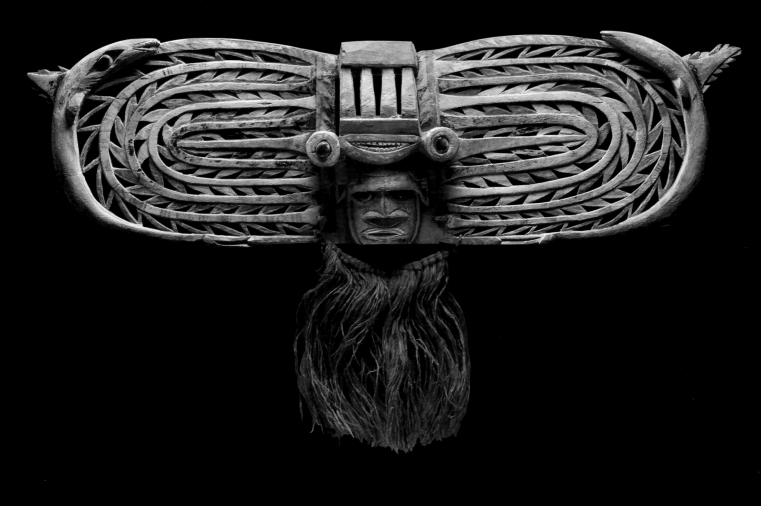

22
Malagan plaque
Melanesia; Papua New Guinea;
Northern New Ireland
19th century
Wood; red, white, and
black pigments
$8\frac{1}{4} \times 29\frac{1}{2} \times 2$ inches
Valerie Franklin Collection

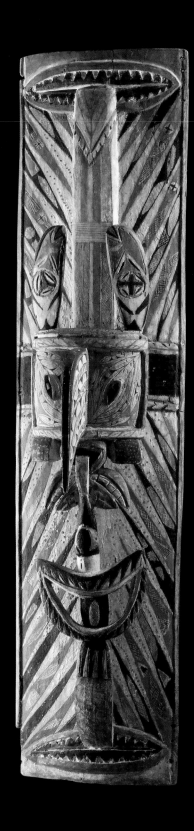

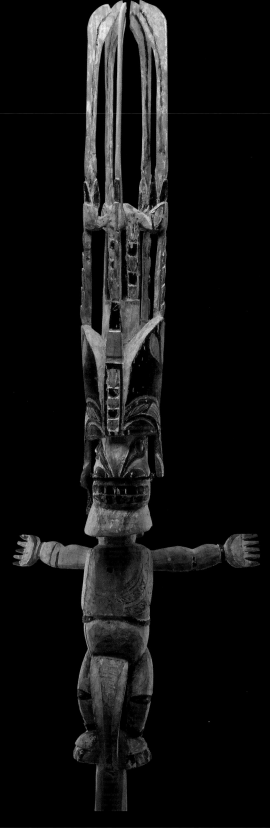

23
Malagan plaque
Melanesia; Papua New Guinea;
Northern New Ireland
19th century
Wood; red, white, and black
pigments
$42 \times 10\frac{1}{8} \times 8$ inches
Valerie Franklin Collection

24
Malagan figure
Melanesia; Papua New Guinea;
Northern New Ireland
19th century
Wood; shell; seaweed; red,
black, and white pigments
$46\frac{1}{2} \times 14 \times 8$ inches
Valerie Franklin Collection

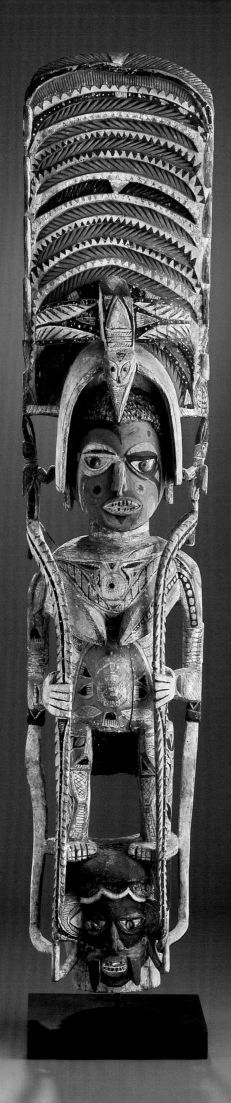

25
Malagan figure
Melanesia; Papua New Guinea;
Northern New Ireland
19th or early 20th century
Wood; shell; fiber; hair; black,
red, yellow, and white pigments
Height 58½ inches
Edward and Mina Smith Collection

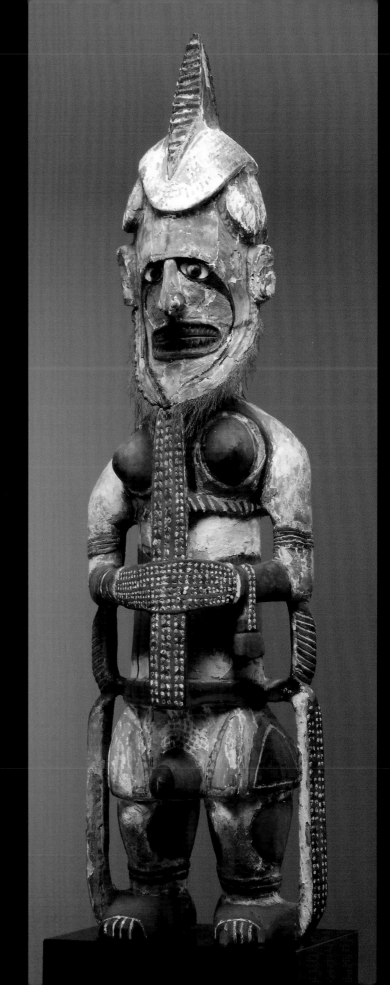

26
Figure (uli)
Melanesia; Papua New Guinea;
Central New Ireland
19th century
Wood; shell; seaweed; black,
red, and white pigments
Height 44½ inches
Valerie Franklin Collection

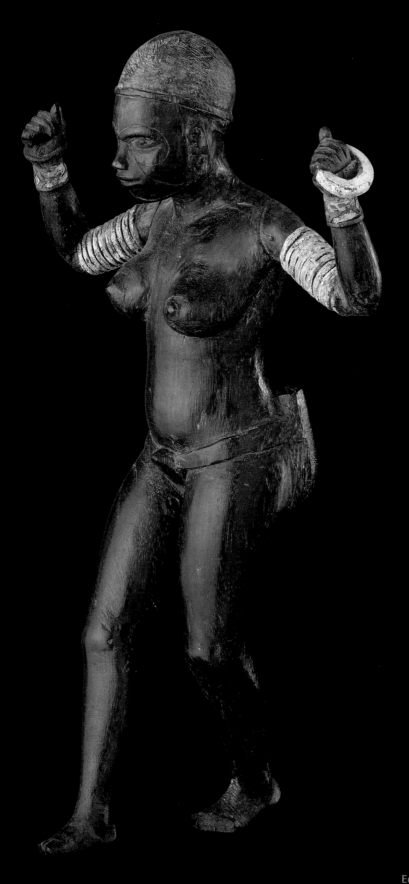

27
Female figure
Melanesia; Papua New Guinea;
Solomon Islands
Mid- to late 19th century
Wood; black, red, gold, and
white pigments
Height 13¾ inches
Edward and Mina Smith Collection

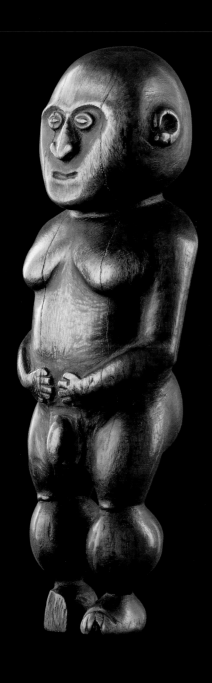

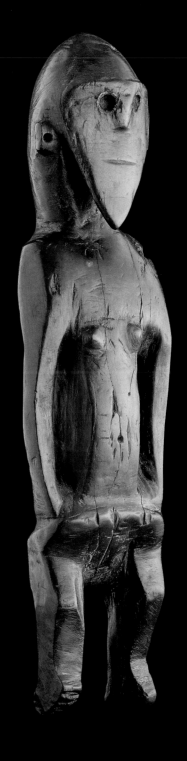

28
Male figure
Melanesia; New Caledonia
Kanak people
19th century
Wood
Height 8½ inches
Edward and Mina Smith Collection

29
Female figure
Polynesia; Fiji
18th century
Wood
Height 13¾ inches
Edward and Mina Smith Collection

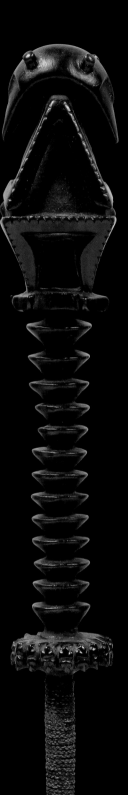
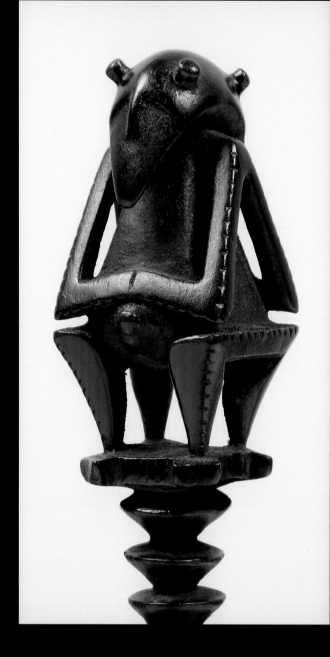

30
Fly whisk
Polynesia; Austral Islands
Late 18th–early 19th century
Wood
Height 12½ inches
Edward and Mina Smith Collection

Tangaroa, the creator god. Its specific use in religious and ritual contexts is also not recorded.[34]

The art of the Marquesas is distinctive in style and varied in form. From monumental stone sculpture to small bone toggles, carved objects include canoe prow ornaments, fan handles, drums, containers, and ornaments. Perhaps most familiar are the clubs known as *u'u*. Both stone and wood freestanding figural sculptures are also known. The standing male figure from the Smith collection (cat. 32) is a unique and impressive example. All Marquesan sculptures in the round are referred to as *tikis*, but the deity represented and its use and context are not known. Marquesan artists paid particular attention to the heads of these figures, and the features were rendered in a unique way, especially the eyes and nose. Eyes are commonly circular, resembling "goggles," and the nose is completely flattened. The eyes of the Smith figure are slanted in a manner that is only rarely seen, a striking departure from convention and an unusual example of artistic license.[35]

The mystery and romance surrounding Easter Island (Rapa Nui) have enthralled and fascinated Westerners since Dutchman Jacob Roggeveen (1659–1729) first landed there in 1722. It is one of the most remote Polynesian islands and has received worldwide notoriety and attention for the monumental stone sculptures that dominate the landscape. Speculation on their dating continues, but it is now believed that they were sculpted over many hundreds of years, with work ending in the seventeenth century.[36]

Easter Island (Rapa Nui) wood sculpture is best known for striking male (*moai kavakava*) and female (*moai papa*) standing figures. A second category of images incorporates the features of humans, birds, and lizards, but the two rare and remarkable sculptures in this volume defy easy categorization. The first type is represented by a fascinating sculpture in the exhibition (cat. 33) that depicts a human head with two arms and hands projecting from its neck. Stylistic conventions typical to Easter Island male and female figures are present, including a bald head with incised designs on its crown, prominent brow ridges, round eyes with shell and obsidian insets, and extended earlobes. The usual goatee-like beard is not present. The absence of a body and the presence of arms and hands projecting from the neck are, however, far from usual, and this piece seems to be unique.[37]

The second sculpture from Easter Island presented here (cat. 34) is related to figures that combine the head of a bird with human features (*moai tangata manu*) as well as figures that combine lizard and human forms (*moko*). This sculpture, however, combines a human head, the ribs and penis of a male figure, and a vulva with the wings of a bird. It is also stylistically related to a limited number of rare crouching figures that combine both human and animal features.[38] This piece does not, however, have the tail found on lizard-man figures, and its head seems more human than bird or lizardlike.

European surrealists avidly collected Easter Island art, which they deemed to be exceptional works produced by completely liberated and unfettered minds that were unrestrained by conscious societal expectations

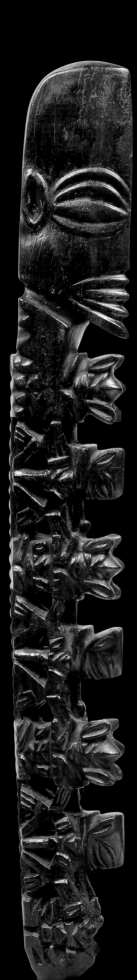

31
God staff
Polynesia; Cook Islands;
Rarotonga
18th century
Ironwood
Height 24½ inches
Edward and Mina Smith Collection

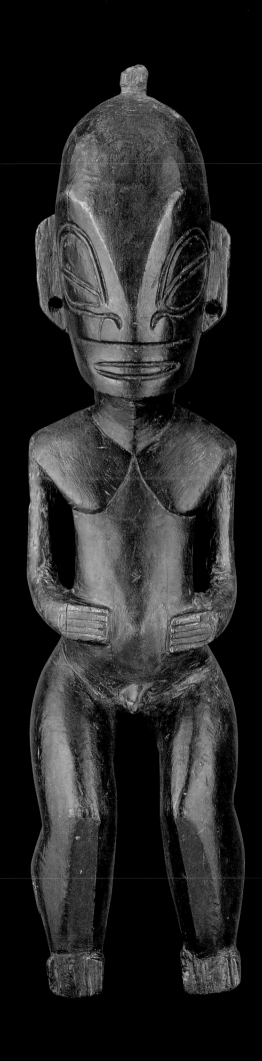

32
Male figure
Polynesia; Marquesas Islands
19th century
Wood
Height 23¾ inches
Edward and Mina Smith Collection

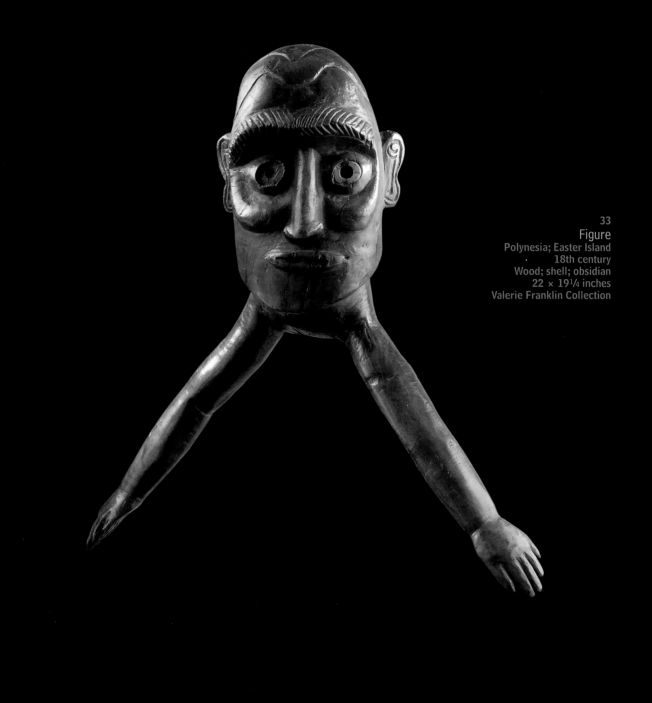

33
Figure
Polynesia; Easter Island
18th century
Wood; shell; obsidian
22 × 19¼ inches
Valerie Franklin Collection

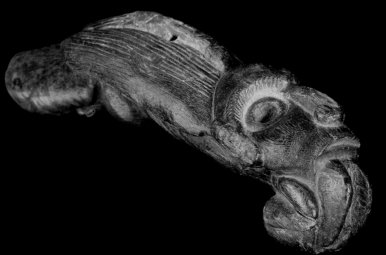

34
Figure
(moai tangata manu)
Polynesia; Easter Island
Late 18th–early 19th century
Wood (toromiro)
8 × 2½ inches
Edward and Mina Smith Collection

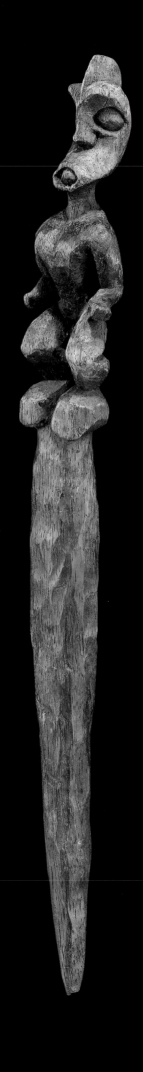

35
Figure (akua ka'ai)
Polynesia; Hawai'i
Late 18th-early 19th century
Wood (accacia koaia)
Height 12¼ inches
Edward and Mina Smith Collection

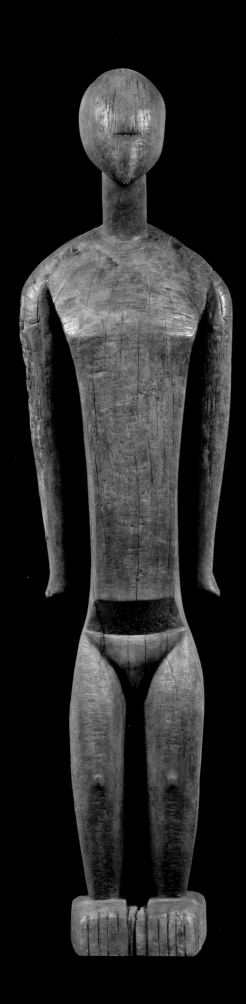

36
Figure (tino aitu)
Micronesia; Caroline Islands;
Nuku'oro
Early 19th century or
earlier, precontact
Wood (breadfruit)
Height 76⅞ inches
Edward and Mina Smith Collection

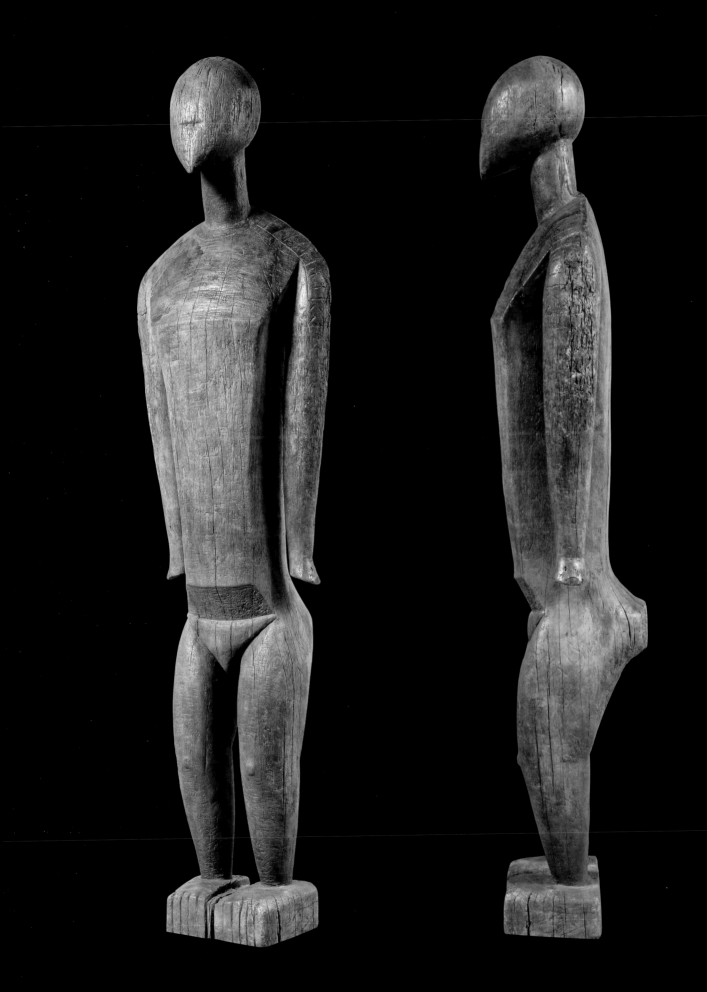

and values.[39] Neither the Franklin nor the Smith piece has any documentation, and we, like the surrealists, are left to admire their aesthetic quality and otherworldly character.

By the end of the nineteenth century the Hawai'ian people, as well as their culture and traditional arts, had been severely compromised by Western contact. Fortunately, a significant number of historic works have survived, and the majority of these are now housed in public collections. Magnificent cloaks, feathered standards, bark cloth, wooden bowls, spear rests, decorated gourds, drums, ornaments, and freestanding human figures provide a glimpse of the richness of Hawai'ian art before European contact. In contrast to most other Polynesian pieces that are scattered throughout the world, many of the aforementioned items remain in Hawai'i, where they are now housed at the Bishop Museum in Honolulu.

The stick image from the Smith collection (cat. 35), like the piece discussed earlier from New Caledonia (cat. 28), has a monumental presence that belies its small size. Figures surmounting a stake are called *akua ka'ai* (stick images). Their small size allowed them to be easily carried and stuck into the ground or into the thatch wall near a household altar. It is assumed that the sticks were primarily used for personal purposes, in contrast to their larger temple counterparts. They were, however, called into public use during specific ceremonies. Members of chiefly or royal lineages are said to have used stick figures to assure fertility. Stick images also served a protective function when carried into battle.[40]

Nuku'oro is a small Polynesian outlier located in Micronesia's Caroline Archipelago. On this 400-acre atoll and others on its fringing reef, arguably the most widely recognized and admired sculptures from Oceania were created. Thirty standing figures constitute the entire known inventory of sculpture from the island. These range in size from approximately fourteen inches to eighty-six inches in height.

The Polish naturalist Johann S. Kubary (1846–1896) visited Nuku'oro in 1873 and 1877, collecting for the Godeffroy Museum in Hamburg, and later in 1884 for the Berlin Museum. He recorded the first scientific description of the island, its customs, and its people before major changes brought about by Western contact had occurred.

Kubary identified two types of deities: mythical beings, or *tupua*, and deified ancestors, or *aitu tanata*. These were represented by stone, animals, coconut shells, and wooden male or female figures. The wooden figures that Kubary saw stood against one wall of the *amalau*, or temple, where they were decorated with flowers and wore headdresses similar to those worn by priests. Figures were shown during harvest festivals, during which dancing, public tattooing, wrestling, and canoe racing were included among events that took place over several days. Sculptures of divinities were called *tino*, and the word *aitu* refers to ancestors. Only eight large *tino aitu* figures have survived, and the magnificent sculpture illustrated in this volume (cat. 36) is the only one in a private collection.[41]

MASKS

Oceanic masks served as agents of social control and were used in spirit manipulation, curing ceremonies, initiation and fertility rites, and in contexts associated with death, burial, and perpetuation. Masked dancers represented supernatural forces, and masks were visualizations of spiritual power. In Melanesia, masking occurred in many areas, but with the exception of bark-cloth masks donned during ceremonies in the Cook Islands during the late nineteenth and early twentieth centuries,[42] masks are absent from Polynesian and Micronesian art.[43]

In Melanesia, masks crafted from wood, bark cloth, palm spathe (a large bract or sheathing leaf enveloping the inflorescence of certain palms), tortoise shell, bone, spiderwebs, rattan, and other materials were widely used, and the masking traditions of New Guinea, New Britain, Vanuatu, New Caledonia, New Ireland, and the Solomons are extraordinarily rich and diverse. Masks range in size from the towering bark-cloth examples from New Guinea's Papuan Gulf to the striking face masks created along the Sepik River. There is an astonishing range of styles. Masks were often complemented by costumes that fully covered the body of the wearer, and dancers were accompanied by drumming, songs, and chants that completed the full dramatic effect.

Without specific information, it is often difficult, if not impossible, to determine the exact function of a given mask, including many from the middle and lower reaches of the Sepik River, Papua New Guinea. The makers of the first mask in the exhibition (cat. 37), however, have been well documented by Western researchers. The most prominent feature of this elegant mask is the extension of the nose, which culminates in a bird that refers to a clan ancestor. Masks of this type are called *mwai*. Appearing in male and female pairs, they were thought to embody the spirits of mythical brothers and sisters and belonged to specific clans. Mwai masks were attached to a basketry framework that covered a dancer's body. They appeared in both public and private contexts, including men's initiation ceremonies.[44] These masks are usually completely covered with nassa shells, but this example has either lost them or was never embellished in this manner.[45]

The second mask in the the exhibition (cat. 38) is beaked, a common characteristic of masks from along the Sepik, especially the middle lower reaches. The holes along the side of the object were used to attach other materials to the mask and to secure it to its costume. The third beautifully carved mask (cat. 39) is also from the lower reaches of the river and has been attributed to the Watam people. The spiral at the end of the nose is unusual, resembling a fern leaf as it begins to unfurl.

New Britain masks are best known through the striking and extraordinary creations of the Sulka and Baining people, and the rare and beautiful Tolai mask from the Franklin collection (cat. 40) also possesses an imposing presence. Along with its accompanying costume, its dramatic impact would have been impressive. There is little information on masks of this type, and limited numbers are found in museum collections. This piece is

59

stylistically related to another known as a *lor* mask that was published by Ingrid Heermann.[46] Possibly used in conjunction with ceremonies conducted by a men's secret society called Iniet, its specific function is not known. The Iniet society, like others in Melanesia, consisted of different levels or grades, and the status of individual members depended on how advanced a man was within the system.

Vanuatu masks vary tremendously in form and material. Many were crafted in highly fragile organic materials for special rituals and were destroyed after use. Wooden masks are far less common and are passed down from generation to generation. Kirk Huffman illustrates several of these masks from Ambryn, Pentecost, and Malakula in *Arts of Vanuatu*,[47] but none exactly replicates the important and unique wooden mask from Vanuatu included in this volume (cat. 41). No specific information regarding the masks' use is recorded. Huffman illustrates one from northeast Malakula, where wooden hand-held masks are used in rituals associated with advancement in men's societies. The Franklin piece bears some resemblance to this work, including the raised areas on the cheeks and the extension at the chin, which the wearer would have used to hold the mask over his face.[48]

Men in Vanuatu belonged to societies in which a member's status and prestige in the community was dependent on the rank or grade he had reached within the organization. The attainment of successive grades within the society required an individual to conduct ceremonies and rites that included dancing, feasting, and pig sacrifice. Various figures, masks, and other objects played a role in these activities. The rare and striking helmet mask from the Smith collection (cat. 42) is from Malakula and would have appeared in dances that were conducted in association with an individual's elevation in rank. The mask is almost identical to another work in the collection of the Metropolitan Museum of Art, also said to be from Malakula.[49] Two types of grade societies existed on Malakula; one was called Nimangki and the other Nalawan. Nalawan masks were collectively known as *temes mbalmbal*, representing recently deceased ancestors who appeared in the last stages of specific ceremonies. The Metropolitan Museum's mask is said to represent Nevimbumbaau, a powerful female figure who played a role in the creation of men's societies. Sitting astride the large head of Nevimbumbaau is a male figure, possibly her husband, Ambat Molondr. Since the two masks are so similar it is likely that the iconography of the Smith mask is the same. Both masks are excellent examples of the use of a variety of ephemeral forest products to create powerful and haunting imagery.

The compelling New Caledonia work from the Smith collection (cat. 43) represents one of the most striking art forms in Oceania. A performer's full costume would have included a helmet constructed of fiber, to which a wooden mask was attached, along with human hair and beard and a cloak of black and brown pigeon feathers. Three New Caledonia mask types exist: a facial plane with flattened features, a second with a more elongated face and very large nose, and a third that combines attributes of both. Conflicting

information exists regarding meaning, function, and use. Some data suggests the masks were used in secret society ceremonies as agents of social control, in death rituals, and in a variety of ceremonial contexts. Other sources contend that the masks represent water spirits called *apouema*. They may also represent the original ancestors.

Big-nosed masks were only carved in northern New Caledonia, and some scholars have speculated that they may be influenced by "big-nosed" examples from Vanuatu, New Caledonia's closest neighbor. Another explanation relates to the legend of Azyu, a cultural hero of northern New Caledonia:

> *Azyu was the son of Dea of Belep Island and Tea Pulivac, the ruler of Poo Island, both islands located to the north of New Caledonia. As he grew older and more powerful, Azyu gained the enmity of his rivals. After a series of failures, his enemies managed to kill him, tearing off his nose and tongue in the process. Dea vainly tried to bring him back to life, but because he was so ashamed of the appearance of his face, Azyu would not allow her to do so. He traveled to the land of the dead, where he made a mask of this type (big nosed) and sent it back to New Caledonia. The large nose, of course, represents the nose he had lost.*[50]

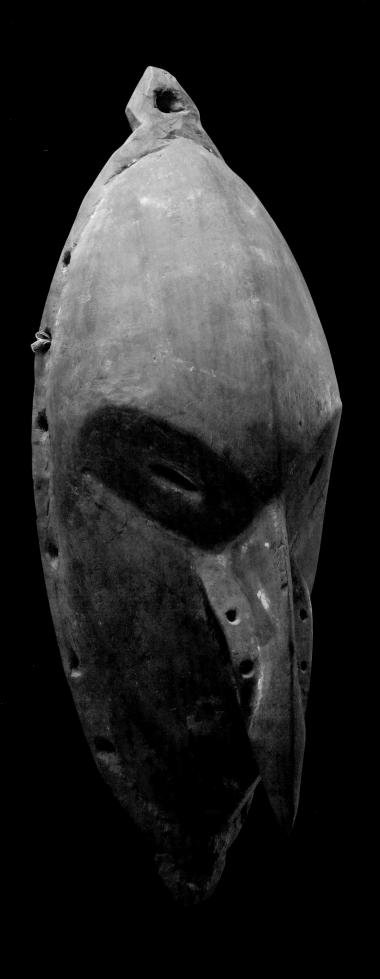

38
Mask
Melanesia; Papua New Guinea;
East Sepik Province;
Coastal Lower Sepik River
19th century
Wood; fiber
16 × 5¾ × 5⅞ inches
Valerie Franklin Collection

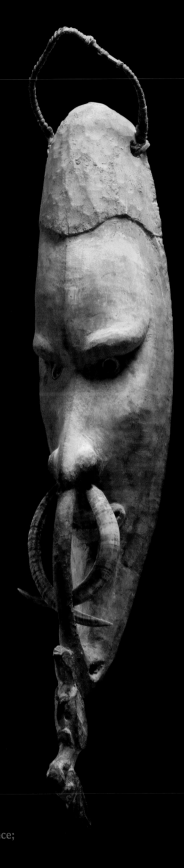

37
Mask (mwai)
Melanesia; Papua New
Guinea; East Sepik Province;
Middle Sepik River
Sawos people
19th century
Wood; fiber; boar's tusks
$16 \times 5^{3}/_{4} \times 5^{7}/_{8}$ inches
Valerie Franklin Collection

39
Mask
Melanesia; Papua New Guinea;
East Sepik Province; North Coast
of the Sepik River
Watam people
19th–early 20th century
Wood
$20^{1}/_{2} \times 7^{1}/_{2} \times 4^{1}/_{4}$ inches
Valerie Franklin Collection

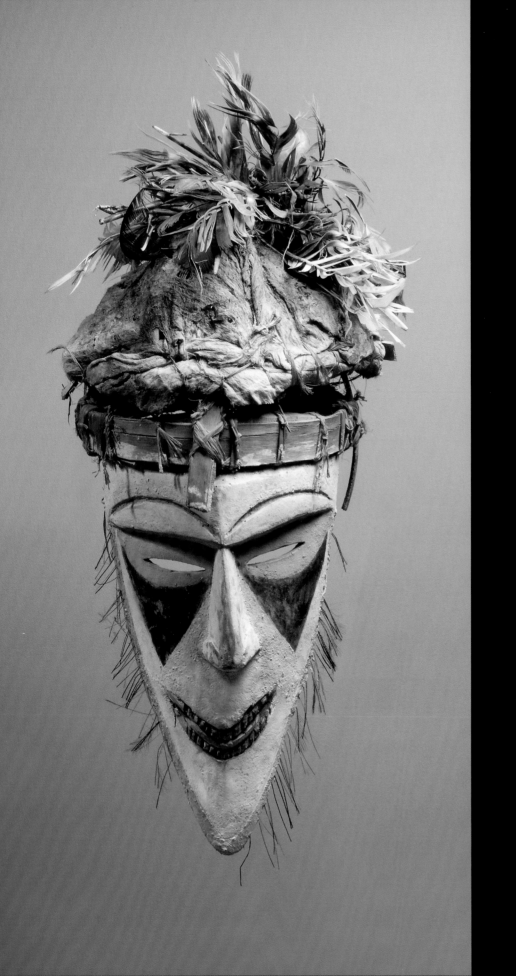

40
Mask (Lor)
Melanesia; Papua New Guinea;
New Britain; Gazelle Peninsula
Tolai people
19th century
Wood; feathers; bark cloth; black,
blue, yellow, and white pigments
19 × 8 × 8½ inches
Valerie Franklin Collection

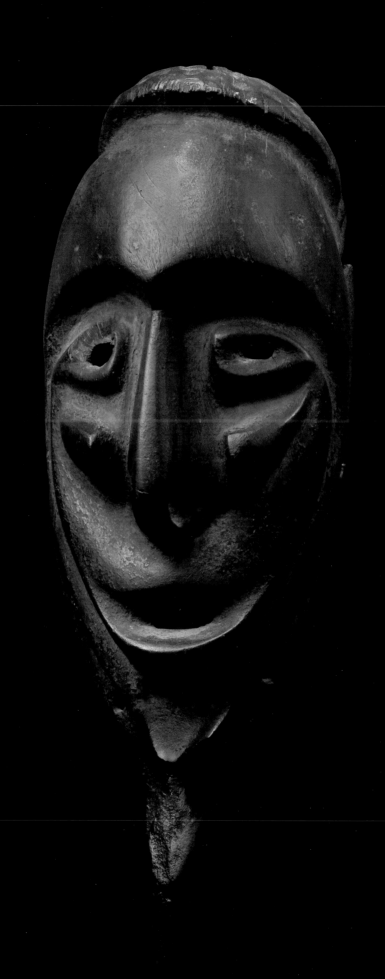

41
Mask
Melanesia; Vanuatu, Vao, or
Rano Island (off Malakula)
19th century
Wood; black with traces of
blue and orange pigments
$14\frac{1}{2} \times 5\frac{1}{8} \times 3\frac{1}{2}$ inches
Valerie Franklin Collection

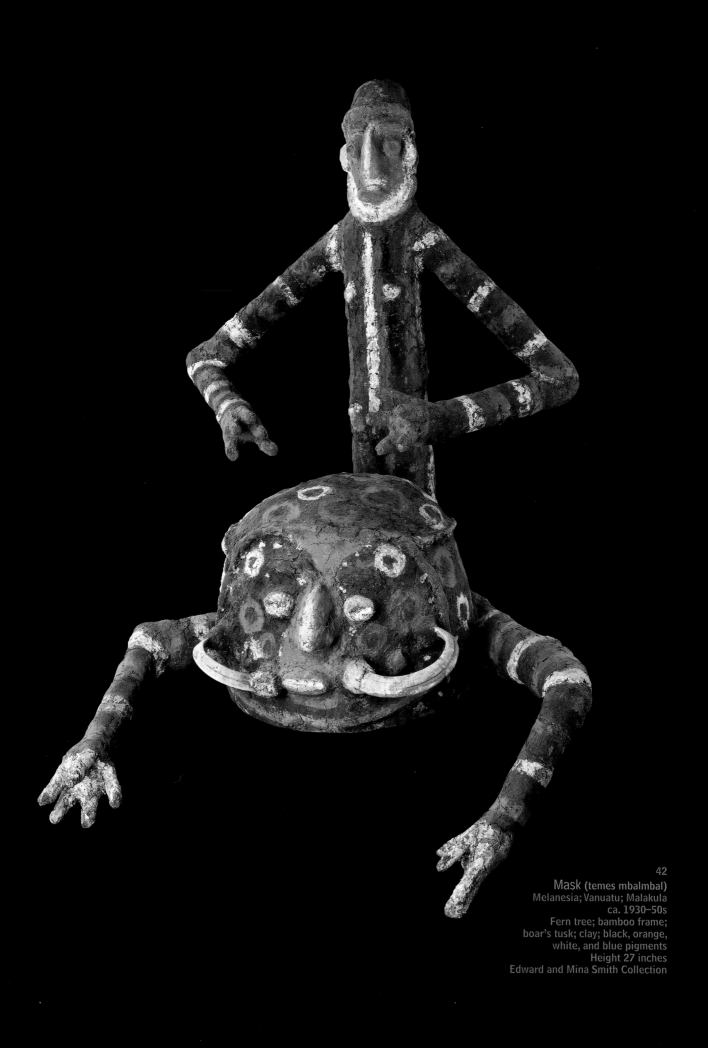

42
Mask (temes mbalmbal)
Melanesia; Vanuatu; Malakula
ca. 1930–50s
Fern tree; bamboo frame;
boar's tusk; clay; black, orange,
white, and blue pigments
Height 27 inches
Edward and Mina Smith Collection

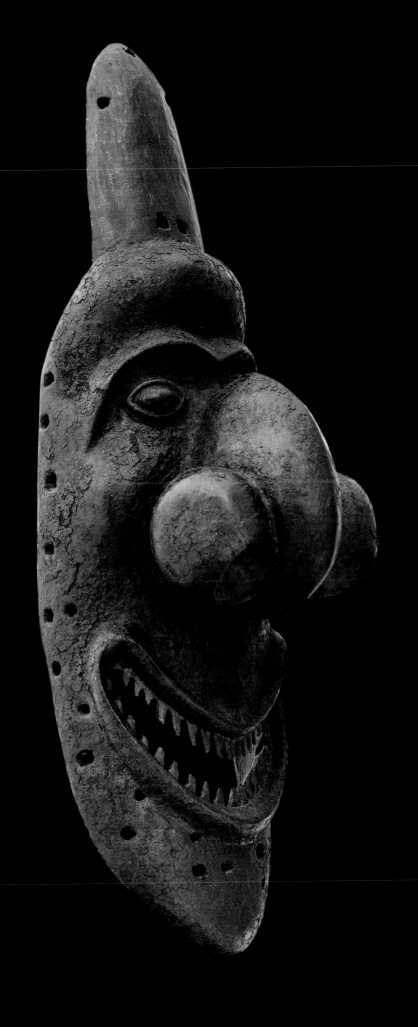

43
Mask (apouema)
Melanesia; New Caledonia
19th century or earlier
Wood
Height 22 inches
Edward and Mina Smith Collection

TAPA

Tapa, or bark cloth, is probably the most widely recognized art form in the Pacific (see cats. 44–47).[51] It is found throughout Melanesia and Polynesia, and with a limited number of exceptions, depending on location, it was, and still is, made by women. An impressive variety of patterns and styles bears witness to the exceptional talents of Oceanic tapa makers, women who were not generally included in Pacific art-making. It has been suggested that tapa has been used in Oceania for thousands of years, possibly having been introduced as early as 1500 BCE by the Lapita people, the ancestors of today's Polynesians. Originating in China and Southeast Asia, tapa-making knowledge spread into Melanesia first, and later moved into the farthest reaches of Polynesia.

Tapa is made from the inner bark of a tree, primarily from the paper mulberry. Although the specific process of its manufacture varies from culture to culture, the basic technique involves the separation of the inner bark from the outer (which is discarded) and the beating of the bark over a wooden, or rarely, stone anvil. The wooden beaters are grooved with various degrees of fineness, and the process involves the use of graduated beaters to produce the desired quality. Designs are produced by painting, stenciling, and printing, traditionally using natural dyes.

Tapa was used for utilitarian and religious purposes, as clothing and bed covers, for mask-making and costumes, as gifts at important communal events, and to wrap or construct images of deities. It was extensively used from birth to death: newborn infants and the deceased were wrapped in its embrace.

Tapa-making remains an important art form in some areas of the Pacific, especially in Samoa, Tonga, and Fiji. Its use and design have changed and evolved in response to existing circumstances, but this enduring art form continues to serve traditional cultural needs and purposes.

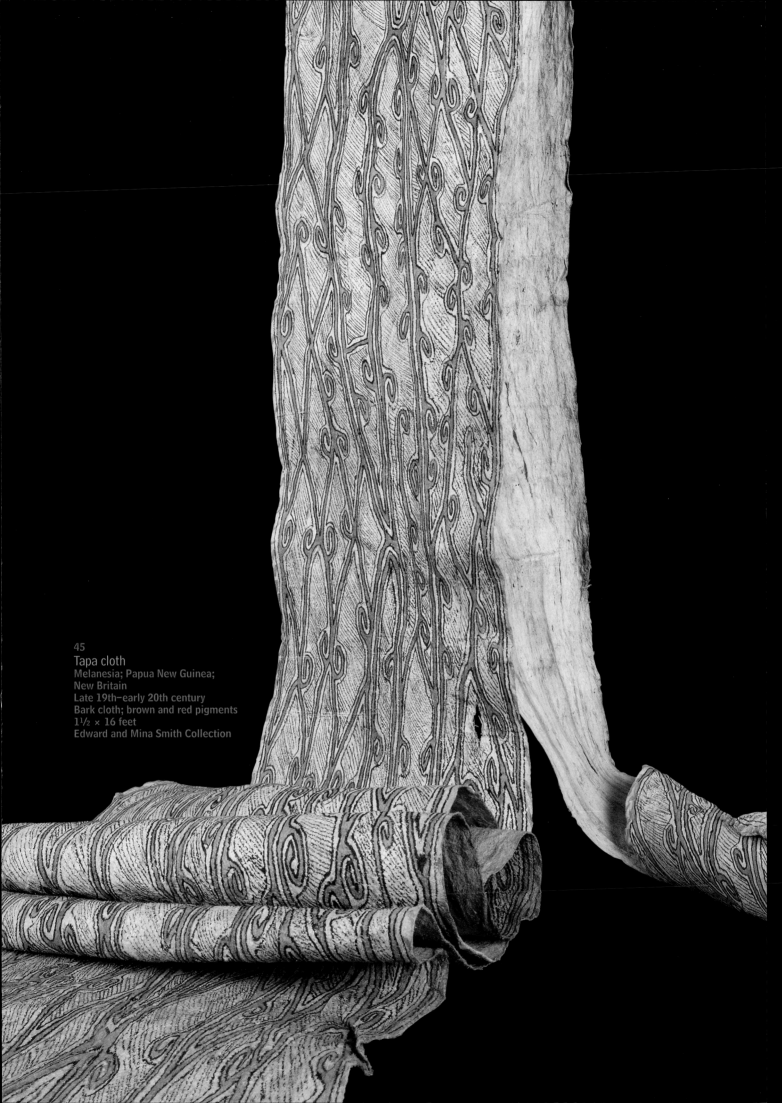

45
Tapa cloth
Melanesia; Papua New Guinea;
New Britain
Late 19th–early 20th century
Bark cloth; brown and red pigments
$1\frac{1}{2} \times 16$ feet
Edward and Mina Smith Collection

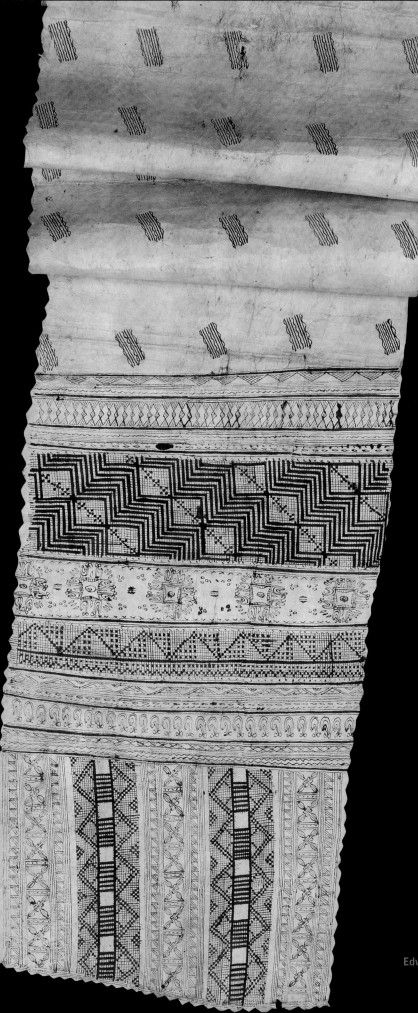

44
Tapa cloth (salatasi)
Polynesia; Futuna Island
19th century
Bark cloth; black pigment
2 × 14 feet
Edward and Mina Smith Collection

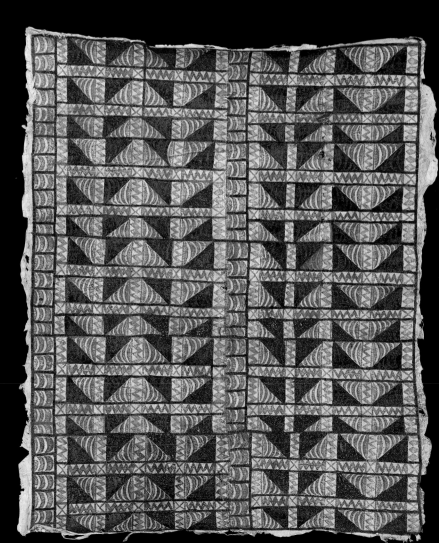

46
Tapa cloth (kapa moe)
Polynesia; Hawai'i
ca. 1850–60
Bark cloth; natural pigments,
including indigo dye
112 × 74 inches
Sana Art Foundation Collection

47
Tapa cloth (siapo vala)
Polynesia; Samoa
Early 20th century
Bark cloth; natural dye
72 × 42 inches
Sana Art Foundation Collection

PERSONAL ADORNMENT

Pacific personal adornments and jewelry were rich and varied.[52] Generally everyone, regardless of social position or gender, wore some minimal jewelry on a daily basis. On special occasions, both secular and religious in nature, the finest appropriate and most precious objects were worn, creating an explosion of color, movement, and sound. Some objects are made from only one material, but others are artful combinations of many media that together create striking patterns and designs through skillful manipulations of line, texture, and form. Materials used to create Oceanic jewelry include wood, shell (including sea turtle), stone, bone, seeds, bark cloth, coconut shells, teeth (animal, human, porpoise, shark, whale, and dog), human hair, fur, bamboo and other grasses, and, through trade, glass beads. Melanesia was especially rich in flora and fauna, resulting in a wider and more eclectic range of materials to exploit, but beautiful jewelry was created throughout the Pacific.

Some materials not available locally were obtained through barter and trade networks that existed both on land and via sea. In this way, rare shells traveled from one ocean location to another and from the sea to the mountains. Precious and valuable feathers were also widely traded. Specific materials, because of rarity and monetary value, became identified with persons of high rank and position. Jewelry was worn not only for aesthetic effect but also to connote social position and to serve as a talisman or amulet for either good or evil purposes. For ceremonial use, select pieces could only appear in correct contexts and could only be worn by those with the right to do so. Other ornaments were symbols of certain accomplishments, and their meaning was readily understood by all.

Circular shell discs, or *kapkap*, were worn by men in the Western Solomon Islands. They were placed on the forehead during battles and acted as symbols of wealth during festivals. The example from the Sana collection (cat. 48) is from Santa Cruz and consists of a circular shell disc that serves as the ground for a tortoise shell–fenestrated overlay, which most likely represents a frigate bird (a type of seabird). In Santa Cruz, these ornaments were worn around the neck. The cords from which they were suspended were sometimes strung with valuable forms of shell currency. Called *tema*, they were worn during men's initiation rites and other ceremonies. Shell discs are crafted from the giant clam (*Tridacna gigas*), and shells were also dug from fossil beds in the Solomons. The material was in high demand and was greatly valued, as was sea-turtle shell.

The Hawai'i necklace (*lei niho palaoa*) illustrated in this volume (cat. 49) is crafted from whale ivory and human hair. Only high-ranking male and female members of Hawai'ian royalty could wear it. Pieces were crafted from wood, bone, stone, and shell, but ivory was the most highly valued material used for these pendants. Precontact examples are generally thought to be smaller; pieces seem to have grown in size after Western traders and whalers began to supply walrus tusks and sperm whale teeth in quantity, beginning in the early nineteenth century.

Only high-ranking Māori chiefs and their family members wore greenstone pendants (*hei tiki*), which were highly valued and passed down as heirlooms. Prior to the introduction of metal, hei tiki were made with sandstone files and grindstones. Greenstone is extremely hard, and months might have been required for the carving and shaping of a single pendant. Sources for this stone were limited, and all were located on the South Island. Pendants were worn around the neck and took several forms: some were simple discs with notched edges, some echoed the shape of parrot leg rings, and others depicted a *manaia*.[53] The Franklin piece in the exhibition (cat. 50) is a rare and early example from the North Island.

Hei tiki are by far the most common pendants, and they are also the most beautiful and highly valued. The pendants represent a female or sexless human whose head is commonly tilted to one side. They would have been suspended from a flax cord with a bird-bone toggle. Unlike most pendants of this type, the example from the Smith collection (cat. 51), dating to the eighteenth century, has retained its cordage and toggle.

Two other excellent hei tiki are included in the exhibition. The first (cat. 52) is estimated to date from the early nineteenth century, and the second (cat. 53) may be from as early as the middle of the eighteenth century. Originally, many hei tiki eye sockets were inset with haliotis.[54] The presence of red sealing wax, as in the first example, could indicate post-European contact manufacture or merely that the wax was applied to an older piece. The color red was highly valued and was associated with high status and prestige. Both pieces indicate extensive wear and use. Two suspension holes in the latter piece are present, the second apparently drilled after the first had opened up after long wear. Hei tiki were named for a particular ancestor, and they would have been carefully stored in beautifully carved "treasure boxes." They were believed to embody the spirit and power of the deceased and were thought to gain in power with each succeeding generation.

The pendant from the Smith collection is a beautiful and rare eighteenth-century example from Tonga (cat. 54). There are no more than twenty of these figures known. Five are carved from wood and the remainder from sperm whale ivory. As is the case with this example, some are drilled for suspension. They are thought to have been worn singly or together with others. Sacred ivory figures were housed in special god's houses but were sometimes worn by high-ranking female chiefs as charms or ornaments. All figures are female, and a great deal of scholarly attention has focused on their point of origin. Because one of these pendants can definitely be assigned to a specific location, all others have also been geographically attributed to the same region of Tonga. Some scholars, however, question this attribution because minor differences in style exist. Those collected on Fiji had also attained important religious significance there. At the time of Western contact, Tongan/Samoan artists also worked for important Fijian chiefs, and there is speculation that these artists might have carved those pieces found on Fiji. The Smith masterpiece is small in scale but monumental in power and spirituality.[55]

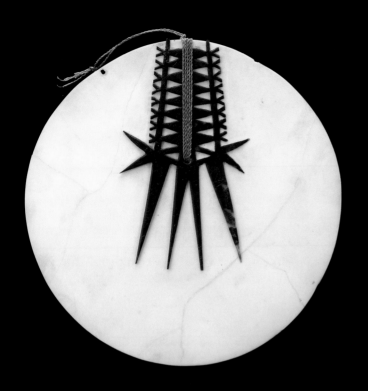

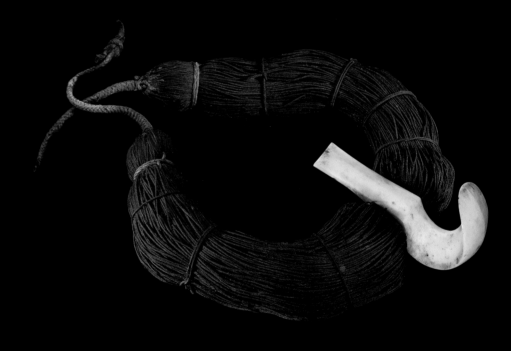

48
Ornament (kapkap)
Melanesia; Solomon Islands;
Santa Cruz
Early 20th century
Tridacna shell; turtle shell;
plant fiber
Diameter 7¼ inches
Sana Art Foundation Collection

49
Necklace (lei niho palaoa)
Polynesia; Hawai'i
19th century
Whale ivory; human hair; sennit
Diameter 12 inches
Sana Art Foundation Collection

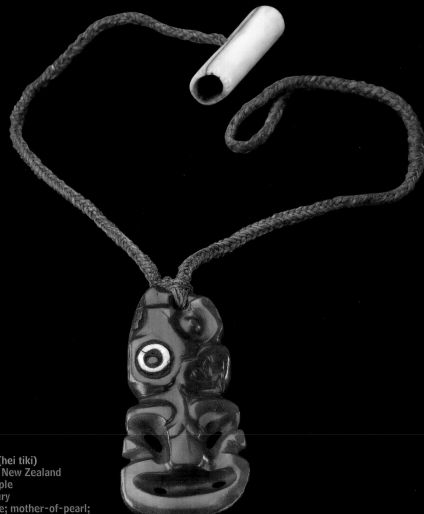

50
Pendant (pekapeka)
Polynesia; New Zealand;
North Island
Māori people
18th–early 19th century
Greenstone
$1\frac{3}{4} \times 3\frac{3}{4} \times \frac{1}{16}$ inches
Valerie Franklin Collection

51
Pendant (hei tiki)
Polynesia; New Zealand
Māori people
18th century
Greenstone; mother-of-pearl;
bird bone; flax cordage
Pendant only: $3\frac{1}{4} \times 1\frac{1}{2} \times$
less than $\frac{1}{4}$ inches
Edward and Mina Smith Collection

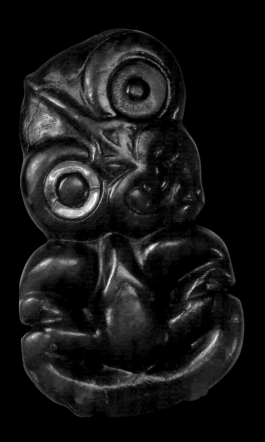

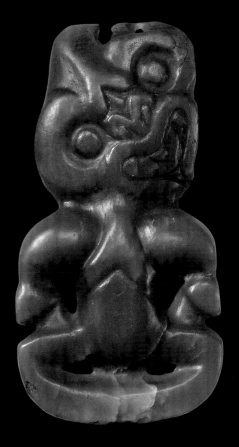

52
Pendant (hei tiki)
Polynesia; New Zealand;
West Coast North Island; Taranaki
Māori people
Early 19th century
Greenstone; red sealing wax; shell
$2 \times 3^5/_8 \times ^1/_4$ inches
Valerie Franklin Collection

53
Pendant (hei tiki)
Polynesia; New Zealand;
West Coast North Island; Taranaki
Māori people
18th century
Greenstone
$3^3/_4 \times 2 \times ^1/_4$ inches
Valerie Franklin Collection

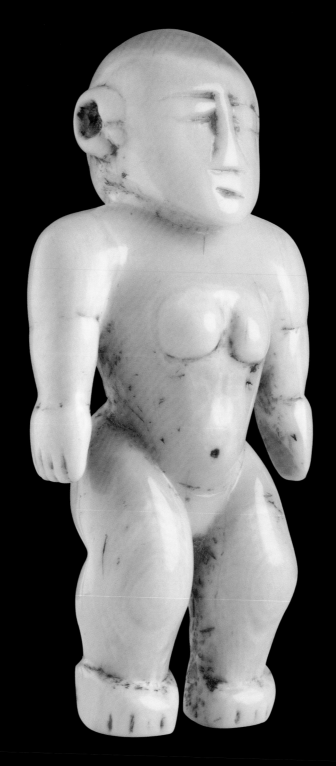

54
Figure
Polynesia; Tonga
18th century
Sperm whale ivory
Height 3¾ inches
Edward and Mina Smith Collection

SACRED AND SECULAR CONTAINERS

Oceanic containers served in both secular and religious contexts and evidence a wide range of styles and materials. Ceramic pots, wooden bamboo vessels, coconuts, gourds, and baskets were utilized in food preparation and cooking, for serving, and for the storage of foodstuffs and valuables. Containers held lime and elegant wooden bowls were important to the preparation and serving of kava.[56]

A large number of miniature wooden vessels used to mix paint or cosmetics have been collected along the Sepik. These containers were carved in animal and human form, and many exhibit characteristics of both. The superb example from the Franklin collection (cat. 55) is said to be from the lower section of the river and is elaborately decorated with bird heads carved at its extremities.

Pottery was made and used in Melanesia but was largely absent in historic Polynesia and Micronesia. Most pottery vessels served utilitarian purposes. Some from the Sepik River area of Papua New Guinea were beautifully decorated. Figurated cooking and storage vessels were the specialty of the Iatmul people living at Aibom Village, Chambri Lake, and other figurated pots used by their neighbors, the Manambu, served religious purposes.

A unique type of pottery was produced in Fiji, on the islands of Viti Levu and Bau. Used by high-ranking chiefs as drinking vessels, these fanciful containers are in the shape of turtles, whale teeth, vegetables, and fruit. One example in the exhibition represents a particular type of citrus fruit called shaddocks (cat. 56). A second example (cat. 57) is called *drua* (twin), which relates to double-hulled canoes or sometimes *drua tabua,* a reference to a whale's tooth. Although the shape of a third vessel from the Smith collection (cat. 58) is not identified, it, too, demonstrates the variety and beauty of these ceramics.

Basketry is found throughout the Pacific region. Early examples from Tonga are especially handsome and were highly praised by members of Captain James Cook's crew in the late eighteenth century. Tongan baskets are made from vines, coconut leaves and fiber, and pandanus leaf strips.[57] Called *kato* (baskets), various types are ranked and specifically valued within Tongan society. The Tongan basket in this volume (cat. 59) is similar to one collected during Cook's second or third voyage and is crafted from creeper, cane, and coir (coconut husk fiber).[58] Although lacking specific collection data, an old tag attached to the piece carries a date of 1845.

Gourds and bamboo vessels used to store lime are frequently decorated with incised and fire-engraved geometric designs. The gourd container from the Smith collection (cat. 60), which would have held water or lime, is surmounted by a wooden stopper that depicts a seated male figure.[59] Sculpture from Nendo Island, politically a part of the Solomon Islands, is distinctive, and only a limited number of works have been documented.[60] The conical extension at the back of the head represents a man's hairstyle. Called *abe,* its construction and shape was a symbol of wealth and high social status, and

59
Basket
Polynesia; Tonga
Early 19th century
Native fibers; black dye and sennit
6 × 10¾ inches
Edward and Mina Smith Collection

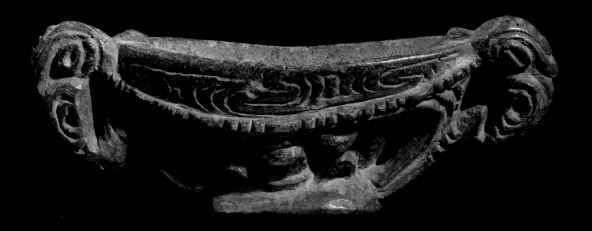

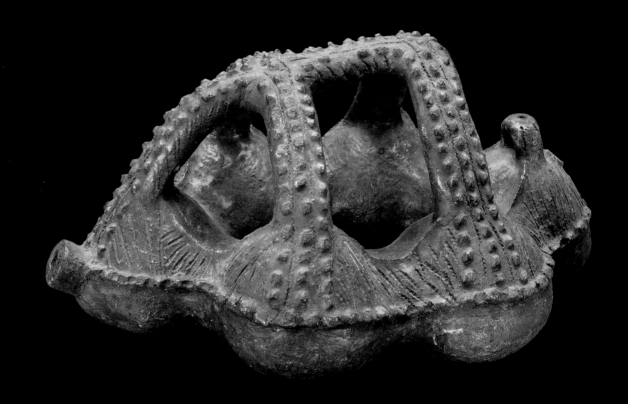

55
Pigment dish
Melanesia; Papua New Guinea;
East Sepik Province;
Coastal Sepik River
Late 19th century
Wood; pigment
$2^1/_2 \times 2^3/_8 \times 7$ inches
Valerie Franklin Collection

56
Container (saga moli)
Polynesia; Fiji
19th century
Ceramic
$6 \times 12 \times 9$ inches
Edward and Mina Smith Collection

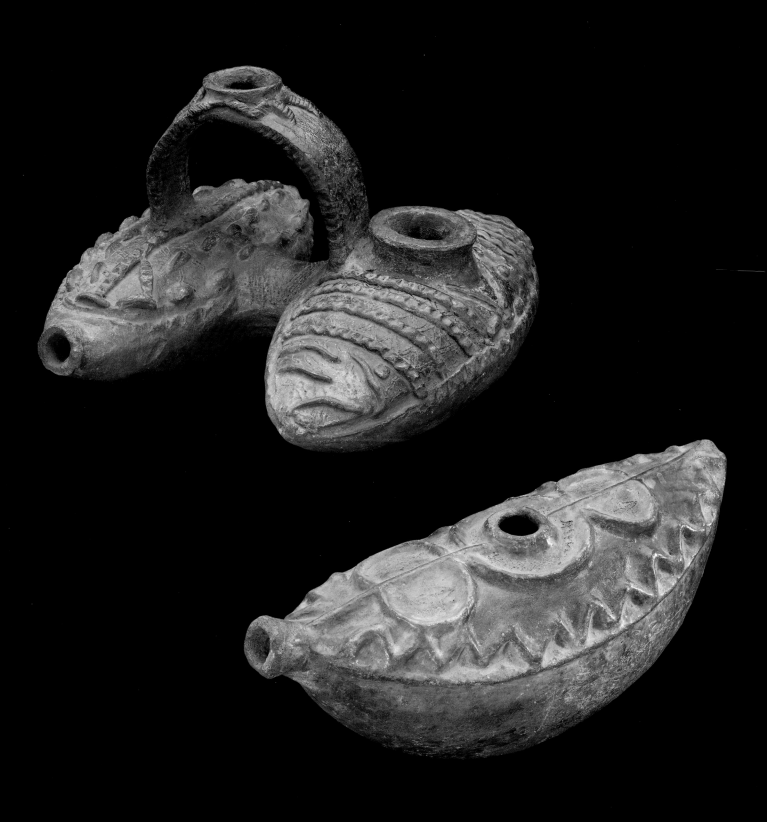

57
Container (saga drua)
Polynesia; Fiji
19th century
Ceramic
7 × 12 × 12 inches
Edward and Mina Smith Collection

58
Container (saga)
Polynesia; Fiji
19th century
Ceramic
Height 12 inches
Edward and Mina Smith Collection

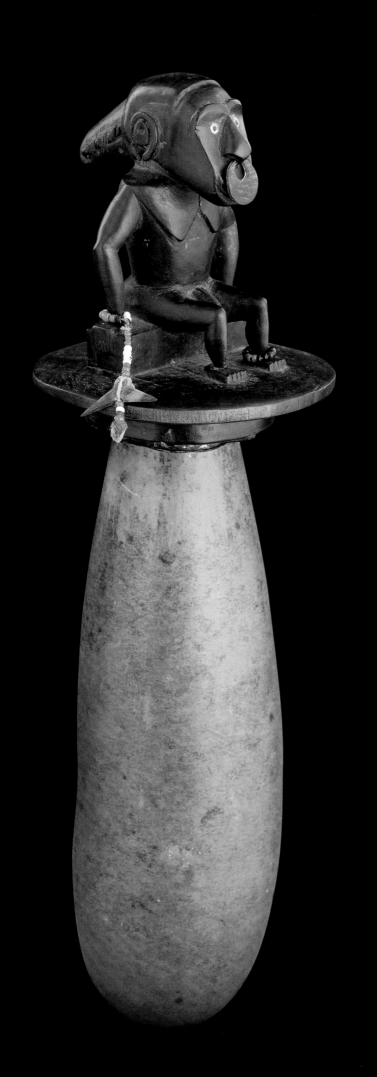

60
Container
Melanesia; Papua New Guinea;
Solomon Islands; Nendo Island
First quarter of 20th century
Gourd; wood; fiber; shell;
rat teeth; turmeric and
black pigments
Height 12¾ inches
Edward and Mina Smith Collection

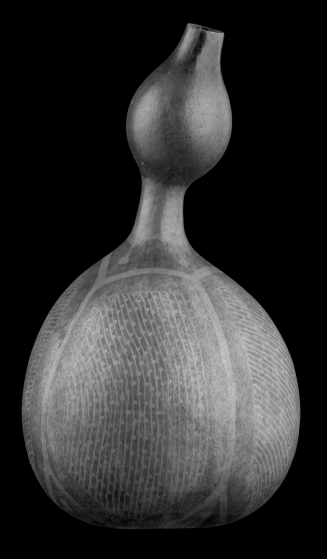

61
Gourd (ipu pawehe)
Polynesia; Hawai'i
19th century
Gourd
Height 12½ inches
Edward and Mina Smith Collection

63
Bowl (umeke la'au puahala)
Polynesia; Hawai'i
18th century
Wood (koo)
Diameter 8½ inches
Edward and Mina Smith Collection

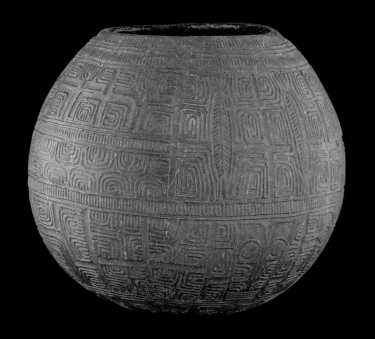

62
Container
Polynesia; Marquesas Islands
Late 19th to early 20th century
Coconut
5½ × 6 inches
Sana Art Foundation Collection

64
Platter
Melanesia; New Guinea;
West Papua; North Coast;
Lake Sentani
Late 19th century
Wood; white lime
42 × 14¼ inches
Valerie Franklin Collection

for older men, it also served the practical purpose of covering bald spots. All Nendo figures refer to deities or supernatural beings.

Gourds were more widely used as containers in Hawai'i than elsewhere in Polynesia. Many are beautifully decorated with geometric designs created by carving patterns into the thin outer skin of the growing gourd and later immersing it in swamp mud. The carved sections absorbed the black color of the mud and the uncarved portions did not. As with the elegant example from the Smith collection (cat. 61), the black color of the carved sections frequently faded. Decorated water gourds were called *ipu pawehe*.[61] The divisions of this gourd are delineated with vertical lines that terminate in V shapes at the neck and base, a possible reference to a coir net binding used for hanging or transporting these containers. The gourds would have held liquids and food for immediate consumption or storage.

Marquesan artists carved beautiful designs on coconut shells well into the twentieth century. A particularly fine example from the Sana collection (cat. 62) is covered with motifs that may derive from tattoo patterns. Elaborately decorated bowls developed after Western contact, possibly in response to the demand for curios.[62]

In Hawai'i, beautiful containers that held poi (fermented taro root) and other materials are among the finest examples of the woodcrafter's art in the world. Early pieces were carved by hand, while later nineteenth-century pieces were most often turned on a lathe. These works were highly valued and when damaged were carefully repaired with wooden patches, some in butterfly form. The small and elegant bowl from the Smith collection, known as *umeke la'au puahala* (cat. 63), has been repaired in this fashion and may have been made in the late eighteenth or early nineteenth century.

Lake Sentani objects from West Papua (the western half of the island of New Guinea and part of the Republic of Indonesia) are extremely rare, but a limited number of beautifully decorated containers for serving fish and sago[63] clearly demonstrate the beauty and quality of utilitarian objects (see cat. 64) from this region. The Oceanic scholar Douglas Newton refers to these everyday objects as "commoner's art" and comments on the perfect harmony between shape and surface decoration.[64] S-shaped double spiral motifs and interconnected scrolls are typical style elements.[65]

Although not itself a container, the Taiwanese circular container lid in this catalogue (cat. 65) is decorated with human and snake motifs. Carved heads and full figures represent ancestors, and snakes denote the ancestors of the noble class among the Paiwan people who are the likely makers of this work. Traditional societies in Taiwan produced woodcarvings in low relief that embellished utilitarian objects and served as powerful architectural enhancements. Taiwan played a pivotal role as one of the gateways for Oceanic migration.

While most containers were used in secular contexts, others were directly associated with both secret and public rituals and ceremonies. Betel nut chewing was largely confined to Melanesia and Micronesia, but the

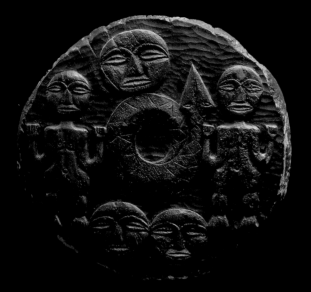

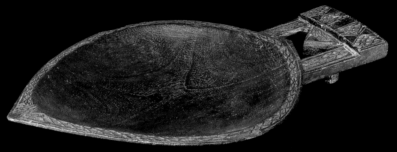

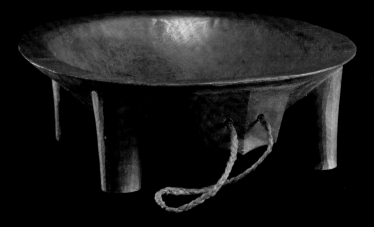

65
Container lid
Taiwan
18th–19th century
Wood; red pigment
Diameter 17¾ inches
Valerie Franklin Collection

68
Oil dish
(sedre ni waiwai)
Polynesia; Fiji
1820–50
Wood (vesi)
18 × 12¼ inches
Edward and Mina Smith Collection

66
Bowl
Polynesia; Fiji
19th century
Wood
5¾ × 16 inches
Valerie Franklin Collection

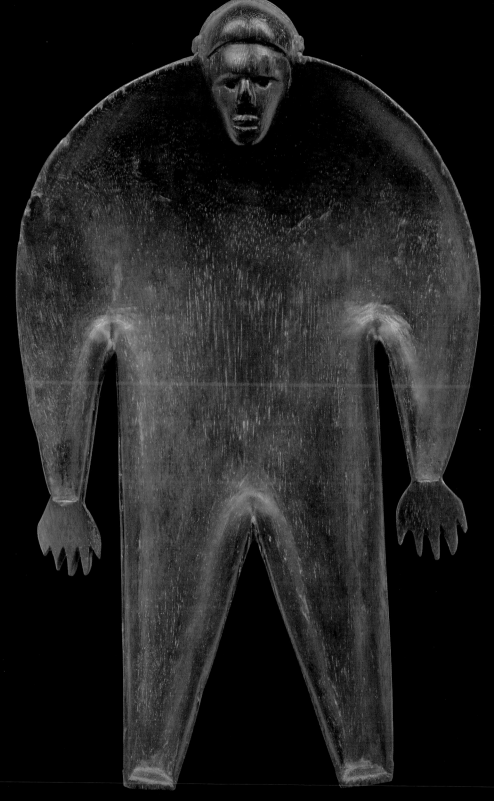

67
Oil dish (daveniyagona)
Polynesia; Fiji
18th–early 19th century
Wood (vesi)
Height 11¼ inches
Edward and Mina Smith Collection

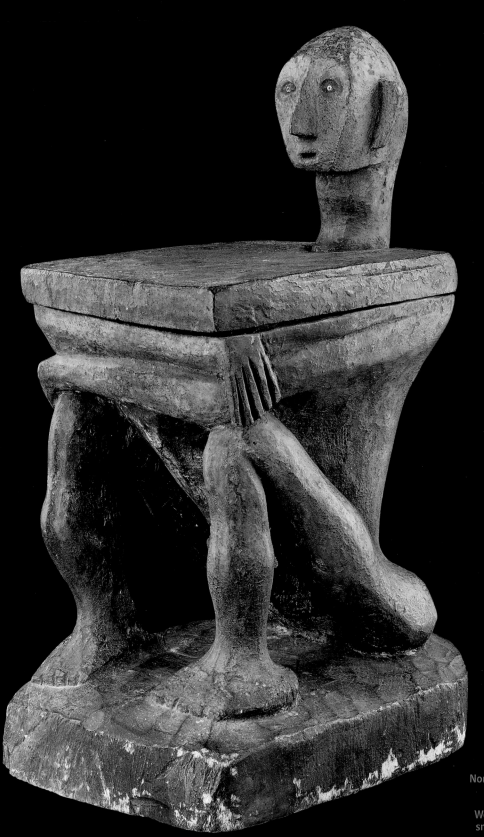

69
Ritual box
Republic of the Philippines;
Northern Luzon; Mayoyao Valley
Ifugao people
Mid-20th century
Wood (box filled with rice, one
small figure, straw, and fibers)
25 × 12 × 15 inches
Edward and Mina Smith Collection

drinking of kava was primarily a Polynesian activity.[66] In Fiji, Tonga, and Samoa, formal kava drinking was firmly embedded in the social and religious fabric of the community. Elegant kava bowls (see cat. 66) were used at weddings and funerals, as well as during important ceremonies dealing with the investiture of chiefs. Formal kava drinking involves strict protocol and ritualized movements when preparing the kava and serving invited guests.[67] Less formal occasions are more casual but retain an underlying sense of respect for this important

Detail, cat. 69.

activity. Kava bowls (called *tanoa* in Fiji) vary in size depending in part on the number of ceremonial participants present. In basic form, Fijian, Tongan, and Samoan bowls are similar; however, the number of legs varies from one culture to the next. Generally, those with four legs are from Tonga and Fiji, but those with six to twelve legs are not exceptional. Samoan examples all have more than four.

Cat. 67 illustrates an extremely rare container from Fiji. Shallow dishes were used in special ceremonies when kava (*yaqona*) was offered to an ancestor spirit that had possessed the body of a priest, enabling the ancestor to speak with its descendants. During this ritual, the priest drew the kava from the dish with the aid of a straw, avoiding any contact with the container, hands, or the possessed priest's lips. Only seven dishes in human form are known to exist, along with a limited number of others in the form of ducks, turtles, and canoes.[68] All known containers in human form are similar, but more than one artist may have been involved in their creation. A second elegant but abstract dish (cat. 68), also from the Smith collection, served the same function.

Important priest's boxes crafted by the Ifugao of northern Luzon, Republic of the Philippines, contain the remnants of prior sacrificial materials and sometimes a smaller figure called *hipag*, a carving usually associated with sorcery. Very few boxes in human form exist, and the one illustrated in this catalogue (cat. 69) is a particularly fine example. Figurated boxes are said to have been specifically utilized during rituals associated with smallpox epidemics, but they could also have been used during harvest ceremonies.[69] The Philippines served as the embarkation point for the settlement of western Micronesia around 1000 BCE. Many cultures in northern Luzon defied Christian conversion and maintained their traditional cultures well into the twentieth century.

MUSIC, DANCE, AND THE VOICES OF THE SPIRITS

Drumming, singing, and dancing were important components of secular and religious life in Oceania, and ceremonies and festivals were instrumental to community welfare and cohesion (cat. 70). In addition to rattles and other sounding devices worn at the wrists and ankles of performers, dancers carried handheld drums shaped like hourglasses. These drums are found throughout Papua New Guinea, and each culture applied stylistically appropriate designs and carving to this basic form. The striking drum from the Franklin collection (cat. 71) was most likely carved by an Iatmul (middle Sepik River, Papua New Guinea) artist. C. Schmid notes that similar examples accompanied clan songs that were sung at ceremonies dealing with a variety of activities, from the launching of a new canoe to the completion of a new men's house.[70] The "mask" at the drum's waist likely represents an ancestor, and the two birds are clan symbols. A second drum in this volume (cat. 72) depends on bands of geometric designs for its visual impact. Its Marind-anim carver, from southwest New Guinea, would have witnessed this instrument used in ceremonies that featured dancers costumed in large, towering, ephemeral structures. Yet another example from Yapen Island in northwest New Guinea (cat. 73) combines beautiful openwork carving with a kneeling figure.[71]

Along the Sepik River and in other areas of Papua New Guinea, artists also carved spectacular and massive slit gongs (drums) that would have rested horizontally underneath men's houses. Drums served multiple purposes: they were beaten to send information between neighboring villages, and they served as the voices of ancestral spirits during specific rites and rituals. Equally impressive vertical slit gongs served similar purposes in Vanuatu.

Water drums and flutes also gave voice to the supernatural world, but flutes were played in secular contexts as well. The sacred flutes of the Iatmul and Biwat people were not played at all, serving instead as prestige items. Flutes were highly decorated, and special figurated ornaments, which surmounted or were attached to the flutes, were "dressed" with feathers, shells, and other materials.[72] Western collectors often discarded the undecorated section (bamboo tubes) of the flutes, leaving only the carved figures. Such is the case with a pair of ornaments in this catalogue (cat. 74), which evidence years of accumulated encrustation, but none of the original embellishments. These busts appear to be male and female.[73] A second beautiful ornament (cat. 75) depicts a standing male figure surmounted by a backward-facing mask and bifurcated extensions that are attached at the back. Also from the middle section of the Sepik, it was possibly made by a Iatmul artist.

While performing, dancers frequently carried weapons and other objects in addition to hand drums. Some especially elaborate and beautifully carved weapons were used in dance and ceremonial contexts, as were dance staffs. This early staff from the Smith collection (cat. 76) would have appeared in dances performed by the Tolai people of New Britain, and it represents an ancestor.

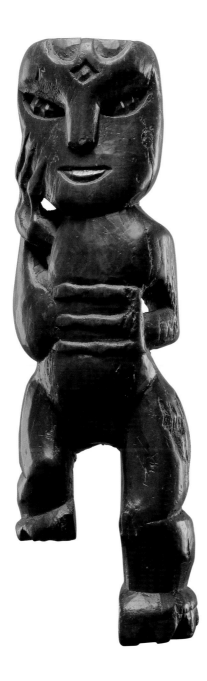

70
"Dancing" figure
Polynesia; New Zealand
Māori people, Arawa tribe
18th–19th century
Wood
$14^3/_8 \times 4 \times 2^3/_8$ inches
Valerie Franklin Collection

Many ethnic groups throughout the Pacific wore dance headdresses. Most were ephemeral in nature and were constructed of organic materials such as rattan, bark cloth, feathers, and shells. The headdresses were assembled for each ceremony and were deliberately destroyed or left to decay afterward. Some materials, such as rare feathers or shells, were preserved for future use. Sculpture from the highlands of New Guinea is rare, but the Siane people carved openwork flat boards, or *gerua,* which were worn on the head during ceremonies staged to honor ancestors and aid in the propagation of pigs, which were highly valued (cat. 77). Each clan performed these ceremonies every three years during a full moon when several thousand participants and several hundred families gathered to witness performances that included dancers wearing these sculptures attached to their heads. After ceremonial feasting was held for the spirits, the headdresses were left to decay.[74]

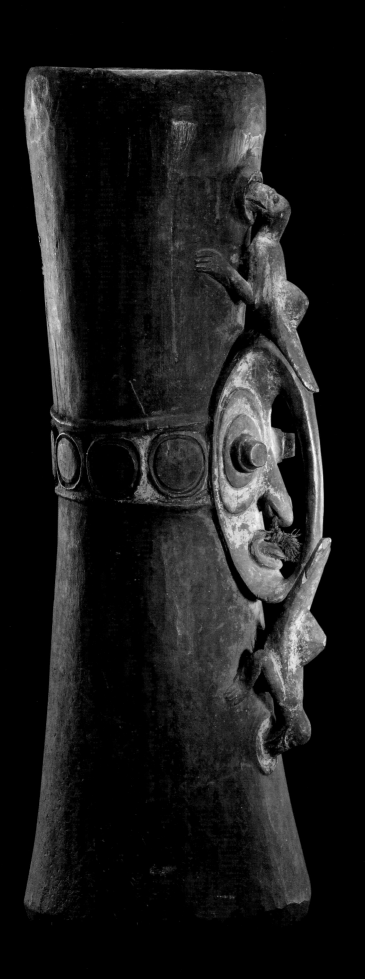

71
Drum (kundu)
Melanesia; Papua New Guinea;
East Sepik Province;
Middle Sepik River
Iatmul people
Late 19th century
Wood; traces of red and
white pigments
$27 \times 9\frac{1}{2} \times 7\frac{1}{2}$ inches
Valerie Franklin Collection

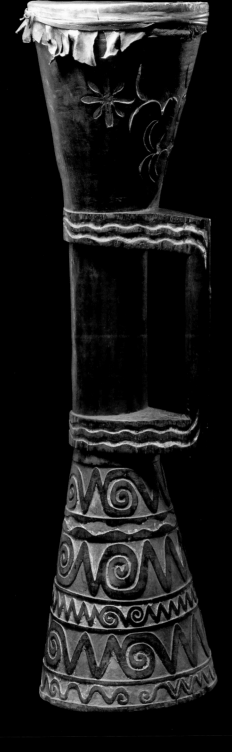

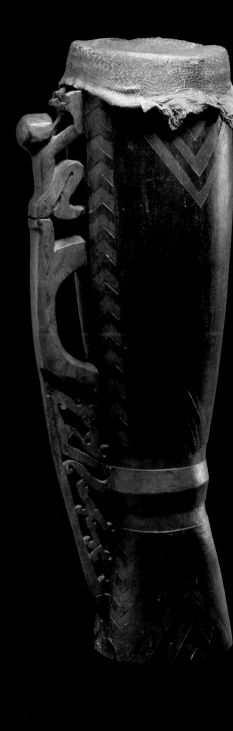

72
Drum (kandara)
Melanesia; New Guinea;
West Papua; South Coast
Marind-anim people
Late 19th century
Wood; red ochre, black, and
white pigments; skin; rattan
$37\frac{3}{4} \times 10 \times 10$ inches
Valerie Franklin Collection

73
Drum
Melanesia; New Guinea;
West Papua; North West Coast;
Geelvink Bay; Yapen Island
Late 19th century
Wood; black and brown pigments;
skin tympanum
$21\frac{1}{2} \times 8$ inches
Valerie Franklin Collection

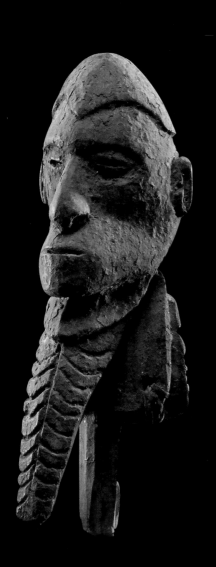
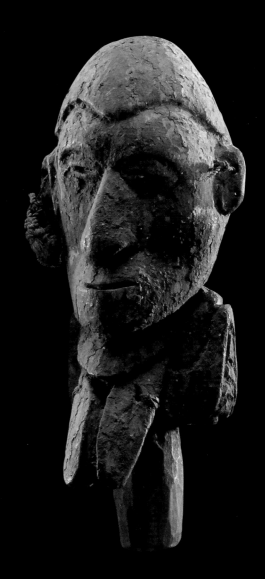

74
Pair of flute ornaments
Melanesia; Papua New Guinea; East
Sepik Province; Lower Sepik River
(Yuat River area)
19th century
Wood; fiber
Male: height 8¾ inches;
Female: height 7¾ inches
Valerie Franklin Collection

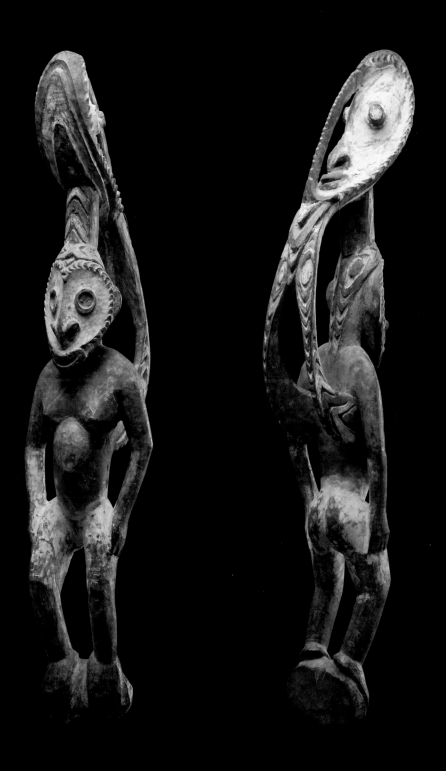

75
Flute ornament
Melanesia; Papua New Guinea; East
Sepik Province; Middle Sepik River
Iatmul people
First third of the 20th century
Wood; traces of red ochre, white,
and black pigments
24 × 5½ × 6 inches
Valerie Franklin Collection

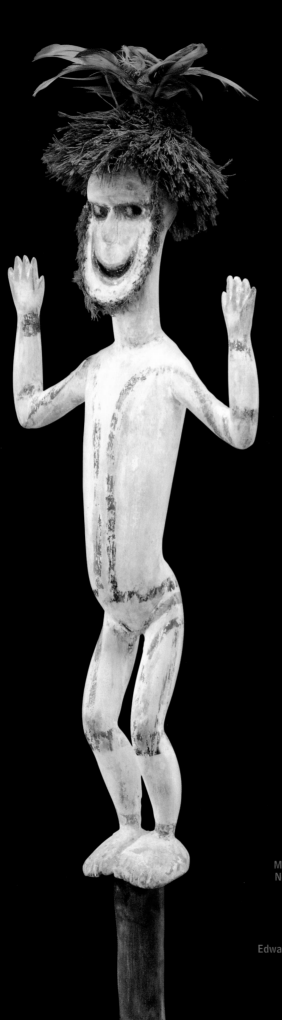

76
Dance staff
Melanesia; Papua New Guinea;
New Britain; Gazelle Peninsula
Tolai people
Late 19th–early 20th century
Wood; feathers; fiber; white,
red, and black pigments
Height 24 inches
Edward and Mina Smith Collection

77
Headdress (wenena gerua)
Melanesia; Papua New Guinea;
Central Highlands
Siane people
Pre-1950
Wood; red, blue, and yellow
pigments
$58\frac{1}{2} \times 14\frac{1}{2}$ inches
Edward and Mina Smith Collection

INSTRUMENTS OF WAR

Although the weapons of choice may differ, the purpose of warfare has not changed over the course of time. Ethnic, cultural, and religious differences; territorial disputes; and myriad other insults to a person, group, or country precipitate armed combat, which is designed to dispatch and kill opponents whenever the occasion demands. The people of Oceania were not the exception, and Western views of peace and prosperity in paradise were often grossly overstated. Peace was certainly preferable to war, but a group's very survival, as well as its prestige, honor, and status, were frequently at stake. The weapons created by man for death and destruction were often beautifully designed and decorated. It would seem that even at the moment of producing objects for killing, the desire for beauty and life somehow asserts itself as part of the human condition.

The arms and armor of Oceania consisted of clubs, spears, bows and arrows, daggers, shields, and body armor. Those produced for the rulers or leaders of particular cultures received the special attention of talented artists who went far beyond function to produce weapons that proclaimed the status and power of their owners to both friend and foe. Beautifully decorated shields are found throughout Melanesia, some with surfaces fully carved and painted with designs intended to instill fear and awe in the enemy and physically and spiritually protect the carrier. The handsome shield of great age and beauty from the Franklin collection (cat. 78) is from the upper Sepik River in Papua New Guinea and is but one example of the striking shields from the region. Its carver skillfully filled its convex surface with complex designs declaring the status of the owner. A second Papua New Guinea example (cat. 79) from the Ramu River is enhanced with a woven fiber wrapping. Shields of this type were carved in one small isolated area that had little continuing contact with Westerners until the late twentieth century, especially by one cultural group, the Kominimung.[75] The designs at the side of these shields are sometimes specific clan symbols and the central face an ancestor. The dominant color used is also determined by clan affiliation.

Oceanic clubs are also beautifully made and decorated. The extraordinary diversity and elegance of these lethal weapons illustrate the creative ability of Oceanic artists. Their use of pure line and form, often enhanced with incised and inlaid decoration, is exceptional. Melanesian and Polynesian clubs from the Solomons, Vanuatu, New Caledonia, Fiji, Tonga, Samoa, the Marquesas, and New Zealand are stylistically unique but united by function and aesthetic quality. The clubs of Oceania in fact often served several purposes: for use in warfare and dance, and as symbols of status and authority. The exhibition includes several examples that can only suggest the full range and beauty of these weapons. The "gunstock" club (*sali*) (cat. 80) from Fiji echoes the shape of an old musket. Its form is enhanced with incised geometric designs and ivory insets. The Tongan example (cat. 81) features a rounded, grooved, ivory and coral–inlaid head and shaft.

Weapons utilized by the Māori included short hand clubs (*patu*). Many clubs, which were collected early by Westerners, are carved from wood, but hand clubs were also crafted in greenstone, sandstone, and whale bone. Two handsome whale bone patu in the exhibition are especially noteworthy. The first club (*patu wahaika,* referring to the shape of the blade) (cat. 82) dates to the early nineteenth century and is from the east coast of the north island. The second eighteenth-century patu (cat. 83) is from the same area. Clubs of this superb quality symbolized high status and rank. They were treated as treasured heirlooms and were passed down from generation to generation. Hand clubs were also carried in dance and served as thrusting and jabbing instruments in warfare. The holes on the handle are for attaching some form of cord that would have encircled the wrist of the owner.

One of the most spectacular types of clubs from Polynesia is the Marquesan *uʻu.* Found in collections worldwide, they have received the attention and admiration of Westerners since the late nineteenth century. Uʻus were both highly effective weapons and symbols that proclaimed the high status and social position of their owners. The top of the club is a stylized human face, and the complete design incorporates small heads and geometric banding. At first glance all these clubs appear similar, but closer examination shows that subtle differences render each piece unique. The club from the Franklin collection (cat. 84) is one of the most beautiful uʻus in the world, its design combining exceptional balance, line, form, and technical mastery. The Marquesans excelled in tattooing, and the designs for clubs and the body show similarities. Some researchers believe that these designs may have been "owned" and could not have been copied by others. Alfred Gell suggests that the designs represent gods and served to protect the owner.[76] A second fine uʻu (cat. 85) demonstrates the subtle design differences between these clubs.

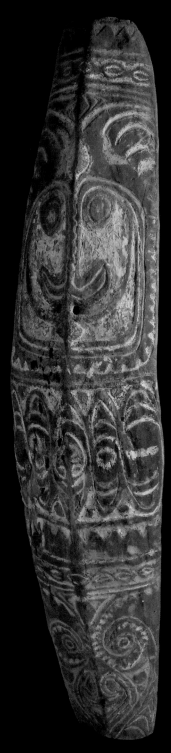

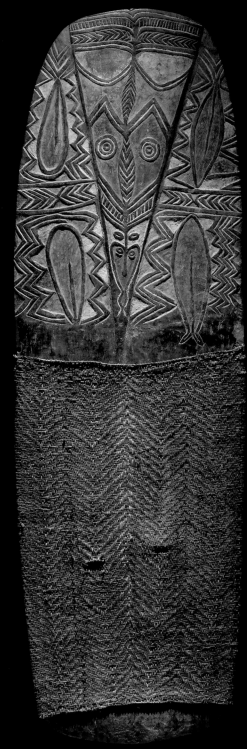

78
Shield
Melanesia; Papua New Guinea;
East Sepik Province;
Upper Sepik River / April River;
Hunstein Mountains
19th century
Wood; pigment
Height 54 inches
Valerie Franklin Collection

79
Shield
Melanesia; Papua New Guinea;
East Sepik Province; Ramu River
19th century
Wood; woven fiber wrapping;
red, yellow, and white pigments
Height 52 inches
Valerie Franklin Collection

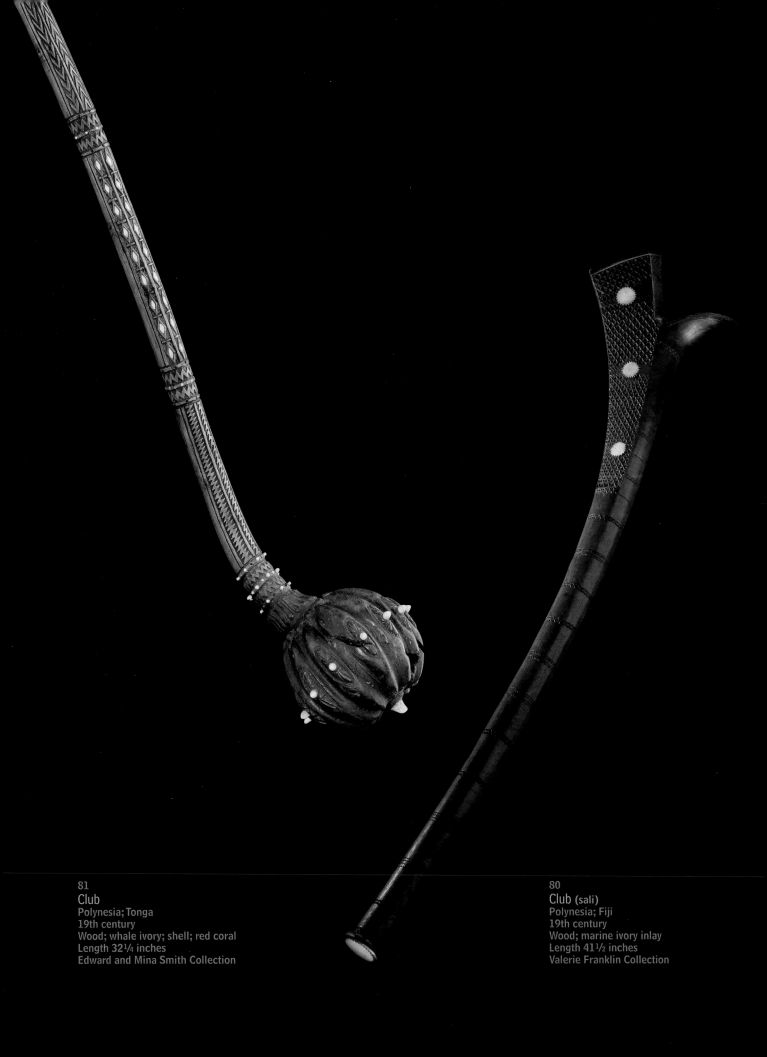

81
Club
Polynesia; Tonga
19th century
Wood; whale ivory; shell; red coral
Length 32¼ inches
Edward and Mina Smith Collection

80
Club (sali)
Polynesia; Fiji
19th century
Wood; marine ivory inlay
Length 41½ inches
Valerie Franklin Collection

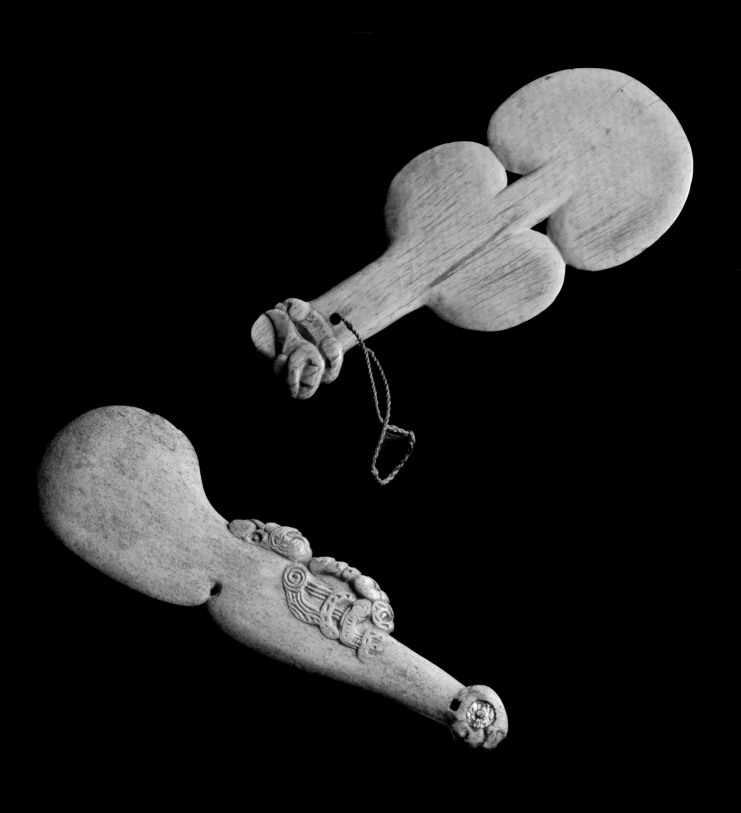

83
Club (patu)
Polynesia; New Zealand;
East Coast North Island
Māori people
18th century
Whalebone; mother-of-pearl
Length 14 inches
Valerie Franklin Collection

82
Club (patu wahaika)
Polynesia; New Zealand;
East Coast North Island
Māori people
Early 19th century
Whalebone
Length 13¼ inches
Valerie Franklin Collection

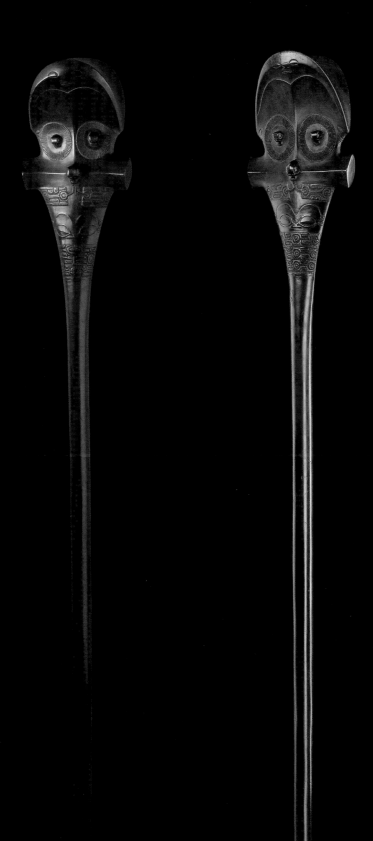

84
Club (u'u)
Polynesia; Marquesas Islands
18th–19th century
Wood
Height 56¼ inches
Valerie Franklin Collection

85
Club (u'u)
Polynesia; Marquesas Islands
18th–19th century
Wood
Height 57¼ inches
Edward and Mina Smith Collection

CANOES AND THEIR ORNAMENTATION

With the exception of mountainous areas, watercraft were essential to conducting all aspects of daily life in the Pacific. Whether large or small, propelled by the wind or paddled, boats were used to connect villages, conduct fishing, and facilitate trade. Stages of construction leading to the completion of a dugout canoe or the building of a large oceangoing outrigger were marked by ceremonies and rituals that indicated and celebrated the importance of watercraft to the community. Craft were named and the protective power of ancestors was evoked to assure the safety of their users. Prows took the form of crocodiles, cassowary (a large flightless bird similar to the ostrich), or other animal or plant life associated with particular clans. Throughout Oceania, watercraft were often lavishly decorated with beautifully carved and applied designs. Canoes in Polynesia are particularly striking, and those of the Māori are among the most beautiful.

Utilitarian canoes received relatively modest decoration, but even the smallest crafts were often decorated. Newton notes that canoes and sometimes paddles were so inbued with religious symbolism that even the most modest seemed invested with some aura of sanctity.[77] This paddle from the Franklin collection (cat. 86) is from Lake Sentani, West Papua. Elegantly painted, it must have been used in a ceremonial context.

Because collecting entire canoes, especially oceangoing craft, was virtually impossible, Western voyagers and collectors detached the most interesting decorative elements. For example, the canoe mask illustrated in cat. 87 would have been part of a larger prow ornament, such as that depicted in cat. 88, also from the Sepik River area. Each served a protective function. A prow ornament (*naho*) from Vanuatu (cat. 89) also played a protective role, but it proclaimed the high status of the canoe's owner as well. In Vanuatu, a man's importance was determined in part by what grade he had achieved in a ranking system (called the graded system or age grade system), which consisted of different ranks, titles, and types of ritual paraphernalia, dependent on geographic location. One such system, called Maki, is followed in small islands off the coast of northeast Malakula. While it only has two grades, it may take an individual twenty to thirty years to complete. The open mouth of the frigate bird on an ornament indicated that the owner had "made Maki." A closed mouth indicated that the owner had not yet participated in the graded system.[78] The fish (or shark) carved on the bird's back (see cat. 89) may be a clan symbol.

In the western Solomon Islands, the bow and stern of headhunting canoes could reach up to twelve feet in height, and canoes were elaborately decorated with inlaid patterns of mother-of-pearl, strings of large cowrie shells, and triangular pieces of giant clam shell. Figures such as the example from the Smith collection (cat. 90) were lashed at the bow just above the waterline of the craft and depicted a male head and arms with hands clasped and raised toward the chin, sometimes holding a head or bird. This ornament (*nguzunguzu*) incorporates inlaid shell lines that echo the painted facial patterns of men and women when adorned for ceremonies. The circular

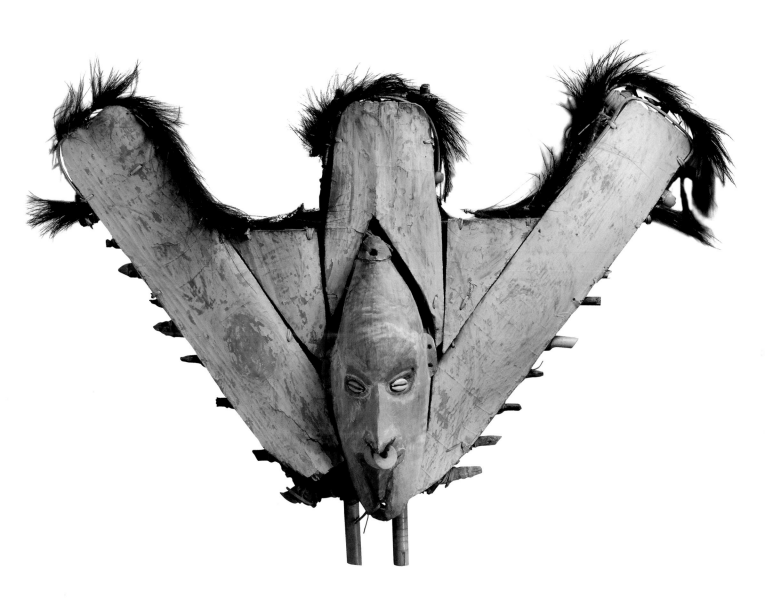

88
Canoe prow shield with mask
Melanesia; Papua New Guinea; East
Sepik Province; Middle Sepik River
Tambunum people
Late 19th–early 20th century
Wood; shell; bark; bamboo;
cassowary feathers; white and
traces of blue pigments
30 × 40½ × 6½ inches
Valerie Franklin Collection

discs represent ear ornaments. Symbolically, the figurehead depicted or embodied sea spirits that protected the occupants of the canoe. Birds may refer to navigation, and heads may signify successful headhunting.[79] A second, two-dimensional janus carving (cat. 91) is also said to be a canoe ornament, but the location it may have occupied on a canoe cannot be determined.

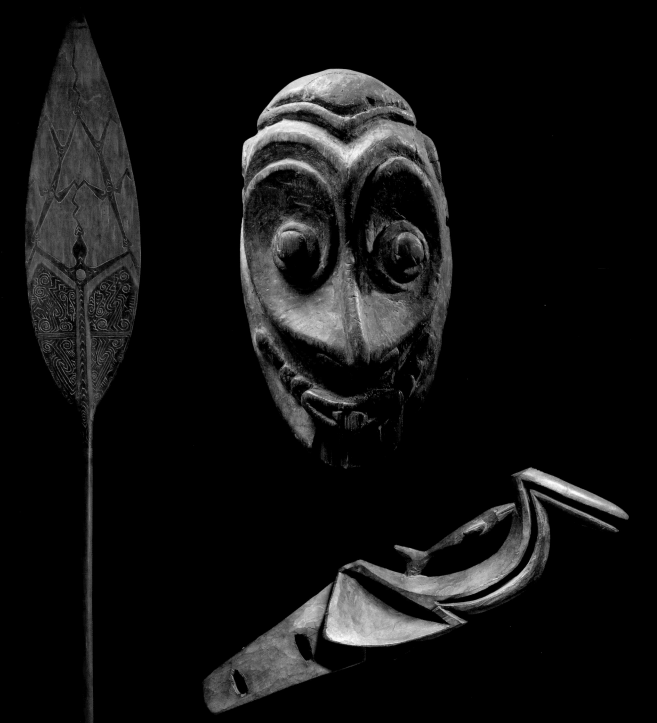

86
Ceremonial paddle
Melanesia; New Guinea; West
Papua; North Coast; Lake Sentani
Late 19th–early 20th century
Wood; black pigment
Length 80 inches
Valerie Franklin Collection

87
Canoe prow mask
Melanesia; Papua New Guinea;
East Sepik Province; Middle
Sepik River; Chambri Lake
19th century
Wood; white pigment
Height 13¼ inches
Valerie Franklin Collection

89
Canoe prow ornament
(naho)
Melanesia; Vanuatu
Late 19th century
Wood
12¾ × 25 × 7 inches
Valerie Franklin Collection

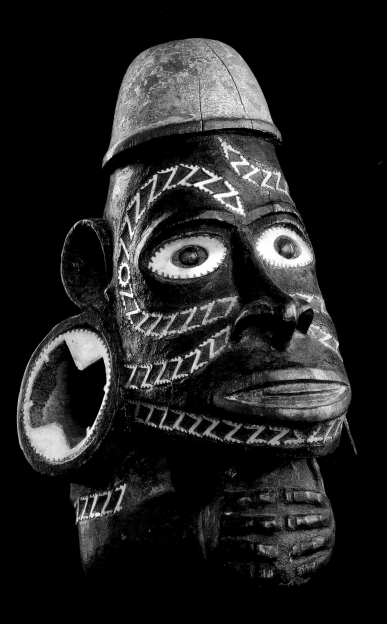

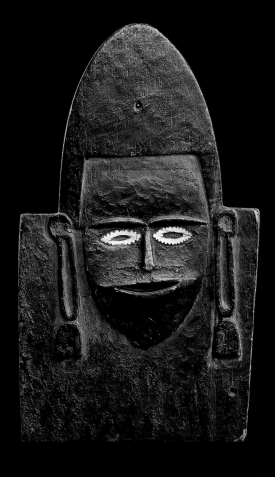

90
Canoe prow ornament
(nguzunguzu)
Melanesia; Papua New Guinea;
Solomon Islands; New Georgia Island
Early to mid-19th century
Wood; trade beads; shell;
red, yellow, and black pigments
Height 9 inches
Edward and Mina Smith Collection

91
Canoe ornament
Melanesia; Papua New Guinea;
Solomon Islands
19th century
Wood; shell
Height 10¼ inches
Edward and Mina Smith Collection

ARCHITECTURE AND DECORATION

Monumental stone platforms served as the foundation for temples on Hawai'i, Easter Island, Tahiti, and the Marquesas, and burial mounds in Tonga were faced with stone. But the construction material used in connection with all Oceanic architecture was organic, subject to decay, and needed continual replacement and refurbishment. Sometimes of fragile construction, sometimes built of sturdy wood, the structures for the most part reflect the ecology and climatic conditions of their respective geographic locations. Materials included wood, palm leaves and spathe, vines, bamboo, and other grasses. Men's houses, other communal structures, and the residences of the most prominent and powerful members of a particular culture were not only the most dominant and impressive structures in a community, they were also the most beautiful. Men's houses along the Sepik River, Papua New Guinea, were among the most impressive in Melanesia. Raised high on beautifully carved wooden posts, these massive edifices were virtual museums that housed a group's most valued cultural treasures. Carved posts, free-standing figures, orator's stools, slit gongs, masks (see cat. 92), figurated hooks, and sacred flutes embellished and protected both structure and inhabitants while making reference to the status and history of the community.

The indigenous people of Taiwan used a variety of materials to construct houses, including stone, wood, brush, bamboo, and adobe. There is no information regarding the exact placement of the Smith carved wall panel (cat. 93) within a structure, but carved architectural planks were used as doorjambs, posts, lintels, walls, and wooden screens in important structures, especially among the Paiwan people. For the Paiwan, carved heads represented ancestors or headhunting trophies. This piece, however, is said to be Yami (a group of people living on the island of Botel Tobago off the southeast coast of Taiwan). Yami houses are partitioned into rooms using planked walls, making this attribution possible.

Life-sized figures, both male (see cat. 94) and female, would have stood on either side of the doorway to men's ceremonial houses in the Admiralty Islands. Very few sculptures have survived, but a similar figure is in the collection of the Fowler Museum at UCLA.[80] Documentation states that the UCLA figure represents "the illustrious dead," but it had no spiritual meaning. Its original purpose could have been protective as well as decorative. It is listed as either Usiai or Mantankol in origin, and the artist responsible for the sculpture in the UCLA collection and the Smith piece is likely the same.

Traditional Kanak great houses in New Caledonia were embellished with impressive carved doorjambs and roof finials (see cat. 95), as well as carved interior posts and beams. The structure itself was circular in form, and the roof finial projected above the center of the cone-shaped roof. Finials vary somewhat in form, depending on region. All finials represent ancestors: the lower section represents the stomach and thorax with the neck and head extending above. Tritons (shell trumpets), which are missing from the Franklin piece, would have been threaded on the spire at the top of the head. The tritons represented the shells blown by the elders to summon villagers.

108

But in all of Oceania, it was the Māori of New Zealand who constructed and embellished buildings that are arguably among the most impressive wooden structures in the non-Western world. The finest examples were lavishly carved with both low- and high-relief designs and three-dimensional figures. Māori architecture consisted of storehouses, which ranged in size from boxlike structures raised on a single pole to more elaborate houses raised on four or more poles. These structures were used to store special foods and other valuables subject to theft. Hereditary chiefs and their immediate families lived in elaborately carved houses that also served as meeting places and guest housing, proclaiming the owners' status in the community as well as to visiting dignitaries.

Carvings depict humanlike figures and a motif called manaia. Humanlike figures are generally referred to as tiki and represent ancestors, gods, or other spirits. Manaia are beings with birdlike heads attached to bodies with arms and legs. Parts may also appear as separate motifs, such as the beak alone. The most common Māori motif is a tiki-manaia combination. Tikis were vehicles for gods and other supernatural beings as well as the abode of ancestral spirits. In the past, every figure had a name and could sometimes be identified by tattoo patterns. Figures are both male and female.

Masks and figures called *teko teko* were placed on buildings at the peak of the roof between the gable ends. They appeared on all types of structures and represented the ancestors of the building's owner. Two teko teko are in the exhibition. On the striking male figure (cat. 96), an arm and hand have been lost, but the remaining hand is in the form of a manaia claw. A second impressive and important teko teko (cat. 97) depicts a single figure standing on the heads of an embracing couple. They in turn surmount a downturned head whose face is also expertly carved. The standing figure is likely an ancestor of power and prestige, and the embracing couple are a reference to fecundity and fertility or the merging of two lineages. This especially elaborate sculpture also combines ancestral images with the birdlike claws of the manaia. Its spiritual and protective qualities would most certainly have instilled fear, respect, and awe in those who saw it.

Three-dimensional architectural elements have been more widely collected than two-dimensional carvings like the one from the Smith collection (cat. 98). This historically important and elegant fragment was located at the end, or *raparapa,* of a façade board (*maihi*). The house that it graced was photographed in 1863, and its specific provenance is therefore not only known, but visually documented. The meeting house was that of King Tāwhiao, the Māori monarch between 1860 and 1895, an extremely important figure in Māori and New Zealand history. Executed with steel tools, the fragment dates to between 1840 and 1860. Figures and abstract patterns interface with an elliptical eye and mouth set above a large openwork spiral. Māori works are clearly representative of the great skill and artistic creativity of talented artists who worked in traditional contexts, and today's Māori artists perpetuate the extraordinary talents of their ancestors.[81]

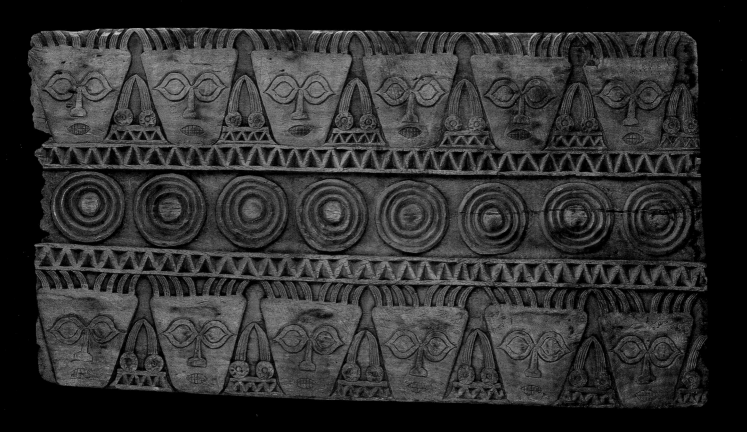

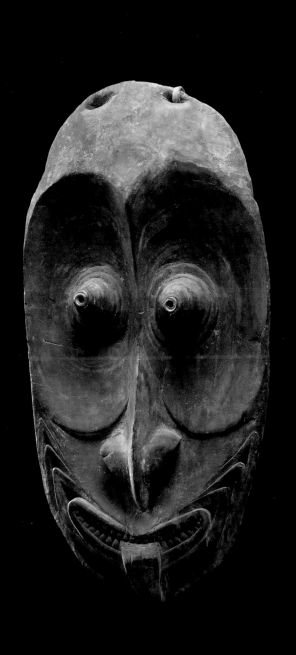

92
Gable mask
Melanesia; Papua New Guinea;
East Sepik Province; Middle
Sepik River; Chambri Lake
19th century
Wood; traces of pigment; shell
$25\frac{3}{4} \times 13\frac{1}{4} \times 3\frac{1}{4}$ inches
Valerie Franklin Collection

95
Roof finial
Melanesia; New Caledonia
19th century
Wood
Height 83 inches
Valerie Franklin Collection

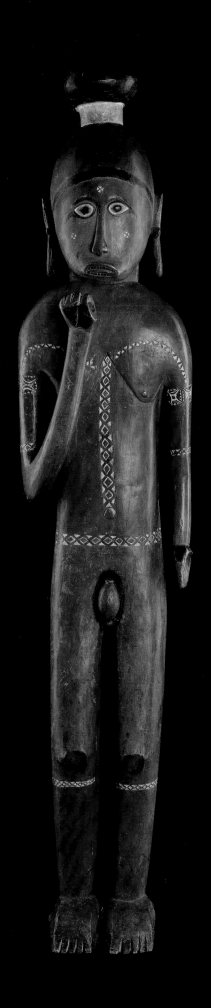

94
Male figure
Melanesia; Papua New Guinea;
Admiralty Islands
Late 19th–early 20th century
Wood; red and black pigments; lime
Height 58¼ inches
Edward and Mina Smith Collection

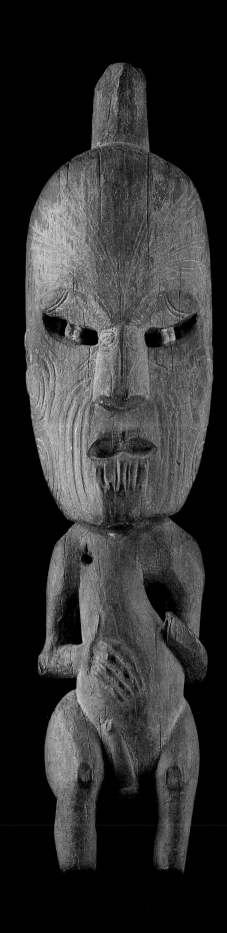

96
Roof gable ornament (teko teko)
Polynesia; New Zealand
Māori people
Early 19th century
Wood; pigment
Height 18 inches
Edward and Mina Smith Collection

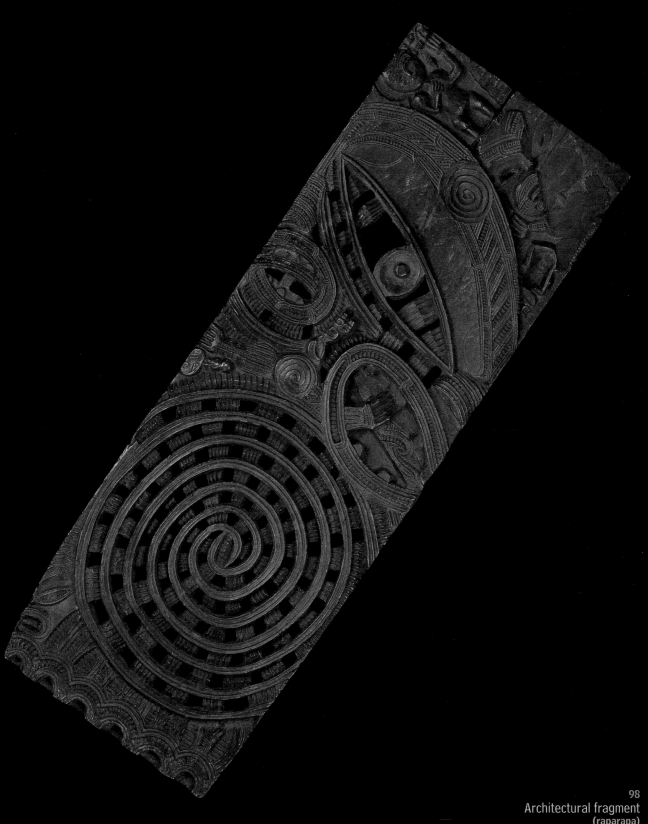

98
Architectural fragment
(raparapa)
Polynesia; New Zealand;
North Island; Ngaruawahia
Māori people; Waikato tribe
1840–60 from King Tāwhiao
meeting house
Wood
Length 64 inches
Edward and Mina Smith Collection

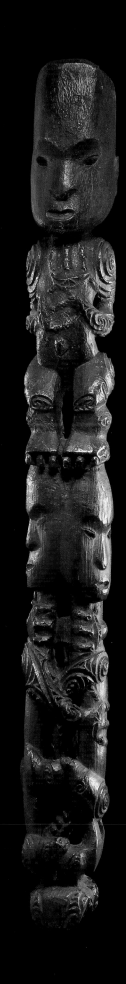

97
Roof gable ornament
(teko teko)
Polynesia; New Zealand
Māori people; Arawa tribe
18th century
Wood; obsidian; pigment
37 × 4 × 3¼ inches
Valerie Franklin Collection

EPILOGUE

Vast areas of Oceania were greatly damaged or compromised in the nineteenth and twentieth centuries, damage that continues unabated in the twenty-first century. Native forests have been overlogged, indigenous flora and fauna lost forever, and fisheries severely depleted. In recent years, another serious threat has been recognized. An ever-increasing chorus of scientists has issued warnings about global warming and its potential consequences for life and the environment. Skeptics initially dismissed these concerns, stating that the science was not "good" or that scientific observations were merely part of normal cyclical weather patterns and variations. Today, however, there is a general consensus that human activities are an important culprit, and scientists have determined that serious reduction of greenhouse emissions is imperative in order to sustain air quality even at its current unsatisfactory pollution levels. It seems likely that the situation will deteriorate further and at a more rapid rate.

This will, of course, impact the entire world, but for many people and cultures in Oceania, its consequences may be greater and come sooner. As temperatures and sea levels rise, creatures of both the land and sea will be affected. In combination with water degradation, these changes will compromise, if not destroy, a way of life for all people living along the shores of Pacific islands, and for those living on low-lying atolls and islands, rising sea levels will literally erase them from the map.

For its people, the varied and sometimes harsh environments of Oceania inspired both respect and fear for a natural world where nature and religion were inseparable. Belief systems reflected a desire to accommodate environmental forces, in contrast to a Western proclivity to impose its will to overpower and ravish them. Islanders controlled and sustained their natural resources utilizing various cultural practices that were validated by social and religious structures.

Nature provided all the materials used by Oceanic artists. Melanesian flora and fauna offered the artist greater choices, but the artists of both Polynesia and Micronesia also harvested the products of land and sea for artistic purposes. Some materials were localized, examples being the greenstone used by the Māori or whale ivory used in Hawai'i, Fiji, and Tonga. Valued ocean shells were often localized, and the funerary sculpture of the Asmat could only have been created in an environment that produced large trees with an exaggerated buttress system. Obsidian-bladed spears and daggers are found only in the Admiralties and on Easter Island, and the spectacular feather capes of Hawai'i could not have been made elsewhere. It would be a mistake, however, to assume that natural materials indigenous to one location were only used there. Trade occurred throughout Oceania, and highly valued materials were often exchanged, sometimes over great distances. Locally available materials were not always utilized, however, and the absence of three-dimensional sculptures in the highlands of New Guinea did not mean that wood was not available.

While artists were often restricted to the use of local materials, what was utilized was also determined by the social and spiritual values of the community. For instance, some animals and plants were symbolic of and the property of particular clans, and still others could only be used by high-ranking members of society.

Restrictions, however, did little to hamper the inventive and highly creative use of natural products for the creation of powerful and beautiful art forms in all areas of the Pacific. Materials included wood; stone; ivory; clay; bark cloth; sennit; bone; feathers; exotic plants; the skins and fur of animals; shells; palm spathe and other tree parts; fruits; various grasses; gourds; and the teeth, skeletal parts, and hair of humans, other mammals, and fish. Prior to the import of artificial pigments, paints were obtained from clay. This source produced yellow, rust, white, and various shades of ochre. Black was produced from charcoal, white from shells, and some dyes were made from plants. Nature was, in fact, the spiritual and material source for a way of life that is increasingly under siege.

The Bishop Museum in Honolulu and the South Pacific Regional Environment Programme

116

recently received a grant from the John D. and Catherine T. MacArthur Foundation to assess the vulnerability of island ecosystems in Melanesia in the face of projected climate changes. This study will determine the projected impacts of weather change on biodiversity and the ability of all Melanesian countries to deal with possible institutional and socioeconomic impacts. This project is very timely, because in 2005 the Papua New Guinea government began a permanent evacuation of the Kilinailau Islands, east of New Guinea, possibly the first people to be directly threatened by climate change. Scientists feel that these islands will be totally submerged by 2015. Two uninhabited islands in Kiribati have already disappeared under the waves.

The nations of Melanesia will be among the first in the world to be seriously impacted, affecting an extraordinary area that is, as we have seen, not only culturally rich but among the most biologically diverse in the world. The traditional arts of past centuries have already disappeared, and the prospect of eventual complete ecological collapse is now within the realm of possibility, displacing people and cultures.

This issue is extremely complex, and in recent years it has been the subject of books, articles, documentaries, and widespread media exposure. Suffice it to say that the destruction of Oceanic ecological systems, which was begun by Westerners in the nineteenth century, has been greatly expanded and accelerated in the twentieth and twenty-first centuries. Traditional cultures are seriously challenged to survive changes that are rapidly creating an exceptionally uniform and bland world that has lost the beauty and originality of unique people and cultures whose belief systems, language, music, and stories are celebrated through their arts.

Earlier in this book the first collecting of Oceanic art by Westerners was briefly touched upon, and ongoing collecting has continued in limited locations, especially in Melanesia. A high percentage of traditional Oceanic art is now in Western museums, primarily in Europe and the United States. In Oceania, large museums exist in Hawai'i, New Zealand, and Australia. The National Museum

of Papua New Guinea houses significant collections of art from the region, and smaller museums and cultural centers are found in other locations, including Vanuatu, Fiji, Guam, New Caledonia, American and Western Samoa, the Cook Islands, Tonga, Tahiti, the Solomons, and Palau. There are a growing number of Melanesian, Micronesian, and Polynesian academics and museum personnel who are playing a much greater role in Pacific-based institutions, preserving the visual arts in museums and cultural centers and recording oral histories, music, dance, and myths. In addition, attempts are being made to revive and to reinvent, when necessary, important ceremonies, dance, and protocols that have been lost.

A number of organizations dedicated to the study, perpetuation, and preservation of Oceanic arts have been established. The Pacific Arts Association (PAA) was officially launched in 1974 when its first symposium was held in Canada. Membership includes academics, museum curators and directors, gallery owners, and collectors from the United States and Europe, as well as Oceania. All members have a strong interest, respect, and admiration for the people and the arts of the Pacific. For thirty-five years this organization has been the primary professional body promoting and publishing scholarship related to the region. PAA distributes a newsletter and has held ten international symposiums since its founding where attendees from the West and Oceania present papers relevant to the theme of each gathering.[82] These papers were subsequently published and represent a good overview of past and current research as well as future directions and matters of concern and interest in the field.[83] The officers of this all-volunteer group are drawn from the general membership, and its president has traditionally been a Pacific Islander. In 1997, a European branch of PAA was formed in Basel, and this group has subsequently met on a number of occasions.

In 1999, the Pacific Islands Museum Association (PIMA) was officially incorporated in Fiji. Membership includes personnel from museums and cultural centers throughout the Pacific. This organization

117

is publishing a newsletter and conducting programs of specific interest to its members. A recent workshop subject was "Designing Museums for the Pacific," which addressed the issues of climate control, insects, mold, and cyclones, all perennial problems in the tropics. PIMA has been meeting in Vanuatu. The aims of the association include the promotion of liaison and coordination among Pacific museums, the presentation of training programs, fundraising, and the formation of international relationships. Their hope is to play a significant role in preserving the material proofs of their history and culture for future generations, to seek repatriation of selected works from Western museums, to conduct research, and to train indigenous people.[84] In 1988, the American Association of Museums formed the Asian, Asian American, Pacific Island Interest Group. (In 1995, the name was changed to the Asian, Asian American, and Pacific American Interest Committee.)

The primary focus of these organizations is the traditional arts of Oceania, both visual and performing, and one consequence of their activities has been increased pride and respect among Oceanic people for their respective heritages. One example of this renewed pride is the Festival of Pacific Arts, a gathering of visual and performing artists from many countries and territories in Oceania, where indigenous people perform and interact with their neighbors in the region. Festivals have been held in a number of Pacific locations.[85] The tenth festival was held in American Samoa in the summer of 2008, attracting more than 2,500 participants from twenty-seven countries.

While efforts by both Westerners and native Pacific Islanders to record, preserve, and revitalize the traditional arts are ongoing, artists schooled in the methods and materials of contemporary Western art now direct their creative efforts to an international audience. Often trained in art schools and universities, these artists show their work in galleries and museums in Oceania, Asia, and the Western world. Excellent work is being created in New Zealand, Hawai'i, and in more limited contexts elsewhere. Although not officially a part of Oceania,

Australia has for decades preserved and promoted the work of Aborigine artists who have achieved international acclaim and recognition. Highly accomplished contemporary performing artists and writers have joined their ranks, and the future seems bright. A great percentage of this "new" art is both formally and spiritually based on the traditional arts of the ancestors of today's people. It does not, however, merely replicate former artistic creativity and genius; it draws inspiration and strength from the past while forging future directions.

Preservation and revival of the traditional arts are central to this effort, but the arts are never static in any culture. Their form, context, and function change over time to meet new needs, demands, and circumstances. In this exceptionally diverse region, change occurs at a pace dependent on local circumstances. What seems clear, however, is that the people of the Pacific are determined and dedicated to the continuance of artistic excellence.

The powerful and beautiful arts presented in this exhibition, and the natural world that has inspired and nurtured them, represent a way of life that can, in fact, never be the same. This exhibition is, however, a celebration of the essential unity of all humankind, for we all share the same basic concerns regarding life on this earth. These matters are expressed in the arts of all cultures in different but complementary ways.

NOTES

1. First proposed by the French explorer Jules-Sébastien-César Dumont d'Urville (1790–1842) in 1832, "Micronesia" refers to small (micro-) islands, "Polynesia" to many (poly-) islands, and "Melanesia" to the dark skin pigmentation (mela-) of its people.

2. In New Guinea alone, a single category of endemic species (mammals) includes four that are critically endangered, nine that are endangered, and seventeen that are vulnerable. For more information, see www.animalinfo.org.

3. Fiji is culturally linked to Melanesia, but its art is closer to that of its Polynesian neighbors.

4. For more information, see the U.S. Department of State listings on their website, www.state.gov.

5. Tom Huth, "Voyage of the Dim-Dims," *Condé Nast Traveler*, January 2008, 110.

6. An excellent source for the most current and comprehensive information and theories regarding the settlement and discovery of the Pacific is K. R. Howe, ed., *Vaka Moana: Voyages of the Ancestors—The Discovery and Settlement of the Pacific* (Auckland, New Zealand: David Bateman, 2006).

7. The dates for the settlement of Polynesia are still in flux, and there is no complete agreement among contemporary scholars. The chronology listed here is from Geoffrey Irwin, "Voyaging and Settlement" in Howe, *Vaka Moana*, sec. 3.

8. Two types of greenstone are found in New Zealand: nephrite and jadeite. Although different in chemical composition and crystalline structure, they are sometimes hard to differentiate after they have been worked and polished.

9. Gregory Hodgins, Philippe Peltier, Dirk Smidt, and Robert L. Welsch, *New Guinea Art: Masterpieces of the Jolika Collection of Marcia and John Friede* (San Francisco: de Young Museum, 2005), 2:74.

10. Christian Kaufmann, *Korewori: Magic Art from the Rain Forest*, trans. Robert Williamson (Honolulu: University of Hawai'i Press; Belair, Australia: Crawford House, 2003), 27.

11. Dirk Smidt, "Major Themes in New Guinea Art," in Hodgins et al., *New Guinea Art*, 2:31.

12. Exhibitions featured Lake Sentani art in 1959–60, Papuan Gulf art in 1961, Asmat art in 1962, and art from the upper Sepik River in 1969.

13. Robert Welsch, "Introduction: Changing Themes in the Study of Pacific Art," in *Pacific Art: Persistence, Change, and Meaning*, ed. Anita Herle et al. (Honolulu: University of Hawai'i Press, 2002), 1.

14. The theme of a recent Pacific Arts Association symposium, held in Paris in 2007, was "exhibition research and relationships." Past and present philosophies and approaches to the display of contemporary and historic Oceanic art were discussed, and papers presented topics that included the challenges facing cultural leaders, artists, researchers, and curators; architecture and design's role in display; the incorporation of research results into public museum and cultural center displays; the role and voice of source communities in the display of Pacific art; the relationship of anthropological, artistic, and art historical approaches in interpreting and displaying this art; and the role of contemporary Pacific and non-native contemporary art in displays of art of the region.

15. For a complete description of these ceremonies, see Douglas Newton, *Crocodile and Cassowary: Religious Art of the Upper Sepik River, New Guinea* (New York: Museum of Primitive Art, 1971), 84–90.

16. An example of a bag used to carry amulets can be seen in Hodgins et al., *New Guinea Art*, 2:89, fig. 42.

17. Allen Wardwell, *Island Ancestors: Oceanic Art from the Masco Collection* (Seattle: University of Washington Press, in association with the Detroit Institute of Arts, 1994), 38, fig. 42.

18. A related sculpture in the May Collection at the Saint Louis Art Museum has retained more of its surface paint, but the exceptional Franklin carving is one of the finest Abelam works in private hands. See Lee Allen Parsons, *Ritual Arts of the South Seas: The Morton D. May Collection* (St. Louis: City Art Museum of St. Louis, 1975), 118, pl. 117.

19. The best source of information dealing with this area is Kaufmann, *Korewori*.

20. Compare a similar figure in the collection of the St. Louis Art Museum, illustrated in Parsons, *Ritual Arts of the South Seas*, 83, fig. 74.

21. Kaufmann, *Korewori*, 53–57.

22. Ibid., 27.

23. The boards are called *gope, kwoi, kaiaimunu, hohao,* or *bioma,* depending on their geographic origin.

24. It was believed that trophy and ancestral skulls retained the power and spirit of the deceased, which were directed to the welfare of the living.

25. For excellent sources of information on Papuan Gulf cultures, see Jacquelyn Lewis-Harris, "Art of the Papuan Gulf," *St. Louis Art Museum Bulletin*, Winter 1966; and Robert L. Welsch, Virginia-Lee Webb, and Sebastine Haraha, *Coaxing the Spirits to Dance: Art and Society in the Papuan Gulf of New Guinea* (Hanover, N.H.: Hood Museum of Art, Dartmouth College, 2006).

26. For a detailed ethnographic report dealing with the Admiralty Islands, see Sylvia Ohnemus et al., *An Ethnology of the Admiralty Islanders: The Alfred Bühler Collection, Museum der Kulturen, Basel* (Honolulu: University of Hawai'i Press, 1998).

27. For excellent accounts of New Ireland art, see Michael Gunn and Philippe Peltier, eds., *New Ireland: Art of the South Pacific* (Paris: Musée du Quai Branly; Milan: 5 Continents, 2006), and Louise Lincoln, *Assemblage of Spirits: Idea and Image in New Ireland* (New York: G. Braziller, in association with the Minneapolis Institute of Arts, 1987).

28. Parsons, *Ritual Arts of the South Seas*, 165, pl. 193.

29. Deborah Waite, *Art of the Solomon Islands: From the Collection of the Barbier-Mueller Museum* (Geneva: Barbier-Mueller Museum, 1983), 120.

30. Steven Phelps, *Art and Artifacts of the Pacific, Africa, and the Americas: The James Hooper Collection* (London: Hutchinson, 1976), 178; 186, pl. 99.

31. See Roger Rose, "On the Origin and Diversity of the 'Tahitian' Janiform Fly Whisks," in *Exploring the Art of Oceania: Australia, Melanesia, Micronesia, and Polynesia*, ed. S. M. Mead (Honolulu: University of Hawai'i Press), 202–23.

32. Roger Rose and Douglas Newton have documented the Smith whisk in unpublished reports. It is similar to one in the Masco Collection and one in the British Museum; see Wardwell, *Island Ancestors*, 198–99.

33. This piece is illustrated in Steven Hooper, *Pacific Encounters: Art and Divinity in Polynesia, 1760–1860* (London: The British Museum Press, 2006), 224, no. 195.

34. Douglas Newton has documented this piece in an unpublished report.

35. A good overview of Marquesan art is provided in Eric Kjellgren and Carol S. Ivory, *Adorning the World: Art of the Marquesas Islands* (New York: Metropolitan Museum of Art; New Haven, Conn.: Yale University Press, 2005).

36. A good synopsis of Easter Island art is included in Eric Kjellgren, *Splendid Isolation: Art of Easter Island* (New York: Metropolitan Museum of Art, 2001).

37. Among the earliest and most popular accounts of Easter Island art is *L'Île de Pâques et ses Mystères* by the Parisian collector Stéphen-Charles Chauvet (Paris: Éditions "Tel," 1935). Chauvet illustrated the work as figure 150. Another work in the same volume belonged to the French writer and artist Pierre Loti, who obtained it from Easter Island in 1872. This same Loti piece is pictured in Kjellgren, *Splendid Isolation* (p. 47, fig. 6) and is equally enigmatic. Although related in spirit, its form differs substantially.

38. Three related figures are illustrated in Kjellgren, *Splendid Isolation*, 57, 58; figs. 21, 22, and 23. All are in the collection of the Peabody Essex Museum in Salem, Massachusetts.

39. Surrealism was created in the early 1920s by a group of French writers and poets. Their philosophy included the belief that dreams are an important part of one's life, that the unconscious mind plays an important role in the creative process, and that myth was needed in one's life. As revealed in dreams and dream symbolism, they sought to follow these beliefs in their creation of literary and visual arts.

40. For an excellent overview of Hawai'ian sculpture, see J. Halley Cox and William Davenport, *Hawai'ian Sculpture*, 2nd ed. (Honolulu: University of Hawai'i Press, 1988). This piece is illustrated on page 198 (K 52).

41. Bernard De Grunne, "Beauty in Abstraction: The Barbier-Mueller Nuku'oro Statue," in *Tribal Art* (Geneva: Musée Barbier-Mueller, 1994). This article was written prior to the discovery of the Smith piece, but it does provide a good overview of what was known about Nuku'oro figures at the time. Douglas Newton has written an unpublished report dealing with this figure, and Roger Neich has written a report that was recently published as "A Recently Revealed Tino Aitu Figure from Nuku'oro Island, Caroline Islands, Micronesia," *Tribal Art* 12, no. 47 (Winter 2007): 136–41.

42. Roger Neich and Mark Pendergrast discuss and illustrate several of these masks in *Pacific Tapa* (Auckland, New Zealand: D. Bateman; Auckland Museum, 1997), 80–81.

43. The architectural masks of the Caroline Islands and New Zealand were not worn.

44. See Hodgins et al., *New Guinea Art*, 2:109.

45. A similar mask is illustrated in Hodgins et al., *New Guinea Art*, 121, no. 240. Most mwai masks encrusted with nassa shells are attributed to the Iatmul people. This mask is attributed to the Sawos people, and like the Franklin piece is devoid of shells. The Franklin piece may also be Sawos.

46. Ingrid Heermann, *Form Colour Inspiration: Oceanic Art from New Britain* (Stuttgart: Arnoldsche, 2001), 57, fig. 15.

47. See Joël Bonnemaison et al., eds., *Arts of Vanuatu* (Honolulu: University of Hawai'i Press, 1996), 24–25. Another in the May Collection at the Saint Louis Art Museum is stylistically similar and is attributed to Ambryn.

48. The information accompanying the Franklin mask states that it is from Vao or Rano Island, near Malakula.

49. For comparison and a discussion of iconography, see Eric Kjellgren, *Oceania: Art of the Pacific Islands in the Metropolitan Museum of Art* (New York: Metropolitan Museum of Art; New Haven, Conn.: Yale University Press, 2007), 188, 189.

50. John McKesson, "In Search of the Origins of the New Caledonia Mask," in *Art and Identity in Oceania*, ed. Allan Hanson and Louise Hanson (Honolulu: University of Hawai'i Press, 1990), quoted in Wardell, *Island Ancestors*, 154. Adapted from Maurice Leenhardt, "Le masque et le mythe en Nouvelle-Calédonie," *Études Mélanésiennes*, no. 8 (1954): 9–20.

51. For an excellent overview of Oceanic tapa, see Neich and Pendergrast, *Pacific Tapa*.

52. For an insightful overview of this topic, see Roger Neich and Fuli Pereira, *Pacific Jewelry and Adornment* (Honolulu: University of Hawai'i Press, 2004).

53. *Manaia* have a male or female human body with a birdlike head. They appear frequently in wood carvings.

54. Haliotis, a type of univalve shell, is an important source of mother-of-pearl.

55. These figures have been widely published and illustrated. For a general overview, see Keith St. Cartmail, *The Art of Tonga* (Honolulu: University of Hawai'i Press, 1997).

56. Lime in combination with betel nuts and pepper leaves was widely chewed in Melanesia and Micronesia, producing a mild narcotic effect.

57. Pandanus is a tree or bush with long, tough, prickly leaves that were also used for thatch.

58. See Hooper, *Pacific Encounters*, 258.

59. For a good source of information on Santa Cruz sculpture, see William H. Davenport, *Santa Cruz Island Figure Sculpture and Its Social and Ritual Contexts* (Philadelphia: University of Pennsylvania Museum of Archaeology and Anthropology, 2005).

60. Ibid. Davenport does not include this piece in his listing of sculpture.

61. Te Rangi Hīroa and Peter H. Buck, *Arts and Crafts of Hawai'i* (Honolulu: Bishop Museum Press, 2003), 58–60.

62. Kjellgren and Ivory, *Adorning the World*, 108–10.

63. Sago "flour" is obtained from the pith of the sago palm and is prepared in a variety of ways.

64. Douglas Newton, ed., *Arts of the South Seas: Island Southeast Asia, Melanesia, Polynesia, Micronesia—The Collections of the Musée Barbier-Mueller* (Munich and New York: Prestel, 1999), 181.

65. For illustrations of other examples, see Douglas Newton, *The Art of Lake Sentani*, trans. G. E. van Baaren-Pape (New York: Museum of Primitive Art, 1959).

66. Kava is made by mixing the crushed and masticated kava root with water. As with betel nut chewing, it has a mild narcotic effect.

67. Adrienne L. Kaeppler, *From the Stone Age to the Space Age in Two Hundred Years: Tongan Art and Society on the Eve of the Millennium* (Tonga: Tongan National Museum, 1999), 19–20.

68. See Fergus Clunie, "Fiji," in Newton, *Arts of the South Seas*, 314.

69. For an overview of Ifugao arts and a figurated priest's box, see George R. Ellis, *The People and Art of the Philippines* (Los Angeles: Museum of Cultural History, University of California Los Angeles, 1981), 251, pl. 255.

70. C. Schmid, "Catalogue," in Suzanne Greub, *Art of the Sepik River: Authority and Ornament, Papua New Guinea* (Basel: Tribal Art Centre, Edition Greub, 1985), 177–210, quoted in Wardwell, *Island Ancestors*, 72.

71. This drum shares some characteristics with one depicted on p. 49 of Suzanne Greub, ed., *Art of Northwest New Guinea: From Geelvink Bay, Humboldt Bay, and Lake Sentani* (New York: Rizzoli, 1992), which was collected on the neighboring island of Sowek. Both Yapen and Sowek are located in Geelvink Bay in New Guinea.

72. See Allen Wardwell, *The Art of the Sepik River* (Chicago: Art Institute of Chicago, 1971), 13.

73. A stylistically related but less eroded example is pictured in Hodgins et al., *New Guinea Art*, 2:122, fig. 122, where it is attributed to the Sawos people.

74. Wardwell discusses a similar work in *Island Ancestors*, 86, fig. 28.

75. See Dirk Smidt, "Kominimung Shields," in *Art and Artists in Oceania*, ed. Sidney M. Mead and Bernie Kernot (Wellington, New Zealand: Dunmore Press; Mill Valley, Calif.: Ethnographic Arts Publications, 1983), 137.

76. Alfred Gell, *Art and Legacy: An Anthropology Theory* (Oxford, England: Clarendon Press; Oxford and New York: Oxford University Press, 1998), 191. For a good overview of Marquesan art, see Kjellgren and Ivory, *Adorning the World*.

77. See Newton, *Crocodile and Cassowary*, 11.

78. In Kirk Huffman, "Vanuatu," in Newton, *The Arts of the South Seas*, 290.

79. Deborah Waite, "*Mon* Canoes of the Western Solomon Islands," in Hanson and Hanson, *Art and Identity in Oceania*, 44.

80. See Ralph Altman, *Masterpieces from the Sir Henry Wellcome Collection at UCLA* (Los Angeles: University of California, Los Angeles, 1966), 154, 155.

81. A good overview of Māori art can be found in Terrence Barrow, *An Illustrated Guide to Māori Art* (Honolulu: University of Hawai'i Press, 1984).

82. Ontario, Canada, 1974; Wellington, New Zealand, 1978; New York, 1984; Honolulu, 1989; Adelaide, Australia, 1993; Chicago, 1999; New Caledonia, 2001; Christchurch, New Zealand, 2003; Salem, Massachusetts, 2005; and Paris, 2007.

83. Mead, *Exploring the Visual Art of Oceania;* Mead and Kernot, *Art and Artists of Oceania;* Hanson and Hanson, *Art and Identity in Oceania;* Philip J. C. Dark and Roger G. Rose, eds., *Artistic Heritage in a Changing Pacific* (Honolulu: University of Hawai'i Press, 1993); Barry Craig, Bernie Kernot, and Christopher Anderson, eds., *Art and Performance in Oceania* (Honolulu: University of Hawai'i Press, 1999); Herle, *Pacific Art.*

84. PIMA has recently merged with ICOMOS Pasifika (International Council on Monuments and Sites, International Scientific Committee of the Pacific Islands). ICOMOS Pasifika is a body of professionals and experts from the Pacific dedicated to the conservation, protection, rehabilitation, and enhancement of the traditional and historical heritage of the Pacific Islands. PIMA and ICOMOS together now have more than ninety members and continue to grow. Its membership covers all the countries, states, and territories of the Pacific region, and together they seek to be an effective voice for successful heritage management in the Pacific. This umbrella organization includes arts councils and cultural associations, governmental agencies, historic sites, international museums with Pacific collections, museums and cultural centers, and national parks.

85. American Samoa, 2008; Belau, 2004; New Caledonia, 2000; Western Samoa, 1996; Cook Islands, 1992; Australia, 1988; French Polynesia, 1985; Papua New Guinea, 1980; New Zealand, 1976; Fiji, 1972.

CHECKLIST

Note: Dating for individual pieces has been kindly provided by the collectors.

Unless otherwise indicated, all measurements are in inches; height precedes width precedes depth.

FIGURES

1. Spirit figure (*yina*)
Melanesia; Papua New Guinea; Upper Sepik River; Ambunti Mountains. Kwoma people. Early 20th c. Wood and feathers; red, white, yellow, and black pigments. H. 49½. Edward and Mina Smith Collection. PROVENANCE: Wayne Heathcote, Brussels; Bruce Seaman, Hawai'i; The Masco Collection, Detroit. PUBLISHED: Sotheby's, New York, November 15, 2002, lot 165.

2. Female hook figure
Melanesia; Papua New Guinea; East Sepik Province; Middle Sepik River. 19th c. Wood. 34 × 10 × 2. Valerie Franklin Collection (247). PROVENANCE: Private German collection (probably Bretschneider, Frankfurt). EXHIBITED: Salt Lake Art Center, Utah, 1963, *New Guinea;* Dallas Museum of Art, 1970, *Arts of Oceania.* PUBLISHED: *Arts of Oceania* (Dallas, 1970), no. 48.

3. Janus hook figure
Melanesia; Papua New Guinea; East Sepik Province; Middle Sepik River. Western Iatmul people. 19th c. Wood. 66 × 10⅛ × 3. Valerie Franklin Collection (2156). PROVENANCE: Charles Ratton, Paris, France. EXHIBITED: Museum and Laboratories of Ethnic Arts and Technology, University of California, Los Angeles, 1967, *Art of New Guinea;* University of Texas at Austin, 1968, *Art of New Guinea.* PUBLISHED: *Art of New Guinea* (Los Angeles, 1967), no. 145.

4. Male hook figure
Melanesia; Papua New Guinea; East Sepik Province; Middle Sepik River. Late 19th c. Wood; traces of red ochre. H. 32. Valerie Franklin Collection (417).

5. Female hook figure
Melanesia; Papua New Guinea; East Sepik Province; Middle Sepik River; Chambri Lake. 19th–early 20th c. Wood. 30¾ × 12¾ × 5¼. Valerie Franklin Collection (1807). PROVENANCE: Private German collection prior to 1914. EXHIBITED: Dallas Museum of Art, 1970, *Arts of Oceania.* PUBLISHED: *Arts of Oceania* (Dallas, 1970), no. 47.

6. Five-pronged hook figure
Melanesia; Papua New Guinea; East Sepik Province; Coastal Lower Sepik River; Murik Lagoon. Murik people. 19th–early 20th c. Wood; bark cloth; plaited fiber. 24½ × 4½ × 4¾. Valerie Franklin Collection (282).

7. Male figure
Melanesia; Papua New Guinea; East Sepik Province; Middle Sepik River. Iatmul people. Late 19th–early 20th c. Wood; fiber; black, red, and white pigments. 77 × 9½ × 3½. Valerie Franklin Collection (1861).

8. Male figure
Melanesia; Papua New Guinea; East Sepik Province; Coastal Sepik River; Murik Lagoon. Murik people. 19th c. Wood; red ochre pigment. 5½ × 2 × 2. Valerie Franklin Collection (65).

9. Male figure
Melanesia; Papua New Guinea; Madang Province; Ramu River Delta. Bosman people. 19th c. Wood; fiber; shell; red ochre pigment. 9¾ × 2⅛ × 1½. Valerie Franklin Collection (327). PROVENANCE: Julius Carlebach, 1949; Denver Art Museum, QM-146.

10. Bust
Melanesia; Papua New Guinea; East Sepik Province; Prince Alexander Mountains. Northern Abelam people. Late 19th–early 20th c. Wood; red, yellow, black, and white pigments. H. 52. Valerie Franklin Collection (935).

11. Figure
Melanesia; Papua New Guinea; East Sepik Province; Prince Alexander Mountains. Northern Abelam people. Late 19th c. Wood. H. 84. Valerie Franklin Collection (1859). EXHIBITED: Museum and Laboratories of Ethnic Arts and Technology, University of California, Los Angeles, 1967, *Art of New Guinea.* PUBLISHED: *Art of New Guinea* (Los Angeles, 1967), p. 64, pl. 219.

12. Female figure (*aripa*)
Melanesia; Papua New Guinea; East Sepik Province; Middle Sepik/Upper Korewori River; probably Ewa Village. Inyai-Ewa people. 19th c. or earlier. Wood. 45 × 6¼ × 4. Valerie Franklin Collection (234).

13. Female figure (*aripa*)
Melanesia; Papua New Guinea; East Sepik Province; Middle Sepik/Upper Korewori River. Inyai-Ewa people. 19th c. or earlier. Wood. 62½ × 11 × 2. Edward and Mina Smith Collection. PROVENANCE: Tom Slimmons, Australia; by descent to Tod Barlin, Australia; Alex Phillips, Australia; Wayne Heathcote, Brussels.

14. Figure (*yipwon*)
Melanesia; Papua New Guinea; Korewori River. Yimar people. Late 19th–early 20th c. Wood; black and red pigments. H. 41. Edward and Mina Smith Collection. PROVENANCE: Barry Hoare, Australia, 1960; Doug Mactaggart, Brisbane, Australia, 1968; Todd Barlin, Australia; Michael Hamson, California.

15. Figure
Melanesia; Papua New Guinea; Gulf Province; Papuan Gulf; Era River District. 19th c. Wood; red ochre and white pigments. 28½ × 11 × 1½. Valerie Franklin Collection (E1).

16. Figure
Melanesia; Papua New Guinea; Gulf Province; Papuan Gulf; Era River District. 19th c. Wood; red ochre and white pigments. 29 × 10 × 1. Valerie Franklin Collection (E2). EXHIBITED: Ethnic Art Galleries, University of California, Los Angeles, 1962, *Primitive Arts,* no. M2.

17. Carved board
Melanesia; Papua New Guinea; Papuan Gulf; Kikori River Delta. Kerewa people. 19th–early 20th c. Wood; black and white pigments. 48 × 9½ × 1⅛. Valerie Franklin Collection (1517).

18. Figure
Melanesia; Papua New Guinea; Papuan Gulf; Era River District. 19th–early 20th c. Wood; red ochre, black, and white pigments. 22 × 5½ × 1. Valerie Franklin Collection (1801). EXHIBITED: Salt Lake Art Center, Utah, 1963, *New Guinea,* no. 21.

19. Figure
Melanesia; Papua New Guinea; Papuan Gulf; Era River District. 19th–early 20th c. Wood; red ochre, black, and white pigments. 21¼ × 5½ × 1¼. Valerie Franklin Collection (1802). EXHIBITED: Salt Lake Art Center, Utah, 1963, *New Guinea,* no. 20.

20. Skull rack (*agiba*)
Melanesia; Papua New Guinea; Papuan Gulf; Kikori River Delta. Kerewa people. First third of the 20th c. Wood; red, white, and black pigments. 35⅜ × 15⅜ × 1¼. Valerie Franklin Collection (1938). EXHIBITED: Barnsdall Municipal Galleries, Los Angeles, 1964; Santa Barbara Museum of Art, 1965; Portland Art Museum, 1965; Seattle Art Museum, 1965; Hood Museum of Art, Dartmouth College, New Hampshire, 2006, *Coaxing the Spirits to Dance.* PUBLISHED: *Coaxing the Spirits to Dance* (New Hampshire, 2006), fig. 66.

21. Male figure
Melanesia; Papua New Guinea; Admiralty Islands. 19th c. Wood; black and white pigments. 28 × 6¼ × 5. Valerie Franklin Collection (437).

22. Malagan plaque
Melanesia; Papua New Guinea; Northern New Ireland. 19th c. Wood; red, white, and black pigments. 8¼ × 29½ × 2. Valerie Franklin Collection (2099). PROVENANCE: Captain Haug, 1907; Linden Museum, Stuttgart, Germany, no. 8136.

23. Malagan plaque
Melanesia; Papua New Guinea; Northern New Ireland. 19th c. Wood; red, white, and black pigments. 42 × 10⅛ × 8. Valerie Franklin Collection (368). PROVENANCE: Collected by Dr. Augustine Kraemer, ca. 1900; Linden Museum, Stuttgart, Germany, no. 88479 (1668). EXHIBITED: Dallas Museum of Art, 1970, *Arts of Oceania*. PUBLISHED: *Arts of Oceania* (Texas, 1970), no. 90.

24. Malagan figure
Melanesia; Papua New Guinea; Northern New Ireland. 19th c. Wood; shell; seaweed; red, black, and white pigments. 46½ × 14 × 8. Valerie Franklin Collection (390). PROVENANCE: Captain Haug, 1907; Linden Museum, Stuttgart, Germany, prior to 1914, L923b,197. EXHIBITED: Dallas Museum of Art, 1970, *Arts of Oceania*. PUBLISHED: *Arts of Oceania* (Texas, 1970), no. 91.

25. Malagan figure
Melanesia; Papua New Guinea; Northern New Ireland. 19th or early 20th c. Wood; shell; fiber; hair; black, red, yellow, and white pigments. H. 58½. Edward and Mina Smith Collection. PROVENANCE: Vincent Price, Los Angeles; Wayne Heathcote, Brussels. EXHIBITED: San Diego Museum of Art, 2006, *Personal Views: Regarding Private Collections in San Diego*. PUBLISHED: Christie's, New York.

26. Figure (*uli*)
Melanesia; Papua New Guinea; Central New Ireland. 19th c. Wood; shell; seaweed; black, red, and white pigments. H. 44½. Valerie Franklin Collection (319). PROVENANCE: Collected by the Grand Duke of Baden-Baden, 1878. EXHIBITED: Dallas Museum of Art, 1970, *Arts of Oceania*. PUBLISHED: *Arts of Oceania* (Texas, 1970), no. 94.

27. Female figure
Melanesia; Papua New Guinea; Solomon Islands. Mid- to late 19th c. Wood; black, red, gold, and white pigments. H. 13¾. Edward and Mina Smith Collection. PROVENANCE: James Hooper, London, no. 1096; Estelle Abrams. PUBLISHED: *The James Hooper Collection* (Hooper & Burland, 1953), pl. 30; Steven Phelps, *The Art and Artifacts of the Pacific, Africa and the Americas: The James Hooper Collection* (Hutchinson, 1976), fig. 136, no. 1096.

28. Male figure
Melanesia; New Caledonia. Kanak people. 19th c. Wood. H. 8½. Edward and Mina Smith Collection. PROVENANCE: Private French collection.

29. Female figure
Polynesia; Fiji. 18th c. Wood. H. 13¾. Edward and Mina Smith Collection. PROVENANCE: Little Hampton Museum, Sussex, 1938; James Hooper, London. PUBLISHED: *The James Hooper Collection* (Hooper & Burland, 1953), fig. 753; Steven Phelps, *The Art and Artifacts of the Pacific, Africa and the Americas: The James Hooper Collection* (Hutchinson, 1976), pl. 99, no. 753; *Polynesian Art at Auction* (1982), pl. 116, no. 2.

30. Fly whisk
Polynesia; Austral Islands. Late 18th–early 19th c. Wood. H. 12½. Edward and Mina Smith Collection. PROVENANCE: Peter Kohler, Asconia; Loed Van Bussel, Amsterdam; Wayne Heathcote, Brussels; Private collection, Europe. EXHIBITED: The Fine Arts Museum of San Francisco, 2005–8. PUBLISHED: Roger Rose, unpublished report, 2005.

31. God staff
Polynesia; Cook Islands; Rarotonga. 18th c. Ironwood. H. 24½. Edward and Mina Smith Collection. PROVENANCE: Peter Matlock, Buffalo, New York, 1930. EXHIBITED: M.H. de Young Memorial Museum, 2004–8. PUBLISHED: Douglas Newton, unpublished report, November 1999.

32. Male figure
Polynesia; Marquesas Islands. 19th c. Wood. H. 23¾. Edward and Mina Smith Collection. PROVENANCE: Mr. & Mrs. Morris Pinto, London; Masco Collection, Detroit. PUBLISHED: Polynesian Art at Auction, 1965–80, Charles Mack, p. 169, no. 2; Sotheby's, London, May 9, 1977, no. 53; Sotheby's, New York, May 10, 2006, no. 15.

33. Figure
Polynesia; Easter Island. 18th c. Wood; shell; obsidian. 22 × 19¼. Valerie Franklin Collection (440). PROVENANCE: A. Flechtheim, Berlin. EXHIBITED: Baltimore Museum of Art, Maryland, 2000–8, *Oceanic Art*. PUBLISHED: Tapano Janssen, "L'Île de Pâques," *Cahiers d'Arts*, March–April 1928, fig. 186; Stéphen-Charles Chauvet, *L'Île de Pâques et Ses Mystères* (Paris, 1935), fig. 150.

34. Figure (*moai tangata manu*)
Polynesia; Easter Island. Late 18th–early 19th c. Wood (toromiro). 8 × 2½. Edward and Mina Smith Collection. PROVENANCE: Tad Dale, Santa Fe.

35. Figure (*akua ka'ai*)
Polynesia; Hawai'i. Late 18th–early 19th c. Wood (accacia koaia). H. 12¼. Edward and Mina Smith Collection. PROVENANCE: Proctor Stanford, Los Angeles; Don Severson, Hawai'i; Charles Mack. EXHIBITED: San Diego Museum of Art, October 2006–January 2007, *Personal Views: Regarding Private Collections*. PUBLISHED: Cox Davenport, *Hawai'ian Sculpture*, 1988, p. 198; Sotheby's Tribal, London, December 3, 1984, lot 63; Sotheby's, London, July 6, 1982, lot 68.

36. Figure (*tino aitu*)
Micronesia; Caroline Islands; Nuku'oro. Early 19th c. or earlier, precontact. Wood (breadfruit). H. 76⅞. Edward and Mina Smith Collection. PROVENANCE: Probably J.L. Young, Auckland; sold prior to 1920 to Percy Matthew Davidson Poole, Auckland; Mattie Poole, Aukland. EXHIBITED: M.H. de Young Memorial Museum, 2004–8. PUBLISHED: Douglas Newton, unpublished essay, 2001; Roger Neich, "A Recently Revealed Tino Aitu Figure from Nuku'oro Island, Caroline Islands, Micronesia," *Tribal Art* 12, no. 47 (Winter 2007), 136–41.

MASKS
37. Mask (*mwai*)
Melanesia; Papua New Guinea; East Sepik Province; Middle Sepik River. Sawos people. 19th c. Wood; fiber; boar's tusks. 16 × 5¾ × 5⅞. Valerie Franklin Collection (424).

38. Mask
Melanesia; Papua New Guinea; East Sepik Province; Coastal Lower Sepik River. 19th c. Wood; fiber. 16 × 5¾ × 5⅞. Valerie Franklin Collection (1789).

39. Mask
Melanesia; Papua New Guinea; East Sepik Province; North Coast of the Sepik River. Watam people. 19th–early 20th c. Wood. $20\frac{1}{2} \times 7\frac{1}{2} \times 4\frac{1}{4}$. Valerie Franklin Collection (E6).

40. Mask (*Lor*)
Melanesia; Papua New Guinea; New Britain; Gazelle Peninsula. Tolai people. 19th c. Wood; feathers; bark cloth; black, blue, yellow, and white pigments. $19 \times 8 \times 8\frac{1}{2}$. Valerie Franklin Collection (1841). PROVENANCE: Missions Kloster, Hiltrup, Westfalia, Germany.

41. Mask
Melanesia; Vanuatu, Vao, or Rano Island (off Malakula). 19th c. Wood; black with traces of blue and orange pigments. $14\frac{1}{2} \times 5\frac{1}{8} \times 3\frac{1}{2}$. Valerie Franklin Collection (481). PROVENANCE: Helena Rubinstein. EXHIBITED: Museum of Cultural History, University of California, Los Angeles, 1977, *Image and Identity*. PUBLISHED: Parke-Bernet Galleries, New York, April 21, 1966, no. 258; *Image and Identity* (Los Angeles, 1977), fig. 25.

42. Mask (*temes mbalmbal*)
Melanesia; Vanuatu; Malakula. Ca. 1930–50s. Fern tree; bamboo frame; boar's tusk; clay; black, orange, white, and blue pigments. H. 27. Edward and Mina Smith Collection. PROVENANCE: Herbert Baker, 1961; The Art Institute of Chicago, 1996. EXHIBITED: University of Wisconsin Art Museum, September–November 1984, *Dialogue with the Spirits*, no. 22. PUBLISHED: *African and Oceanic Art*, Sotheby's, New York, November 16, 2001, lot 183; Christie's New York, 1996; *Melanesian Art: Dialogue with the Spirits* (University of Wisconsin, 1984).

43. Mask (*apouema*)
Melanesia; New Caledonia. 19th c. or earlier. Wood. H. 22. Edward and Mina Smith Collection. PROVENANCE: Douglas Newton, New York; Wayne Heathcote, Brussels. EXHIBITED: San Diego Museum of Art, November 2006–February 2007, *Personal Views: Regarding Private Collections in San Diego*.

TAPA
44. Tapa cloth (*salatasi*)
Polynesia; Futuna Island. 19th c. Bark cloth; black pigment. 2×14 ft. Edward and Mina Smith Collection. PROVENANCE: Alex Phillips, Melbourne, Australia. PUBLISHED: *The Space Between* (Sana Art Foundation, California, 2006), p. 7.

45. Tapa cloth
Melanesia; Papua New Guinea; New Britain. Late 19th–early 20th c. Bark cloth; brown and red pigments. $1\frac{1}{2}$ ft. $\times 16$ ft. Edward and Mina Smith Collection. PROVENANCE: Alex Phillips, Melbourne, Australia.

46. Tapa cloth (*kapa moe*)
Polynesia; Hawai'i. Ca. 1850–60. Bark cloth; natural pigments, including indigo dye. 112×74. Sana Art Foundation Collection. PROVENANCE: Don Severson, Hawai'i. EXHIBITED: California Center for the Arts, Escondido Museum, 2007–8. PUBLISHED: *Rituality* (California Center for the Arts, Escondido, 2007); *The Space Between* (Sana Art Foundation, 2006), p. 7.

47. Tapa cloth (*siapo vala*)
Polynesia; Samoa. Early 20th c. Bark cloth; natural dye. 72×42. Sana Art Foundation Collection. PROVENANCE: Howard Hitchcock Family, Hilo, Hawai'i.

PERSONAL ADORNMENT
48. Ornament (*kapkap*)
Melanesia; Solomon Islands; Santa Cruz. Early 20th c. Tridacna shell; turtle shell; plant fiber. DIAM. $7\frac{1}{4}$. Sana Art Foundation Collection. EXHIBITED: Heritage of the Americas Museum, El Cajon, California, 2000, *Art of Adornment*.

49. Necklace (*lei niho palaoa*)
Polynesia; Hawai'i. 19th c. Whale ivory; human hair; sennit. DIAM. 12. Sana Art Foundation Collection. PROVENANCE: Don Severson, Hawai'i. Proctor Stafford, Los Angeles and Hawai'i. EXHIBITED: California Center for the Arts, Escondido Museum, 2007–8; San Diego State University, 2006. PUBLISHED: *Rituality* (California Center for the Arts, Escondido, 2007); *The Space Between* (Sana Art Foundation, 2006), p. 7.

50. Pendant (*pekapeka*)
Polynesia; New Zealand; North Island Māori people. 18th–early 19th c. Greenstone. $1\frac{3}{4} \times 3\frac{3}{4} \times \frac{1}{16}$. Valerie Franklin Collection (5018). PROVENANCE: Hori Haupapa, New Zealand; Haupapa Sheet, New Zealand; Sam Mitchell, New Zealand; Marion A. Radcliffe-Taylor, 1970.

51. Pendant (*hei tiki*)
Polynesia; New Zealand. Māori people. 18th c. Greenstone; mother-of-pearl; bird bone; flax cordage. Pendant only: $3\frac{1}{4} \times 1\frac{1}{2} \times$ less than $\frac{1}{4}$. Edward and Mina Smith Collection. PROVENANCE: Craig Helms, San Diego. EXHIBITED: Heritage of the Americas Museum, El Cajon, California, 2000, *Art of Adornment*.

52. Pendant (*hei tiki*)
Polynesia; New Zealand; West Coast North Island; Taranaki. Māori people. Early 19th c. Greenstone; red sealing wax; shell. $2 \times 3\frac{5}{8} \times \frac{1}{4}$. Valerie Franklin Collection (5020).

53. Pendant (*hei tiki*)
Polynesia; New Zealand; West Coast North Island; Taranaki. Māori people. 18th c. Greenstone. $3\frac{3}{4} \times 2 \times \frac{1}{4}$. Valerie Franklin Collection (5019).

54. Figure
Polynesia; Tonga. 18th c. Sperm whale ivory. H. $3\frac{3}{4}$. Edward and Mina Smith Collection. PROVENANCE: J. Bristol, London; John Hewett, London; A. H. Dorsey, London.

SACRED AND SECULAR CONTAINERS
55. Pigment dish
Melanesia; Papua New Guinea; East Sepik Province; Coastal Sepik River. Late 19th c. Wood; pigment. $2\frac{1}{2} \times 2\frac{3}{8} \times 7$. Valerie Franklin Collection (1833).

56. Container (*saga moli*)
Polynesia; Fiji. 19th c. Ceramic. $6 \times 12 \times 9$. Edward and Mina Smith Collection. PROVENANCE: Pitt Rivers Museum, Farnham, UK; Masco Collection, Detroit. PUBLISHED: Allen Wardwell, *Island Ancestors* (The Masco Collection, 1994), p. 174.

57. Container (*saga drua*)
Polynesia; Fiji. 19th c. Ceramic. $7 \times 12 \times 12$. Edward and Mina Smith Collection.

58. Container (*saga*)
Polynesia; Fiji. 19th c. Ceramic. H. 12. Edward and Mina Smith Collection.

59. Basket
Polynesia; Tonga. Early 19th c. Native fibers; black dye and sennit. $6 \times 10\frac{3}{4}$. Edward and Mina Smith Collection. PROVENANCE: F. H. North, London, 1961; Veena and Peter Schnell. PUBLISHED: Sotheby's, Paris, December 3, 2004, lot 162.

60. Container
Melanesia; Papua New Guinea; Solomon
Islands; Nendo Island. First quarter of
20th c. Gourd; wood; fiber; shell; rat teeth;
turmeric and black pigments. H. 12¾. Edward
and Mina Smith Collection. PROVENANCE:
Eastern European Collection; collected on
Utupua Island, GA 1953.

61. Gourd (*ipu pawehe*)
Polynesia; Hawai'i. 19th c. Gourd. H. 12½.
Edward and Mina Smith Collection.

62. Container
Polynesia; Marquesas Islands. Late 19th to
early 20th c. Coconut. 5½ × 6. Sana Art Foun-
dation Collection. PUBLISHED: Christie's,
London, Tribal Art auction, December 6,
1995, lot 22, no. 5523.

63. Bowl (*umeke la'au puahala*)
Polynesia; Hawai'i. 18th c. Wood (*koo*).
DIAM. 8½. Edward and Mina Smith Collec-
tion. PROVENANCE: Proctor Stanford, Los
Angeles and Hawai'i; Don Severson, Hawai'i.

64. Platter
Melanesia; New Guinea; West Papua; North
Coast; Lake Sentani. Late 19th c. Wood; white
lime. 42 × 14¼. Valerie Franklin Collection
(418).

65. Container lid
Taiwan. 18th–19th c. Wood; red pigment.
DIAM. 17¾. Valerie Franklin Collection (1792).

66. Bowl
Polynesia; Fiji. 19th c. Wood. 5¾ × 16. Valerie
Franklin Collection (1848). PROVENANCE:
Ralph Altman, Los Angeles. EXHIBITED:
Dallas Museum of Art (1970), *Arts of Oceania.*
PUBLISHED: *Arts of Oceania* (Dallas, 1970),
no. 132.

67. Oil dish (*daveniyagona*)
Polynesia; Fiji. 18th–early 19th c. Wood (*vesi*).
H. 11¼. Edward and Mina Smith Collection.
PROVENANCE: Dr. Riedewaldt, 1888; German
dealer, Umlauff, 1890s; Danish Collection.
EXHIBITED: M.H. de Young Memorial
Museum, 2004–8. PUBLISHED: Douglas
Newton, unpublished essay, November 30,
1999.

68. Oil dish (*sedre ni waiwai*)
Polynesia; Fiji. 1820–50. Wood (*vesi*). 18 × 12¼.
Edward and Mina Smith Collection. PROVE-
NANCE: Jeff Hobbs, New Zealand.

69. Ritual box
Republic of the Philippines; Northern Luzon;
Mayayao Valley. Ifugao people. Mid-20th c.
Wood (box filled with rice, one small figure,
straw, and fibers). 25 × 12 × 15. Edward and
Mina Smith Collection. PROVENANCE: Jean-
Luc Andre, 1990. PUBLISHED: Sotheby's,
Paris, December 9, 2005.

MUSIC, DANCE, AND THE VOICES OF THE SPIRITS

70. "Dancing" figure
Polynesia; New Zealand. Māori people, Arawa
tribe. 18th–19th c. Wood. 14⅜ × 4 × 2⅜. Valerie
Franklin Collection (453). PROVENANCE:
Dr. J. Stein, Los Angeles. INSCRIPTION:
"Te Mokamokai, Rotoiti December 1882."

71. Drum (*kundu*)
Melanesia; Papua New Guinea; East Sepik
Province; Middle Sepik River. Iatmul people.
Late 19th c. Wood; traces of red and white
pigments. 27 × 9½ × 7½. Valerie Franklin Col-
lection (1142). EXHIBITED: Lang Galleries,
Scripps College, Claremont, California, 1960,
Primitive Arts of the Sepik River, New Guinea;
Denver Art Museum, 1961, *Oceanic Art;*
Museum and Laboratories of Ethnic Arts
and Technology, University of California,
Los Angeles, 1967–68, *Art of New Guinea;* Uni-
versity of Texas at Austin, 1968, *Art of New
Guinea;* Museum of Cultural History, Univer-
sity of California, Los Angeles, 1973, *Music
in Visual Arts.* PUBLISHED: *Primitive Arts of
the Sepik River, New Guinea* (California, 1960);
Oceanic Art (Denver, 1961), no. 4403; *Art of
New Guinea* (Los Angeles, 1967), no. 160;
Music in Visual Arts (Los Angeles, 1973).

72. Drum (*kandara*)
Melanesia; New Guinea; West Papua; South
Coast. Marind-anim people. Late 19th c.
Wood; red ochre, black, and white pigments;
skin; rattan. 37¾ × 10 × 10. Valerie Franklin
Collection (801). EXHIBITED: Lang Galleries,
Scripps College, Claremont, California, 1960,
Primitive Arts of the Sepik River, New Guinea;
Downey Museum of Art, California, 1960.
PUBLISHED: *Primitive Arts of the Sepik River,
New Guinea* (California 1960).

73. Drum
Melanesia; New Guinea; West Papua; North
West Coast; Geelvink Bay; Yapen Island. Late
19th c. Wood; black and brown pigments;
skin tympanum. 21½ × 8. Valerie Franklin
Collection (1545).

74. Pair of flute ornaments
Melanesia; Papua New Guinea; East Sepik
Province; Lower Sepik River (Yuat River area).
19th c. Wood; fiber. Male H. 8¾; female H. 7¾.
Valerie Franklin Collection (1969). EXHIB-
ITED: Museum and Laboratories of Ethnic
Arts and Technology, University of Califor-
nia, Los Angeles, 1967-68, *Art of New Guinea;*
University of Texas at Austin, 1968, *Art of
New Guinea;* Art Institute of Chicago, 1971,
Arts of the Sepik River. PUBLISHED: *Art of New
Guinea* (Los Angeles, 1967), no. 161; *Arts of
the Sepik River* (Chicago, 1971), no. 160.

75. Flute ornament
Melanesia; Papua New Guinea; East Sepik
Province; Middle Sepik River. Iatmul people.
First third of the 20th c. Wood; traces of red
ochre, white, and black pigments. 24 × 5½ × 6.
Valerie Franklin Collection (E29).

76. Dance staff
Melanesia; Papua New Guinea; New Britain;
Gazelle Peninsula. Tolai people. Late 19th–
early 20th c. Wood; feathers; fiber; white,
red, and black pigments. H. 24. Edward and
Mina Smith Collection. PROVENANCE:
Kramer; Dresden Museum, Germany.

77. Headdress (*wenena gerua*)
Melanesia; Papua New Guinea; Central
Highlands. Siane people. Pre-1950. Wood;
red, blue, and yellow pigments. 58½ × 14½.
Edward and Mina Smith Collection. PROVE-
NANCE: S. G. Moriaty, 1954. PUBLISHED:
Sotheby's, New York, May 19, 2001.

INSTRUMENTS OF WAR

78. Shield
Melanesia; Papua New Guinea; East Sepik
Province; Upper Sepik River/April River;
Hunstein Mountains. 19th c. Wood; pigment.
H. 54. Valerie Franklin Collection (1519).
EXHIBITED: Hood Museum of Art, Dart-
mouth College, Hanover, New Hampshire,
1997, *New Guinea Shields.*

79. Shield
Melanesia; Papua New Guinea; East Sepik
Province; Ramu River. 19th c. Wood; woven
fiber wrapping; red, yellow, and white pig-
ments. H. 52. Valerie Franklin Collection
(E36). EXHIBITED: Denver Art Museum, 1961,
Oceanic Art; Dallas Museum of Art, 1970, *Art
of Oceania.* PUBLISHED: *Art of Oceania* (Texas,
1970), no. 68.

80. Club (*sali*)
Polynesia; Fiji. 19th c. Wood; marine ivory inlay. L. 41½. Valerie Franklin Collection (448). PROVENANCE: Collection of Dr. J. Stein, Los Angeles.

81. Club
Polynesia; Tonga. 19th c. Wood; whale ivory; shell; red coral. L. 32¼. Edward and Mina Smith Collection. PROVENANCE: Depue; by descent to Bernard Lueck, San Diego.

82. Club (*patu wahaika*)
Polynesia; New Zealand; East Coast North Island. Māori people. Early 19th c. Whalebone. L. 13¼. Valerie Franklin Collection (591). PROVENANCE: William Spratling, New Mexico; John Wise, New York; Dr. J. Stein, Los Angeles.

83. Club (*patu*)
Polynesia; New Zealand; East Coast North Island. Māori people. 18th c. Whalebone; mother-of-pearl. L. 14. Valerie Franklin Collection (594). PROVENANCE: Dr. J. Stein, Los Angeles. EXHIBITED: Los Angeles County Museum of Natural History, California, 1971, *Art of the Pacific*; Los Angeles County Museum of Natural History, California, 1983, *Tangata, The Maori Vision of Mankind*.

84. Club (*u'u*)
Polynesia; Marquesas Islands. 18th–19th c. Wood. H. 56¼. Valerie Franklin Collection (1180). PROVENANCE: Helena Rubinstein. EXHIBITED: Museum of Modern Art, New York, 1984–85, *Primitivism in 20th Century Art*; Detroit Institute of Arts, *Primitivism in 20th Century Art*; Dallas Museum of Art, *Primitivism in 20th Century Art*. PUBLISHED: "The Helena Rubinstein Collection," Parke-Bernet Galleries, New York, no. 250; William Rubin, ed., *Primitivism in 20th Century Art* (New York, 1984), p. 198.

85. Club (*u'u*)
Polynesia; Marquesas Islands. 18th–19th c. Wood. H. 57¼. Edward and Mina Smith Collection. PROVENANCE: Luisa Muller Van Isterbeek, Brussels; Jacques Hautelet, La Jolla, California. PUBLISHED: Sotheby's, New York, November 14, 1980, lot 75; *Polynesian Art at Auction*, Mack, p. 181; *Arts d'Afrique Noire*, no. 43 (Winter 1981): 33.

CANOES AND THEIR ORNAMENTATION

86. Ceremonial paddle
Melanesia; New Guinea; West Papua; North Coast; Lake Sentani. Late 19th–early 20th c. Wood; black pigment. L. 80. Valerie Franklin Collection (E35).

87. Canoe prow mask
Melanesia; Papua New Guinea; East Sepik Province; Middle Sepik River; Chambri Lake. 19th c. Wood; white pigment. H. 13¼. Valerie Franklin Collection (113).

88. Canoe prow shield with mask
Melanesia; Papua New Guinea; East Sepik Province; Middle Sepik River. Tambunum people. Late 19th–early 20th c. Wood; shell; bark; bamboo; cassowary feathers; white and traces of blue pigments. 30 × 40½ × 6½. Valerie Franklin Collection (E37). EXHIBITED: Salt Lake City Art Center, Utah, 1963, *New Guinea*. PUBLISHED: *New Guinea* (Salt Lake City, 1963), no. 41.

89. Canoe prow ornament (*naho*)
Melanesia; Vanuatu. Late 19th c. Wood. 12¾ × 25 × 7. Valerie Franklin Collection (1817). PROVENANCE: French private collection. EXHIBITED: Dallas Museum of Art, 1970, *Arts of Oceania*. PUBLISHED: *Arts of Oceania* (Dallas, 1970), no. 88.

90. Canoe prow ornament (*nguzunguzu*)
Melanesia; Papua New Guinea; Solomon Islands; New Georgia Island. Early to mid-19th c. Wood; trade beads; shell; red, yellow, and black pigments. H. 9. Edward and Mina Smith Collection. PROVENANCE: Jacques Lipchitz, New York; Merton Simpson, New York; Wally Zollman, Indianapolis.

91. Canoe ornament
Melanesia; Papua New Guinea; Solomon Islands. 19th c. Wood; shell. H. 10¼. Edward and Mina Smith Collection. PROVENANCE: Frederic Mueller, Hawai'i. PUBLISHED: Christie's, New York, June 5, 1990, lot 142.

ARCHITECTURE AND DECORATION

92. Gable mask
Melanesia; Papua New Guinea; East Sepik Province; Middle Sepik River; Chambri Lake. 19th c. Wood; traces of pigment; shell. 25¾ × 13¼ × 3¼. Valerie Franklin Collection (E8).

93. Panel
Taiwan. 19th c. or earlier. Wood. H. 32½. Edward and Mina Smith Collection. PROVENANCE: Bob Wilhelmson, Hawai'i.

94. Male figure
Melanesia; Papua New Guinea; Admiralty Islands. Late 19th–early 20th c. Wood; red and black pigments; lime. H. 58¼. Edward and Mina Smith Collection. PROVENANCE: Patricia Withoff, London; Sotheby's, London, May 12, 1980, lot 92.

95. Roof finial
Melanesia; New Caledonia. 19th c. Wood. H. 83. Valerie Franklin Collection (1857). PROVENANCE: Denver Art Museum, 74QP.

96. Roof gable ornament (*teko teko*)
Polynesia; New Zealand. Māori people. Early 19th c. Wood; pigment. H. 18. Edward and Mina Smith Collection. PROVENANCE: Collected by John Jacobs before 1897 in Rotorua, New Zealand; Alex Phillips, Australia. EXHIBITED: San Diego Museum of Art, 2006, *Personal Views: Regarding Private Collections in San Diego*. PUBLISHED: Sotheby's, Sydney, November 9, 1997, lot 580.

97. Roof gable ornament (*teko teko*)
Polynesia; New Zealand. Māori people; Arawa tribe. 18th c. Wood; obsidian; pigment. 37 × 4 × 3¼. Valerie Franklin Collection (E30). PROVENANCE: André Bréton–Paul Éluard, Paris; Helena Rubinstein. EXHIBITED: Los Angeles County Museum of Natural History, California, 1983, *Tangata, The Maori Vision of Mankind*; Baltimore Museum of Art, Maryland, 2000–2008, *Oceanic Art*. PUBLISHED: "Sur L'Art Maori," in *Cahiers D'Art* (Paris, 1929), fig. 142; *Sculptures D'Afrique, D'Amerique, D'Oceanie* (Paris, 1931), cat. no. 142, pl. 142.

98. Architectural fragment (*raparapa*)
Polynesia; New Zealand; North Island; Ngaruawahia. Māori people; Waikato tribe. 1840–60 from King Tawhiao meeting house. Wood. L. 64. Edward and Mina Smith Collection. PROVENANCE: Julius Carlebach, New York; Howard Rose, New York; Kevin Conru, Brussels; Casey Conway, Arizona. PUBLISHED: *Conru Southeast and Oceanic Art*, 2005.

126

SELECTED BIBLIOGRAPHY

Altman, Ralph. *Masterpieces from the Sir Henry Wellcome Collection at UCLA.* Los Angeles: University of California, Los Angeles, 1966.

Arts of Oceania. Dallas: Dallas Museum of Fine Arts, 1970.

Barbier, Jean Paul. *Indonésie et Mélanésie: Art tribal et cultures archaïques des Mers du Sud.* Geneva: Collection Barbier-Muller, 1977.

Barrow, Terence. *Arts of the South Sea Islands in British and Continental Museums.* Wellington, New Zealand: J. Milne, 1959.

———. *Art and Life in Polynesia.* Rutland, Vt.: C. E. Tuttle, 1972.

———. *An Illustrated Guide to Māori Art.* Honolulu: University of Hawai'i Press, 1984.

Bonnemaison, Joël, et al., eds. *Arts of Vanuatu.* Honolulu: University of Hawai'i Press, 1996.

Bounoure, Vincent. *Vision d'Océanie.* Paris: Musée Dapper, 1992.

Chauvet, Stéphen-Charles. *L'Île de Pâques et ses Mystères.* Paris: Éditions "Tel," 1935.

Clunie, Fergus. "Fiji." In Newton, *Arts of the South Seas,* 314–23.

Cox, J. Halley, and William Davenport. *Hawai'ian Sculpture.* 2nd ed. Honolulu: University of Hawai'i Press, 1988.

Craig, Barry, Bernie Kernot, and Christopher Anderson, eds. *Art and Performance in Oceania.* Honolulu: University of Hawai'i Press, 1999.

Dark, Philip J. C., and Roger G. Rose, eds. *Artistic Heritage in a Changing Pacific.* Honolulu: University of Hawai'i Press, 1993.

Davenport, William H. *Santa Cruz Island Figure Sculpture and Its Social and Ritual Contexts.* Philadelphia: University of Pennsylvania Museum of Archaeology and Anthropology, 2005.

De Grunne, Bernard. "Beauty in Abstraction: The Barbier-Mueller Nuku'oro Statue." In *Tribal Art.* Geneva: Musée Barbier-Mueller, 1994.

Ellis, George R. *The People and Art of the Philippines.* Los Angeles: Museum of Cultural History, University of California, Los Angeles, 1981.

Ewins, Rod. *Fijian Artefacts: The Tasmanian Museum and Art Gallery Collection.* Hobart, Tasmania: Tasmanian Museum and Art Gallery, 1982.

Feldman, Jerome, and Donald H. Rubinstein. *The Art of Micronesia: The University of Hawai'i Art Gallery.* Honolulu: University of Hawai'i Art Gallery, 1986.

Force, Roland W. *The Fuller Collection of Pacific Artifacts.* London: Lund Humphries, 1971.

Gathercole, Peter, Adrienne L. Kaeppler, and Douglas Newton. *The Art of the Pacific Islands.* Washington, D.C.: National Gallery of Art, 1979.

Gell, Alfred. *Art and Agency: An Anthropological Theory.* Oxford, England: Clarendon Press; Oxford and New York: Oxford University Press, 1998.

Greub, Suzanne. *Art of the Sepik River: Authority and Ornament, Papua New Guinea.* Basel: Tribal Art Centre, Edition Greub, 1985.

———, ed. *Art of Northwest New Guinea: From Geelvink Bay, Humboldt Bay, and Lake Sentani.* New York: Rizzoli, 1992.

Guiart, Jean. *The Arts of the South Pacific.* Vol. 4 of *The Arts of Mankind.* Translated by Anthony Christie. New York: Golden Press, 1963.

Gunn, Michael, and Philippe Peltier, eds. *New Ireland: Art of the South Pacific.* Paris: Musée du Quai Branly; Milan: 5 Continents, 2006.

Haberland, Eike. *The Caves of the Karawari Mountains.* New York: D'Arcy Galleries, 1968.

Hanson, Allan, and Louise Hanson, eds. *Art and Identity in Oceania.* Honolulu: University of Hawai'i Press, 1990.

Heerman, Ingrid. *Form Colour Inspiration: Oceanic Art from New Britain.* Stuttgart: Arnoldsche, 2001.

Herle, Anita, et al. *Pacific Art: Persistence, Change, and Meaning.* Honolulu: University of Hawai'i Press, 2002.

Hīroa, Te Rangi, and Peter H. Buck. *Arts and Crafts of Hawai'i.* Honolulu: Bishop Museum Press, 2003.

Hodgins, Gregory, Philippe Peltier, Dirk Smidt, and Robert L. Welsch. *New Guinea Art: Masterpieces from the Jolika Collection of Marcia and John Friede.* Vol. 2. San Francisco: de Young Museum, 2005.

Hooper, Steven. *Pacific Encounters: Art and Divinity in Polynesia, 1760–1860.* London: The British Museum Press, 2006.

Howe, K. R., ed. *Vaka Moana: Voyages of the Ancestors—The Discovery and Settlement of the Pacific.* Auckland, New Zealand: David Bateman, 2006.

Huffman, Kirk. "Vanuatu." In Newton, *Arts of the South Seas,* 290.

Huth, Tom. "Voyage of the Dim-Dims." *Condé Nast Traveler,* January 2008, 110.

Irwin, Geoffrey. "Voyaging and Settlement." In Howe, *Vaka Moana,* sec. 3.

Kaeppler, Adrienne L. *"Artificial Curiosities": Being an Exposition of Native Manufactures Collected on the Three Pacific Voyages of Captain James Cook, R.N.* Honolulu: Bishop Museum Press, 1978.

———. *From the Stone Age to the Space Age in Two Hundred Years: Tongan Art and Society on the Eve of the Millennium.* Tonga: Tongan National Museum, 1999.

Kaeppler, Adrienne L., Christian Kaufmann, and Douglas Newton. *Oceanic Art.* English-language edition of *L'Art Océanien* (Paris: Citadelles and Mazenod, 1993). Translated by Nora Scott and Sabine Bouladon with Fiona Leibrick. New York: Abrams, 1997.

Kaufmann, Christian. *Korewori: Magic Art from the Rain Forest.* Translated by Robert Williamson. Honolulu: University of Hawai'i Press; Belair, Australia: Crawford House, 2003.

Kjellgren, Eric. *Splendid Isolation: Art of Easter Island.* New York: Metropolitan Museum of Art, 2001.

———. *Oceania: Art of the Pacific Islands in the Metropolitan Museum of Art.* New York: Metropolitan Museum of Art; New Haven, Conn.: Yale University Press, 2007.

Kjellgren, Eric, and Carol S. Ivory. *Adorning the World: Art of the Marquesas Islands.* New York: Metropolitan Museum of Art; New Haven, Conn.: Yale University Press, 2005.

Kooijman, Simon. *The Art of Lake Sentani.* Translated by G. E. van Baaren-Pape. New York: Museum of Primitive Art, 1959.

Leenhardt, Maurice. "Le masque et le mythe en Nouvelle-Calédonie." *Études Mélanésiennes,* no. 8 (1954): 9–20.

Lewis-Harris, Jacquelyn. "Art of the Papuan Gulf." *St. Louis Art Museum Bulletin,* Winter 1966.

Lincoln, Louise. *Assemblage of Spirits: Idea and Image in New Ireland.* New York: G. Braziller, in association with the Minneapolis Institute of Arts, 1987.

Linton, Ralph, and Paul S. Wingert, in collaboration with René d'Harnoncourt. *Arts of the South Seas.* New York: Museum of Modern Art, 1946.

Mallon, Sean. *Samoan Art and Artists (O Measina a Samoa).* Honolulu: University of Hawai'i Press, 2002.

Maybury-Lewis, David. *Millennium: Tribal Wisdom and the Modern World.* New York: Viking, 1992.

McKesson, John. "In Search of the Origins of the New Caledonia Mask." In Hanson and Hanson, *Art and Identity in Oceania*.

Mead, Sidney M. *Te Maori: Maori Art from New Zealand Collections*. New York: Abrams, in association with the American Federation of Arts, 1984.

——, ed. *Exploring the Visual Art of Oceania: Australia, Melanesia, Micronesia, and Polynesia*. Honolulu: University Hawai'i Press, 1979.

Mead, Sidney M., and Bernie Kernot, eds. *Art and Artists of Oceania*. Wellington, New Zealand: Dunmore Press; Mill Valley, Calif.: Ethnographic Arts Publications, 1983.

Neich, Robert. "A Recently Revealed Tino Aitu Figure from Nuku'oro Island, Caroline Islands, Micronesia." *Tribal Art* 12, no. 47 (Winter 2007): 136–41.

Neich, Robert, and Mark Pendergrast. *Pacific Tapa*. Auckland, New Zealand: D. Bateman; Auckland Museum, 1997.

Neich, Robert, and Fuli Pereira. *Pacific Jewelry and Adornment*. Honolulu: University of Hawai'i Press, 2004.

Newton, Douglas. *The Art of Lake Sentani*. Translated by G. E. van Baaren-Pape. New York: Museum of Primitive Art, 1959.

——. *Art Styles of the Papuan Gulf*. New York: Museum of Primitive Art, 1961.

——. *New Guinea Art in the Collection of the Museum of Primitive Art*. New York: Museum of Primitive Art, 1967.

——. *Crocodile and Cassowary: Religious Art of the Upper Sepik River, New Guinea*. New York: Museum of Primitive Art, 1971.

——, ed. *Arts of the South Seas: Island Southeast Asia, Melanesia, Polynesia, Micronesia—The Collections of the Musée Barbier-Mueller*. Munich and New York: Prestel, 1999.

Ohnemus, Sylvia, et al. *An Ethnology of the Admiralty Islanders: The Alfred Bühler Collection, Museum der Kulturen, Basel*. Honolulu: University of Hawai'i Press, 1998.

Orliac, Catherine, and Michael Orliac. *Easter Island: Mystery of the Stone Giants*. Translated by Paul Bahn. New York: Longitude Press, 1995.

Parsons, Lee Allen. *Ritual Arts of the South Seas: The Morton D. May Collection*. St. Louis: City Art Museum of St. Louis, 1975.

Phelps, Steven. *Art and Artifacts of the Pacific, Africa, and the Americas: The James Hooper Collection*. London: Hutchinson, 1976.

Price, Sally. *Primitive Art in Civilized Places*. 2nd ed. Chicago: University of Chicago Press, 2001.

Rose, Roger. "On the Origin and Diversity of the 'Tahitian' Janiform Fly Whisks." In Mead, *Exploring the Art of Oceania*, 202–23.

Rubin, William, ed. *"Primitivism" in Twentieth-Century Art: Affinity of the Tribal and the Modern*. New York: Museum of Modern Art, 1984.

Schmid, C. "Catalogue." In Suzanne Greub, *Art of the Sepik River: Authority and Ornament, Papua New Guinea*. Basel: Tribal Art Centre, Edition Greub, 1985. Quoted in Wardwell, *Island Ancestors*, 72.

Smidt, Dirk. "Kominimung Shields." In Mead and Kernot, *Art and Artists in Oceania*, 137.

——. "Major Themes in New Guinea Art." In Hodgins et al., *New Guinea Art*, 2:31.

Sowell, Teri L. *Worn with Pride: Celebrating Samoan Artistic Heritage*. Oceanside, Calif.: Oceanside Museum of Art, 2000.

St. Cartmail, Keith. *The Art of Tonga*. Honolulu: University of Hawai'i Press, 1997.

Teilhet, Jehanne, ed. *Dimensions of Polynesia*. San Diego: Fine Arts Gallery of San Diego, University of California, San Diego, 1973.

Waite, Deborah. *Art of the Solomon Islands: From the Collection of the Barbier-Mueller Museum*. Geneva: Barbier-Mueller Museum, 1983.

——. "*Mon* Canoes of the Western Solomon Islands." In Hanson and Hanson, *Art and Identity in Oceania*, 44.

Wardwell, Allen. *The Sculpture of Polynesia*. Chicago: Art Institute of Chicago, 1967.

——. *The Art of the Sepik River*. Chicago: Art Institute of Chicago, 1971.

——. *Island Ancestors: Oceanic Art from the Masco Collection*. Seattle: University of Washington Press, in association with the Detroit Institute of Arts, 1994.

Welsch, Robert L. "Introduction: Changing Themes in the Study of Pacific Art." In Herle et al., *Pacific Art*, 1.

Welsch, Robert L., Virginia-Lee Webb, and Sebastine Haraha. *Coaxing the Spirits to Dance: Art and Society in the Papuan Gulf of New Guinea*. Hanover, N.H.: Hood Museum of Art, Dartmouth College, 2006.